American Letters

*This book is dedicated
to the children,
grandchildren,
and great-grandchildren
of the Pollock brothers*

JACKSON POLLOCK & FAMILY

American Letters 1927–1947

Choice of letters by Francesca Pollock
Edited and annotated by
Sylvia Winter Pollock
Introduction by Michael Leja
Drawings by Charles Pollock

polity

First published in French as *Lettres Américaines* © Grasset & Fasquelle, 2009

This augmented and enlarged English edition © Polity Press, 2011

Drawings by Charles Pollock © Charles Pollock Archives, Paris

Polity Press
65 Bridge Street
Cambridge CB2 1UR, UK

Polity Press
350 Main Street
Malden, MA 02148, USA

ISBN-13: 978-0-7456-5155-2

A catalogue record for this book is available from the British Library.

Typeset in 11 on 13 pt Sabon
by Servis Filmsetting Ltd, Stockport, Cheshire
Printed and bound in Great Britain by MPG Books Group Limited, Bodmin, Cornwall

The publisher has used its best endeavours to ensure that the URLs for external websites referred to in this book are correct and active at the time of going to press. However, the publisher has no responsibility for the websites and can make no guarantee that a site will remain live or that the content is or will remain appropriate.

Every effort has been made to trace all copyright holders, but if any have been inadvertently overlooked the publisher will be pleased to include any necessary credits in any subsequent reprint or edition.

For further information on Polity, visit our website: www.politybooks.com

Contents

Acknowledgments

Some letters are in private collections, others have been given to the Archives of American Art, Smithsonian Institution, Washington, D.C., where they are classified among the Charles Pollock Papers.

Most of the letters from Jackson Pollock are in the collection of the Pierpont Morgan Library, New York.

The letters from Thomas Hart Benton are in the Charles Pollock Archives. Text by Thomas Hart Benton © Thomas Hart Benton and Rita P. Benton Testamentary Trusts/UMB Bank Trustee/Licensed by VAGA, New York, N.Y.

The drawings by Charles Pollock are in private collections. Their titles are purely descriptive.

We would like to thank the Archives of American Art, Smithsonian Institution, Washington, D.C., the Pierpont Morgan Library & Museum, and the Pollock-Krasner Foundation, New York.

This book would not have been possible without the cooperation and participation of the family: Jeremy, Jonathan, Karen, and Jason. Special thanks to them, and to Sanford McCoy, Sanford LeRoy's grandson, for his insights.

Notes on Text

Most eccentricities of spelling and punctuation have not been retained.

The dates in square brackets come from postmarks or other sources.

The term "Project" invariably refers to the Federal Art Project W.P.A./F.A.P. (see Glossary).

Abbreviations for the names of cities have not been annotated: N.Y. for New York, K.C. for Kansas City, S.F. for San Francisco, L.A. for Los Angeles, N.O. for New Orleans.

The Pollock brothers are referred to throughout these letters by different diminutives: Charles as Chas, C; Marvin Jay as Jay, Mart, Marvin; Sanford as Sande, Sandy, Sante, S, San; Paul Jackson as Jack, Jackson.

To see America you have to
get down in the dust,
under the wheels,
where the struggle is.
Thomas Hart Benton to Charles Pollock, 1927

Family Tree

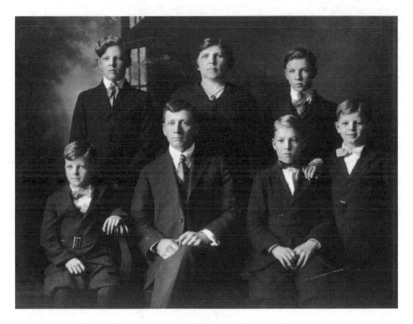

Sanford LeRoy, Charles Cecil, LeRoy, Stella, Frank Leslie, Marvin Jay,
Paul Jackson*

* During the cross-country trip made by Charles and Jackson in 1930,
Charles suggested that Jackson drop his first name, Paul, and just use
Jackson: "Jackson Pollock, that sounded good." (Taped interview with
Sylvia Winter Pollock.)

LeRoy (McCoy) Pollock
1877–1933
m
Stella Mae McClure
1875–1958

Charles Cecil
1902–1988
m
Sylvia Winter

Marvin Jay
1904–1986
m
Alma Brown

Frank Leslie
1907–1994
m
Marie Levitt

Sanford LeRoy (McCoy)
1909–1963
m
Arloie Conaway

Paul Jackson
1912–1956
m
Lee Krasner

Elizabeth Feinberg

Francesca 1967

Jeremy 1938

Jonathan 1942

Karen 1941

Jason 1948

LeRoy Pollock was born a McCoy and adopted by a Pollock family.
Sanford Pollock changed his name to McCoy in the 1930s.

The Pollock Brothers

Charles Cecil Pollock was born in 1902 in Denver, Colorado. He studied with Thomas Hart Benton at the Art Students League in New York, and met his partner Elizabeth Feinberg after moving to New York. They had a daughter, Jeremy. Charles was a painter all his life and taught calligraphy, lettering, typography and printmaking from 1946 to 1968. He moved to Paris with his second wife Sylvia Winter and their daughter Francesca in 1971; he died there in 1988.

Marvin Jay Pollock was born in Cody, Wyoming, in 1904. Jay worked in printing, as a plate-maker and re-etcher in rotogravure, and finally as the foreman of a printing plant. He was always active in the labor unions. He married Alma Brown; they had no children. He died in California in 1986.

Frank Leslie Pollock was born in Cody, Wyoming, in 1907. He went to New York with Charles in 1926, where he studied journalism and writing at Columbia University while working at the law library. He worked in journalism, but after his marriage to Marie Levitt, went into his wife's uncle's wholesale rose-growing business. He had one son, Jonathan. Frank died in California in 1994.

Sanford LeRoy Pollock was born in Cody, Wyoming, in 1909. Starting out as a painter, he worked for the W.P.A. with his

brothers Charles and Jackson, then did silk-screen printing. He married his childhood sweetheart Arloie Conaway; they had two children, Jay (Jason) and Karen. During the war he worked for an industry that printed electronic circuits by silk screen. Sande died of lymphoma at the age of fifty-four.

Paul Jackson Pollock was born in Cody, Wyoming in 1912. He joined Charles and Frank in New York in the 1930s to study with Thomas Hart Benton at the Art Students League; he lived with Charles and Elizabeth, then with Sanford and Arloie. Beginning his career as a Social Realist, he later became a major figure of Abstract Expressionism. He was married to the painter Lee Krasner; they had no children. Jackson died in a car crash in East Hampton, Long Island, at the age of forty-four.

Introduction

Michael Leja

The letters collected in this volume were written principally between 1927 and 1945 by members of the Pollock family: parents LeRoy and Stella; their five sons, Charles, Marvin, Frank, Sanford, and Jackson; and the sons' wives, Elizabeth, Alma, Marie, Arloie, and Lee. The correspondence begins as the sons are leaving high school and moving away from home in search of jobs, professional training, excitement, and challenges. It ends just as the youngest of them, Jackson, is beginning to attract attention as one of the most daring and original painters in New York.

"Such is life," LeRoy wrote to his oldest son, Charles, "families grow up and scatter." As the Pollock family scattered, letters became the principal means of keeping others posted on how each was faring in very difficult times. The importance of this contact is everywhere evident in the letters themselves, most obviously in the earnest exhortations to "write back soon" and the countless apologies for not doing so. Merely keeping track of where the others were living was a challenge in itself. The Pollocks were always on the move.

The family had been peripatetic almost from the moment the parents married in 1903, when they relocated from the farmland of Tingley, Iowa, to Cody, Wyoming, where all their sons except the first, Charles, were born. When Jackson, the youngest, was less than a year old, the family moved briefly to southern California, then to a farm in Phoenix for

four years, and on to northern California, where they spent a year or two apiece in Chico, Janesville, and Orland. In 1922 they moved back to Phoenix for two years, then to Riverside, California, which was their home base when the letters collected in this volume begin. In 1928 the family moved to Los Angeles, where Stella continued to live through the 1930s. Her husband, LeRoy, frequently took jobs on surveying and road construction crews that kept him away from home for long periods. When his sons were old enough to work, they sometimes accompanied him to summer jobs, as Jackson did in Santa Ynez, California, in 1929.[1]

Charles's decision in 1926 to move to New York to study art set a career path that his two youngest brothers followed, and established a family outpost on the other side of the country that would last for decades. Frank, the second brother to settle in New York, took journalism classes at Columbia and worked in the law library there; subsequently, Jackson and then Sande joined the New York branch of the family. The younger brothers stayed on long after Charles moved to Washington D.C. and then to Detroit, and Frank returned to California. Mart stayed largely in California during this time, although he moved north to San Francisco.

For a few years after setting out on their own – that is, into the mid-1930s – the brothers in New York traveled back to California for summer jobs or Christmas holidays by hitchhiking, hopping freight trains, or driving a car when they could get one. Traveling so widely, they witnessed at first hand the effects of the Great Depression in all regions of the country, and they recorded their experiences in letters that are sometimes colorful and insightful and sometimes frustratingly opaque.

These letters, then, tell several stories. One concerns the members of a family striving to remain close in spite of the great distances that separate them and the extraordinary hardships they face. They handle sensitive family business – such as collecting money to enable the aging Stella to get her teeth fixed, or helping an out-of-work sibling find a job, or reporting on a brother who is having "a succession of periods of emotional instability" – through their letters.

A second story features historical testimony: ground-level

accounts of epic events unfolding in the nation: There is a view from inside a boxcar passing Texas panhandle of lots of "interesting bums and the average American looking for work"; an overheated automobile of a dazed, withere the Midwestern dust bowl saying over and over you can have some water"; and a view from across the desk of a social worker pointing at a chart showing "how three [people] were to live on $38 a month."

And, of course, there is the Jackson Pollock *Bildungsroman* – the story of his transformation from confused and rebellious high-school student to internationally significant artist. That story has been told many times before by biographers and art historians, but the version that emerges here is refreshingly short on sensationalism and speculative psychologizing. Furthermore, the more familiar materials – Jackson's own letters and the reports about him given by others – look different when seen within the context of the previously unpublished family correspondence.[2] The broader frame gives us a sense of the ongoing conversations in which Jackson's words were embedded – conversations on such urgent topics as the relations of art and politics and the future of the country. Jackson's famous remark in a 1933 letter to his father that "this system is on the rocks so no need to try to pay rent and all the rest of the hokum that goes with the price system" has been cited as evidence of his political extremism during the Great Depression. It sounds positively restrained, however, when compared with Frank's words to Charles that same year: "our chances of changing the system by means of the vote are slight . . . nothing short of an armed revolution will attain the desired end." Or compare Sande's letter to his mother regarding the 1936 presidential election, in which he speculates that if the Republican candidate Alf Landon defeats Franklin Roosevelt, it "might not be so bad either, for then we could start the shooting."

Because three of the Pollock brothers were pursuing careers as artists during the period covered in this volume, artworld matters claim a large amount of space in their letters. Their words often make vivid and immediate the character of life for these particular struggling artists in New York in the

1930s and early 1940s. They give us insight into the issues artists were talking about in those days, into their ambitions and conflicts, their enthusiasms and disappointments, and their ways of coping with the challenges presented by the Great Depression, World War II, and other cataclysmic events of the time. That story, perhaps the richest in these letters, warrants a bit of background.

Art and Politics in the 1930s

The Pollock family correspondence is densest in the mid-1930s, years of extreme hardship and conflict when the living conditions brought by the Depression were becoming normal, fascism was on the rise in Europe, and another world war was starting to seem inevitable. For artists, the challenge of simply surviving was more than matched by the challenge of deciding what kind of art to make in this time of crisis. The three Pollock brothers felt these pressures acutely and addressed them in their letters.

First, there was the uncertainty and fear about earning enough money to stay off the breadlines. Franklin Roosevelt's New Deal included some limited relief for artists: beginning with the Public Works of Art Project in 1933 and culminating in 1935 in the Federal Arts Projects of the Works Progress Administration, the government commissioned artists to paint murals for public buildings, teach community art classes, clean and restore public sculpture, make photographs documenting the conditions of farm life, or even make paintings and sculptures on their own. Across the country, the program funded the production of over 2,500 murals and over 100,000 paintings and sculptures, encompassing a remarkably broad range of subjects and styles.[3] To qualify for the program, artists had to sign a form saying they were penniless, which many found demeaning, but no more so than having to swear that they had never been affiliated with the Communist Party, which they were also sometimes required to do. The stipend was barely enough to live on, but artists were not allowed to pool their resources. Jackson and Sande broke the rules by sharing living and working space while

both were funded by the Project, and this deception caused them considerable anxiety. Sande wrote to Charles in 1939: "We have been investigated on the Project. Don't know yet what the result of it all will be. Should they ever catch up with my pack of lies they'll probably put me in jail and throw the key away! They are mighty clever at keeping the employees in a constant state of jitters." The next year he wrote to Stella, "We on the Project have been forced to sign an affidavit to the effect that we belonged to neither the Communist or Nazi parties. A wholly illegal procedure." A few months later he continued the story in a letter to Charles: "[The Project] has never been so shaky as now. They are dropping people like flies on the pretense that they are Reds, for having signed a petition about a year ago to have the CP put on the ballot. We remember signing it so we are nervously awaiting the axe."

Like other kinds of salaried employees struggling to survive the Depression, artists formed associations to defend their rights and promote their interests. The Artists' Union, founded in 1933, sought to improve the situations of artists on the Projects. For those artists committed to effecting radical political change through art there were the John Reed Clubs, named after the journalist who wrote classic accounts of the Russian Revolution. A broader coalition of leftist and liberal artists, the American Artists' Congress, was founded in 1936 to unite all progressive artists in the fight against war and fascism.[4] The Pollock brothers participated in these organizations – they exhibited paintings at the John Reed Club, attended the Artists' Congresses, and belonged to the Artists' Union. Their letters recount aspects of the meetings, protests, and workshops and name names when leading lights such as "George Biddle and Rockwell Kent were the main speakers and God how they stank."

Then there was the problem of what and how to paint in the midst of the crisis. Like workers of all sorts during this period, many artists became radicalized by the Depression. They gravitated toward Marxist and Communist explanations for the financial collapse and agreed with the authors of the John Reed Club manifesto: "The present crisis has stripped capitalism naked. It stands more revealed than ever

xvii

as a system of robbery and fraud, unemployment and terror, starvation and war."[5] Even relative conservatives, such as the art critic Thomas Craven, were willing to concede that no artist of the 1930s should set out to celebrate America, because "no self-respecting artist could glorify capitalism."[6] Radicals and conservatives also agreed that art should be designed to speak to the people, not some economic or intellectual elite but the great mass of mankind. Where Craven and his associates would part company with the John Reed artists was when the latter called for art to be made "a weapon in the battle for a new and superior world."[7] Should art be propaganda? On this issue there were deep disagreements.

One side held that "art is propaganda, or it is not art." Those words of Diego Rivera, a Mexican painter who had come to international prominence as a muralist and advocate for a revolutionary art, were much quoted in American magazines in the 1930s. Rivera had been part of the cubist avant-garde in Paris in the 1920s, but after the Mexican Revolution he developed a monumental figurative art indebted to the indigenous murals of pre-conquest Mexico and to popular prints, which he believed had greater potential to underpin a popular and revolutionary art. He became an influential spokesman for the radicals, advocating a proletarian art that would replace the misguided and exhausted bourgeois program of "art for art's sake" or "pure art." Art must now be put to the service of the working classes in their struggle for political power, he asserted. "They have need of an art which is as full of content as the proletarian revolution itself, as clear and forthright as the theory of the proletarian revolution."

Such an art might be labeled propaganda, but to Rivera,

all painters have been propagandists or they have not been painters. Giotto was a propagandist of the spirit of Christian charity, the weapon of the Franciscan monks of his time against feudal oppression. Breughel was a propagandist of the struggle of the Dutch artisan petty bourgeoisie against feudal oppression. Every artist who has been worth anything in art has been such a propagandist. The familiar accusation that propaganda ruins art finds its source in bourgeois prejudice.

For Rivera, even art for art's sake had "enormous political content – the implication of the superiority of the few."[8]

Craven took Rivera's words as a point of departure for framing his antithetical position: art must never proceed from belief, political or otherwise. To Craven, true art was rooted in the observation of life.

> No art can be enslaved to doctrine. Art, in its proper manifestations, is a communicative instrument; but it communicates its own findings – not what is doled out to it; not what an economic theory imposes upon it, but its discoveries in any department of life . . . I have only one medicine to prescribe for the painter – an interest in living.

Craven pointed to the work of Thomas Hart Benton as an example of this approach to art. Unlike Rivera, whose representations of American life Craven saw as devoid of any direct experience of that life, Benton painted murals that take "their final form and character from the American environment . . . Benton's murals reveal and communicate the actual conditions of his native land; its restless spirit, its interest in facts and details, its exaggerated buffoonery, and some of its pathos. He has created a valid American art."[9] Craven's valorization of art that captured a unique national identity did not mesh with Rivera's desire for an art that spoke to and for an international working class; and Craven's confidence that artists could suspend their beliefs and interests and observe the world without prejudice would certainly have struck Rivera as naive. Nonetheless, these two positions became powerful alternatives in the 1930s, and the letters of the Pollock brothers are vivid documents of their struggle to come to terms with them.

Early in their artistic careers, Charles and Jackson were captivated by the Benton-Craven position. As students of Benton at the Art Students League in New York, they subscribed to his theories and imitated his art; both made paintings that were obviously indebted to his. Benton encouraged his students to paint pictures celebrating the dynamism and uniqueness of ordinary, rural life in the United States. To really experience the country, he advised, artists had to travel,

had to get off the main roads, "get down in the dust, under the wheels, where the struggle is," as he wrote to Charles in 1927 in a letter commending him for doing just this. "From such a position the notion of a stereotyped land and people is ludicrous." Other portions of this letter preview remarks Benton would make seven years later, in 1934, to *Time* magazine, which featured him in a cover story on American Scene painting. His populism included attacks on intellectuals and the affluent: "I have not found the U.S. a standardized mortuary and consequently have no sympathy with that school of detractors whose experience has been limited to first class hotels and the paved highways."[10] Benton, along with his wife Rita, became a lifelong friend of the Pollock brothers, and several of his letters to them are included in the present volume.

Charles and Jackson followed Benton's example in making travel an essential, generative ingredient of their art. Their cross-country trips home to California gave them good opportunities to seek out gritty, picturesque scenes and to record them carefully and exuberantly. Some of the letters describing their travels sound like descriptions of Benton's paintings. Jackson, for example, slipped into Bentonesque clichés when recounting the sights he encountered on a trip across the Midwest: Kansas wheat farmers preparing for harvest and "Negroes playing poker, shooting craps and dancing along the Mississippi in St. Louis." Benton was criticized by the left for perpetuating such caricatures – of "Negroes shooting crap as a picture of Negro life, or a landscape with a contented farmer ... these elements are often treated abstractly and picturesquely without reference to a social meaning."[11] Jackson's letter suggests that he was seeing the country through the lens of Benton's painting, which calls into question Craven's theory about objective observation through art.

Jackson was adamant about his allegiance to Benton and Craven in the early 1930s. In a letter to his mother of April–May 1932 he defended Craven to Sande.

Sande didn't say in his letter if he heard Thomas Craven lecture there or not – he should have. I meant to write him about it, he

is one critic who has intelligence and a thorough knowledge of the history of art. I heard that he was made quite a joke out there which is not unlikely for the element of painters found out there.

Early on, the Pollock brothers had no problem admiring the work of Benton and more politically radical painters, such as Rivera, simultaneously. In a letter to Jackson from October 1929, Charles writes that some of the Mexico City murals of Rivera and José Clemente Orozco are "the finest painting that has been done, I think, since the sixteenth century." Charles and Jackson made a special trip to see murals by Orozco at Pomona College in 1930. But by the mid-1930s the paintings of Benton and those of the Mexican muralists were becoming incompatible in terms more of politics than aesthetics. The Pollock brothers still appreciated Benton's way of painting, but they came to reject the political implications of his work.

The first evidence of the turn is a letter from April 1935 to Charles from Frank, who must have become acquainted with Benton through Charles during their time together in New York. "I was stunned to read the narrow attitude Benton has taken on the Marxist position." Frank enclosed with the letter an article from the *Los Angeles Times* of April 1, 1935, headlined "Muralist Benton Quits New York for Midwest," in which Benton was quoted as saying, "I'm anti-Marxist. Back in New York I'm in continual controversy with the Communists . . . I'm sick of New York." Benton had come under intense criticism from the radical artists in New York for his nationalism and for his rejection of political art. He explicitly sided with Craven and argued that "Belief, when it becomes dogma, has been historically detrimental to the evolution of artistic practice because belief . . . resents discoveries in perception which might force modifications in belief structures."[12] As recently as February, Charles had identified with Benton: "Benton has just returned from an extensive speaking tour which was most successful . . . He is considering moving to the Midwest. This of course is what we all want to do." But two months later Charles's tone changed and he concurred with Frank's disillusionment. "A good deal that he [Benton] has had to say and many of his

actions have been indefensible . . . I know that he is hope-lessly muddled . . . Benton of course is aware that the young people around him – his former students – are going left, and it has hurt him." Some of this shift of attitude may have resulted from Charles's disappointment over Benton's choice of another student to accompany him to Kansas City as his assistant. Charles acknowledged that Benton's choice was a "rude shock" to him, but he remained unwavering in his belief in the rightness of Benton's art: "he remains the one man in this country who can offer us something substantial in the technique of painting." Sande, writing to Charles in 1937, rejected Benton in the strongest terms of all: "The man is artistically bankrupt and . . . politically rotten."

By 1936, Sande and Jackson had joined the workshop of another leader of the Mexican muralists, David Alfaro Siqueiros. Among other projects they helped produce sculpted heads, measuring 24 feet high, of William Randolph Hearst and Adolf Hitler portrayed as twins seated on a canon. Sande explained to Stella that this construction "will be placed on a boat and paraded back and forth in front of the millions of people who will be on the beach at Coney Island." In 1939, Sande, who seems always to have preferred the Mexican muralists to Benton, wrote to Charles that Orozco "is the only really vital living painter." In 1944, following his first major solo exhibition, Jackson collaborated on an interview for *Arts and Architecture* magazine that made definitive and public his distance from Benton: "My work with Benton was important as something against which to react very strongly."

Although they continued to be friends with the Benton family and to admire Benton's art, both Charles and Jackson had to find ways to break free of their teacher's influence. They took different routes toward this end.

By 1935, Charles had decided to turn his attention to polit-ical cartoons. He modeled his work on that of Thomas Nast and Honoré Daumier, both of whom were widely admired at this time as practitioners of effective political art. Benton himself spoke of these artists as exceptions to his rule that art cannot be in service to politics. For him, their examples necessitated a distinction between "social understanding" and "belief": "The 'social understanding' of Daumier and

Nast did not keep them from being great artists."[13] Charles was willing to go much further than this, and in 1937 he expanded his ambitions to encompass visual propaganda in many media. "I intend to promote as intensively as possible the use of posters, murals and all forms of graphic art in the development of propaganda and education. This will include photography, the motion picture, the animated cartoon and strip film."

For Jackson, the path away from Benton, both political and aesthetic, ran through modernist art infused with politics: the Mexican muralists, Surrealism, the Picasso of *Guernica*. The family members who were living with Jackson or seeing him regularly noted the drastic changes appearing in his work around 1936. The first mention of this comes in a letter from Elizabeth, Charles's wife, from August of 1936: "Jack's work is improving amazingly; he is going to be a magnificent painter one of these days. It, the work, is entirely different from Charles's in style. Jack's is much more imaginative and unrealistic and I like this about it." In 1940, Jackson himself acknowledged to Charles that "I have been going through violent changes the past couple of years. God knows what will come out of it all – it's pretty negative stuff so far." A few months later, Sande reinforced Elizabeth's positive appraisal: "Jack however is doing very good work. After years of trying to work along lines completely unsympathetic to his nature, he has finally dropped the Benton nonsense and is coming out with honest, creative art."

A factor in the emergence of this honest and negative art was Surrealism, particularly the work of André Masson and Joan Miró. This topic is conspicuously absent from the Pollock family letters, which may indicate that Surrealism was not an interest Jackson shared with his brothers. The Surrealists embraced the unconscious as a generative source for art and revolutionary politics, and they developed ways to engage it in their art, including automatic writing, free association, and dream imagery. Jackson was interested in these ideas, certainly by 1939, when he was experimenting with automatic writing. He had also by that time begun to consult Jungian analysts for help in understanding his self-destructive and violent behavior, including his excessive drinking. That

he used his drawings in these sessions as a way of opening up discussion is an indication of his embrace of the premises of Surrealism. Making art and conducting psychological self-analysis were becoming overlapping operations for him.[14]

Jackson's artistic break from Benton took forms and symbols of political conflict devised by Orozco and Picasso, mixed them with motifs derived from myth as analyzed by Jung and his followers and with ideas and forms discovered in the Surrealism of Masson and Miró, and placed this unlikely combination in a cosmic frame such that violent struggle became the essence of human experience and art. He described what he was doing as "painting out of the unconscious," although his efforts were always considerably more conscious and artful than this made them sound. The full ramifications of this approach would not become clear until the later 1940s and the development of his poured paintings.

So the routes that led Charles and Jackson away from Benton diverged. Although Charles's work continued to resemble Benton's formally until about 1945, he embraced Rivera's commitment to art as propaganda. Jackson's work by the late 1930s looked nothing at all like Benton's, but it pursued exploration in realms where belief was at best fragmentary and changing. It was not the look of ordinary American life that interested him now, but the conflicts – cosmic and psychic – that shaped his own psyche and maybe all minds.

The Pollock Wives

The importance to Jackson's development of Stella, the strong-willed matriarch of the Pollock family, and Lee Krasner, his wife and an accomplished and original painter in her own right, is well known. Krasner, whose relationship with Pollock did not really develop until 1942, figures only slightly in the letters collected here.

The wives of Jackson's brothers, however, emerge more fully, in part because they often took responsibility for keeping up family correspondence when their husbands slacked off. Elizabeth wrote to Stella that she had "stopped

hounding [the boys] about neglecting to write ... I made myself a pest for a while and don't think it got any results. Perhaps men just don't think of these things the way we do."

Elizabeth's letters in particular reveal her to be a talented and remarkable individual. Elizabeth Feinberg Pollock appears first in 1931 as Charles's new wife, introducing herself to her mother-in-law in an elegantly articulate letter.[15] Amidst professions of her deep love for Charles and profound admiration for his art ("in truth, I fell in love with his work first"), she assures Stella that her own work "is of far less importance to me than the hope of furnishing Charles whatever outward encouragement and aid he needs to advance toward full growth in his art." Incidentally, Elizabeth also assisted Benton by modeling for one of the prominent figures – a woman watching a movie – in one of his *America Today* murals, *City Activities with Dance Hall*, done originally for the New School for Social Research in New York.[16]

Elizabeth's own work was writing – primarily plays and journalism, although she took other kinds of work to earn income. In early 1934, Charles reported that Elizabeth was working in real estate and "becoming more radical every day and wants now to go into the Midwest and organize." She had also just finished a play titled *Men Grow Taller*. Later that year she was employed by the Federal Theater Project, which brought her to Vermont, evidently to assist with staging one of her plays. A letter from Charles, who was driving across the country with Jackson that summer, indicates that the production was scheduled to move to New York. Another play, unnamed in the letters but described by Charles as "the best thing she has done yet," was finished in 1936 and sent to Elizabeth's agent amid high hopes that it would be produced. Among her friends was Lester Cole, a highly successful writer of screenplays in the 1930s and 1940s who was later blacklisted as one of the Hollywood Ten.

In addition to her writing, Elizabeth worked as an activist and labor organizer. She taught in 1935 at Brookwood Labor College in Katonah, New York, one of the first colleges founded by labor activists and catering to students from the working classes. Two years later she took a job working the

night shift in a U.S. Rubber factory, where she tolerated the terrible odors in hopes of helping to organize a union. Her activism and her writing were curtailed by her pregnancy in 1938. In 1940, she wrote to Frank and Marie that she had become "a housebroken hausfrau, nursemaid, and laundress – but the baby's worth it all."

Alma Brown Pollock, Mart's wife, is also a striking character in the letters. Active in labor organizing and publishing, at one point she broadcast on a local radio station in Springfield, Ohio, a fifteen-minute commentary on relations between the United States and China. These letters make us want to know more about the unsung women in the Pollock clan.

Family Culture

The Pollock family – economically unstable, frequently in transit, resident largely in provincial hinterlands – was not an obvious incubator for children with ambitions to be producers of high culture. Father LeRoy spent his life shuttling from job to job (as farmer, surveyor, plasterer, road construction worker, stonemason, dishwasher), never accumulating much money, and considering himself a financial failure, as he told his sons in so many words. Stella was tireless as a mother and housekeeper, but her stern determination to provide an elegant and dignified home was often frustrated by insufficient resources. How did it happen that this family produced three aspiring artists and a fourth son educating himself to be writer?

The parents' commitment to culture was certainly a factor, and it becomes evident early in the letters – for example, when LeRoy takes pride in the fact that the young Jackson, working with him on a summer job, is reading "quite a lot of good magazines." Subsequent letters show most of the Pollock brothers to be avid readers, especially of the publications of the radical press: *The New Masses*, *The Nation*, *Daily Worker*, *Workers' Age*, *Modern Monthly*, *Common Sense*. Contributors to these publications included some of the most important writers and intellectuals of the period. Some of the Pollock brothers tried their hands as authors: even the least

literary of them, Mart (also known as Jay), who worked principally as a printer and photo-engraver, collaborated with his wife Alma and others to write a union bulletin, which they produced on a mimeograph machine, assembled by hand, and mailed out to 500 recipients. Like many of their contemporaries in the radical left, the Pollock brothers believed in the value of taking an active part in the production and circulation of information, political argument, and culture.

All the Pollocks were deeply immersed in the culture of their time: they were readers of *Literary Digest* and of the novels and plays of Sinclair Lewis, Clifford Odets, and William Saroyan; they discussed the architecture of Frank Lloyd Wright, went to movies, and listened to the radio programs of Edgar Bergen. Among the friends mentioned by name in their letters are leading intellectuals and teachers and powerful political figures. Benton's connections among the New York intelligentsia enlarged their circle of friends with cultural cachet.

That the oldest of the brothers, Charles, made becoming an artist look so possible and exciting also helps to account for the large number of artists in the family. His guidance helped Jackson early on, and the extent of his influence over his youngest brother is obvious from their exchange of letters in October 1929, the month of the stock-market crash. Charles told Jackson to forget the religion and theosophy he was learning from his high-school art teacher and accept the challenge of contributing to the progress of modern life and culture. He recommended looking up the art of Benton and the Mexican muralists in magazines such as *The Arts* and *Creative Art* and delving into psychology and sociology. Jackson took Charles's advice very seriously: "I have read and re-read your letter with clearer understanding each time." He "dropped religion for the present," subscribed to the art magazines Charles mentioned, and fantasized about moving to Mexico City. A few months later he was back to theosophy and trying to figure out how a book of theosophical teachings could seem to him helpful despite being "contrary to the essence of modern life."

There must have been competition among the Pollock brothers. Charles was arguably the most erudite and

articulate, to judge from the letters, and one can only imagine the mixed feelings he must have had while watching the rise to artistic stardom of the self-destructive and impulsive little brother he had tutored. Jackson was openly competitive with influential modernist artists like Picasso, whose work he sought to surpass, and with his associates among the Abstract Expressionists. But of competition among the brothers the letters gathered here contain little or no evidence. Rather, they foreground the support and assistance the brothers provided one another and the pride they took in each other's achievements.

The importance of familial culture and familial relationships in generating the artistic aspirations of the Pollock brothers is indicated in a letter Sande wrote to his brothers in 1933 on the occasion of the death of their father. He assessed LeRoy's legacy this way: "His absence will leave a gap in our lives which can only be filled by our untiring efforts toward those cultural things which he, as a sensitive man, found so sordidly lacking in our civilization."

Waiting for the New Order

In the later 1930s and early 1940s, international events undermined the convictions of many of the radical artists and intellectuals, including the Pollock brothers. The Moscow Trials, in which Stalin eliminated his competition through trumped-up charges, caused visceral confusion and shock. Frank wrote that "the Moscow trials upset me for a couple of weeks . . . Who are we to trust?" Sande, too, was shaken: "The Russian trials have knocked the guts out of my beliefs toward any kind of Communism or proletarian (as well as all kinds of) dictatorship . . . I am developing a shell of extreme fatalism."

The confusion and despair only deepened in 1939, as international treachery and aggression increased and world war approached. The letters provide a vivid sense of the profound personal disorientation that was the collective experience in these years. In Mart's words, "In times like these one hardly knows what will happen next as the old order comes tumbling

down and the new order is rapidly pushing forward." Sande likened the feeling to dizziness: "This national and international situation has become so complex and run through with incongruities that it makes one dizzy in search of solid ground to stand on." The optimism and determination despite adversity, characteristic of letters of the mid-1930s, were giving way to a sense of confusion and powerlessness. Established beliefs now felt inadequate to dealing with the traumas of the new order, and new models of human nature and the human condition were called for. Such fundamental questioning created a situation of extreme openness in which tremendous challenges and possibilities confronted artists ambitious enough to face them. The letters in this volume do not answer the question of how it was that Jackson Pollock, rather than Charles or Sande or any other painter, became a leader forging ahead into the new artistic order. They do, however, clarify the terms of the mystery.

Notes

1 For background history on the Pollock family, see Steven Naifeh and Gregory White Smith, *Jackson Pollock, An American Saga* (New York: Clarkson Potter, 1989).

2 Many of Jackson's letters were originally published in Francis V. O'Connor and Eugene V. Thaw, eds., *Jackson Pollock: A Catalogue Raisonné of Paintings, Drawings, and Other Works* (New Haven, Conn.: Yale University Press, 1978), vol. 4.

3 Francis V. O'Connor, *Art for the Millions* (Greenwich, Conn.: New York Graphic Society, 1973).

4 Andrew Hemingway, *Artists on the Left: American Artists and the Communist Movement, 1926–1956* (New Haven, Conn.: Yale University Press, 2002).

5 "Draft Manifesto of the John Reed Clubs," *New Masses*, June 1932, 14; reprinted in David Shapiro, ed., *Social Realism: Art as a Weapon* (New York: Frederick Ungar, 1973), 42.

6 Thomas Craven, "Art and Propaganda," *Scribner's*, March 1934, 189–94; reprinted in Shapiro, 94.

7 "Draft Manifesto of the John Reed Clubs," Shapiro, 46.

8 All quotations by Rivera from "The Revolutionary Spirit in Modern Art," *Modern Quarterly*, autumn 1932, 51–7; reprinted in Shapiro, 54–65.

9 All quotations by Craven from "Art and Propaganda"; Shapiro, 81–94.

10 "Art: U.S. Scene," *Time Magazine*, December 24, 1934, 24–7.

11 John Kwait, "John Reed Club Art Exhibition," *New Masses*, February 1933, 23–4; reprinted in Shapiro, 66.

12 Thomas Hart Benton, "Answers to Ten Questions," *Art Digest*, March 15, 1935, 20; reprinted in Shapiro, 99.

13 Ibid., 99–100.

14 For further discussion of this, see my *Reframing Abstract Expressionism: Subjectivity and Painting in the 1940s* (New Haven, Conn.: Yale University Press, 1993).

15 Although Elizabeth refers to herself as Charles's wife, they did not legally marry.

16 Naifeh and Smith, 189.

American Letters, 1927–1947

1927

*Thomas Hart Benton[1] (Massachusetts[2]) to Charles
(New York)*

[September 6, 1927]

My dear Pollock,

I see by your letters that you have not had an entirely dull summer. I like to do just the sort of thing you and Mitchell did this summer[3] and in fact came pretty close to it, though I was in a more fortunate locality for picking up rides. I covered a good deal of territory from St. Louis through Missouri, Arkansas, Oklahoma, Texas and New Mexico and gathered in a good supply of engaging material for work.

I become more and more in love with America the more I get out in it. It offers so much that art has never touched. As for its being stereotyped and built up on the same pattern everywhere that is only a blanket which our intellectuals throw over their incapacity for sensitive observation. The upper middle classes are alike over the whole western world just as are their hotels and cultural pretenses but it is not in that class as such that an intelligent person hunts for realities. To reach the imagined felicities of that class is undoubtedly the more or less conscious ambition of the majority of Americans but the means employed gives rise to innumerable

varieties. Like in our own art, realities are found while on the way not in an attainment.

Most of our critics judge America from the lobbies of its first class hotels or from the drawing rooms of people already corroded with cultural aspirations, arrivées who have felt the futility of complete arrival. Naturally their judgments are cockeyed. To see America you have to get down in the dust, under the wheels, where the struggle is. From such a position the notion of a stereotyped land and people is ludicrous.

Of course you can't do this unless you can hold to a strictly objective attitude. You can't see the world through the glasses of any sort of partisanship and see it as it is even if you are in the very center of its works.

However, enough of this. You see why I don't write letters with any frequency. Whenever I get a pen in my hand all the stuff that is boiling away in my noodle begins to spill over. I have so many objections to the crochets of our "critical intelligence" that they color even a friendly letter.

I expect to return to N.Y. about the first of October. I shall be anxious to see what you have done. As to the League business, trust absolutely to your intuitions – you will otherwise get into politics – the which can be relied upon to cook an artist's hash.

Sincerely yours,
Thomas H. Benton
T.P. Benton and I send our best to you
T.P.'s mama[4]

Notes
[1] Thomas Hart Benton (1889–1975), American regionalist painter; Professor at the Art Students League in New York City from 1926 to 1935.
[2] Martha's Vineyard.
[3] Charles Pollock had crossed the United States and Canada on foot and riding freights with a classmate at the Art Students League, William (Bill) Mitchell. Mitchell went on to a long and brilliant career as an automobile designer at General Motors and retired as vice-president of the design staff.
[4] These few words were written by Benton's wife, Rita Piacenza Benton. Their son, Thomas Piacenza Benton (called T.P.), was born in 1926.

LeRoy (California) to Jackson (California)

December 11, 1927

Dear Son Jack –
Well I have just gotten in and have been thinking of you
a great deal your case is sure a problem to me. I would so
much like to see you go on through high school as I know
if you could you would be in a better position to start into
something. Education should really be a mind training – a
training to make you think logically. The problems you solve
today give you strength to solve a little harder ones tomorrow
and so it goes. It takes a lot of application and concentration
and interest in your work in fact a hunger for knowledge and
power of mind. However if you are well satisfied that this
is impossible at present I suppose the thing to do is to go to
work at something where you can gain knowledge and train-
ing by practical experience. I would be a poor Dad indeed
if I did not wish for you the best future possible. I am sorry
that I am not in a position to do more for all you boys and I
sometimes feel that my life has been a failure – but in this life
we can't undo the things that are past we can only endeavor
to do the best possible now and in the future with the hope
that you will do what is best for your own good.
 I am your affectionate
 Dad

1928

September 19, 1928

Dear Son Jack:–
Well it has been some time since I received your fine letter. It makes me a bit proud and swelled up to get letters from five young fellows by the names of Charles, Mart, Frank, Sande and Jack. The letters are so full of life, interest, ambition and good fellowship. It fills my old heart with gladness and makes me feel *"Bully"*. Well Jack I was glad to learn how you felt about your summers work & your coming school year. The secret of success is concentrating interest in life, interest in sports and good times, interest in your studies, interest in your fellow students, interest in the small things of nature, insects, birds, flowers, leaves, etc. In other words to be fully awake to everything about you & the more you learn the more you can appreciate, & get a full measure of joy & happiness out of life. I do not think a young fellow should be too serious, he should be full of the Dickens some times to create a balance.

I think your philosophy on religion is O.K. I think every person should think, act & believe according to the dictates of his own conscience without too much pressure from the outside. I too think there is a higher power, a supreme force,

a Governor, a something that controls the universe. What it is & in what form I do not know. It may be that our intellect or spirit exists in space in some other form after it parts from this body. Nothing is impossible and we know that nothing is destroyed, it only changes chemically. We burn up a house and its contents, we change the form but the same elements exist; gas, vapor, ashes. They are all there just the same.

I had a couple of letters from mother the other day, one written the 12th and one the 15th. Am always glad to get letters from your mother, she is a Dear isn't she? Your mother and I have been a complete failure financially but if the boys turn out to be good and useful citizens nothing else matters and we know this is happening so why not be jubilant?

The weather up here couldn't be beat, but I suppose it won't last always, in fact we are looking forward to some snow storms and an excuse to come back to the orange belt. I do not know anything about what I will do or if I will have a job when I leave here, but I am not worrying about it because it is no use to worry about what you can't help, or what you can help, moral "don't worry".

Write and tell me all about your school work and yourself in general. I will appreciate your confidence.

You no doubt had some hard days on your job at Crestline[1] this summer. I can imagine the steep climbing, the hot weather etc. But those hard things are what builds character and physic. Well Jack I presume by the time you have read all this you will be mentally fatigued and will need to relax. So good night, Pleasant Dreams and God bless you.

Your affectionate Dad

Note
[1] A small town in the San Bernardino mountains, southern California.

Hemet
November 6, 1928

Dear Son Frank,

I rec'd your letter, written in route also the folder relating to
the Canal Zone. I was sure glad to get your letter and I was
glad to know that you were having such a good time. This
trip and the experience will always, I am sure, be a benefit
to you educationally and the environment and the acquaint-
ances you made all help in a liberal education. Since getting
your letter I have also read the letter you wrote to Mother
and the boys after you had finished your journey and were
with Chas in New York. No doubt you were happy at the
meeting and I trust your being together will be a source of
pleasure and a benefit to each of you. I would sure like to see
Chas, you might remind him that he owes me a letter though
of course I hear from him through the letters he writes home.
I suppose he is pretty busy and does not have the time to do
much letter writing.

I left the Kaibab Forest[1] on the 23rd of October and spent
three days at home and then came to Hemet. I do not know
how long we will be here. I am very nicely located at the
Palomar Hotel. Get good accommodations and good food
so it is quite an agreeable change from the camp life in the
mountains. The weather since coming here has been perfect
so I am enjoying the work O.K. One of the boys I am working
with made the trip from San Francisco to Baltimore through
the Canal and he also thought it a great trip.

Well I suppose there is a lot of excitement in New York
tonight as this is election night. The returns thus far as we get
them here at this hour (10 P.M.) denotes a sweeping victory
for Hoover so I suppose the people on the sidewalks of New
York are not so jubilant, as New York City is Smith's strong-
hold.[2] Well things will go on pretty much the same regardless
of which man is elected. I think they are both pretty good
men.

The folks at L.A. are very nicely situated and I surely
enjoyed being with mama and the boys and the three days

were entirely too short. However I am nearer now and can go home oftener. Write often and tell me about your experiences it's a happy moment when I get a letter from one of my boys.

　With love to you and to Chas,
　　Your affectionate Dad

Notes

[1] Arizona. The Kaibab National Forest is the name given to the forest that surrounds the Grand Canyon.

[2] In the U.S. presidential election of 1928 Republican Herbert Hoover (1874–1964) ran against Democrat Al Smith (1873–1944). The Republicans were identified with the booming economy of the 1920s, whereas Smith, a Roman Catholic, suffered politically from anti-Catholic prejudice, his anti-prohibitionist stance, and the legacy of corruption of Tammany Hall with which he was associated. Hoover won by a landslide.

1929

LeRoy (California) to Charles (New York)

Santa Ynez
April 26, 1929

Dear Son Charles,
Some time has elapsed since the arrival of your very welcome letter – I like to hear from you once in a year at least.

I am still on the road job[1] at Santa Ynez and am getting along fine. Jay and I are batching and recently have had a couple of fellows staying with us. Paul Wiese and Fred Shuler from Texas, they will be here a few days longer they are working for the contractor.

The countryside is still nice and green with myriads of wild flowers but this will soon be over for this year, as we are not likely to have any more rain until next fall. I was down home a couple of weeks ago on a short visit, everyone was well and happy I guess. Sanford was over to Riverside,[2] Jack and Mama at home. Sande came home before I left so I got to see him also. I got a letter from Mama yesterday with Frank's letter to her enclosed was glad to hear from you boys in that way. I also had a card from Marvin. He was O.K. though he said he didn't particularly care for Cleveland [Ohio]. Thought he might seek work in New York later. I wish you boys were all located in Calif. so we could see you oftener.

But such is life. Families grow up and scatter – but always try to keep in touch with your mother – because when she doesn't hear from you she worries. I expect to go home again in a couple of weeks.

 With best wishes for your health and success in life,
 I am your affectionate Dad

Notes
[1] LeRoy was a construction worker for the United States Bureau for Public Roads (U.S.B.P.R.).
[2] Southern California, 60 miles east of Los Angeles. Arloie Conaway, Sanford's girlfriend and future wife, lived there.

LeRoy (California) to Charles and Frank (New York)

Santa Ynez
July 20, 1929

Dear Sons Charles and Frank,
Well will write you a line to let you know the part of the family here at Santa Ynez are well and happy that includes Jack and myself. Our family will be more scattered than ever in a few days I guess, as Mama expects to start to Iowa next Monday to visit with her mother.[1]

 Mama was up here from the 1st to the 14th and it was quite a relief to get out of cooking and washing dishes for that long. Jack is working with me and is getting along fine he reads quite a lot of good magazines and so doesn't seem to get lonesome for the city.

 I will probably be here until Oct. and then I do not know where I will go. How are you boys getting along and do you stand the heat of New York all right. I notice by the papers they have had some pretty warm weather there. It has been quite hot here by spells some days it got up to 106 in the shade. The nights are always nice and cool so a person gets up in the morning very much refreshed.

 I haven't heard from Marvin for some time except through his letters to Mama. I guess he is O.K. and has a good job in Toronto Canada.

Air travel is sure on the increase out here we are on the route from Los Angeles to San Francisco and some days there are a dozen or more big liners go over.

Jack and I have a lot of fun batching together. He is a very good and pleasant companion always in a good mood so we are very happily situated for the summer – we are going to Solvang to purchase supplies and will mail this en route. Write us a letter right away.

As ever your affectionate Dad

Note

[1] Stella's mother, Cordelia Jane (Jennie) McClure (1848–1941), lived in Tingley, Iowa.

Charles (New York) to Jackson (California)

[October 1929]

Your letter[1] has dumbfounded me and I am inescapably led to write you a long letter to attempt if possible to persuade you of the folly of your present attitude toward the problems of life. I do this without wishing to meddle in your own personal problems but because I am interested in you and because I have myself gone through periods of depression and melancholy and uncertainty which threatened to warp all future effort.

I am sorry I have seen so little of you these past years when you have matured so rapidly. Now I have the vaguest idea of your temperament and interests. It is apparent though that you are gifted with a sensitive and perceptive intelligence and it is important that this quality should develop normally and thoroughly to its ultimate justification in the service of some worthy endeavor and not be wasted.

I know quite well this is no easy matter and that the problems of adjusting oneself to the standards of the contemporary school system, if one be equipped with intelligence and a sensitive spirit, are at times almost insuperable. Still, wisdom and understanding we must achieve one way or another. If

help and sympathetic understanding are not forthcoming from those appointed to instruct them to those to whom this is a vital necessity and not a mere stepping-stone to social popularity it must be achieved by self search and slow painful progress.

Now the one hope in this country for improvement in the quality of our national life is the increasing body of protest in the youth and the critical concern of the liberal thinkers and artists and the earnestness with which they accept responsibility for sound and clear thinking on the many aspects of contemporary life. The philosophy of escape to which you have momentarily succumbed is a negation which should have no place in twentieth century America. If one thing is more certain than another it is that we are born into potentially one of the most magnificent countries in all of history – into a material prosperity before unheard of with a stupendous force at the command of intelligence ready, if we ignore our responsibilities, to destroy us – controlled and directed, the possible means to an ideal and humane civilization. I am unwilling to believe that with your gifts you are willing to forego the challenge, for a contemplative life that can have no value because it ignores realities – for a religion that is an anachronism in this age – for adherence to an occult mysticism whose exponents in this country are commercial savants. I know well that we live in a harsh, blatant, and unsympathetic environment but at any rate it is not a permanent one, it is changing rapidly and it is subject to control. Progress in the past has been made slowly and laboriously over centuries of time and in China and India had crystallized prematurely and imperfectly and though those peoples had a marvelous culture it was a means nevertheless of subjecting countless millions of human beings to virtual slavery.

The potentialities for the good life are more numerous today than in any other age.

I am delighted that you have an interest in art. Is it a general interest or do you consider you may wish to become a painter? Have the possibilities of architecture ever interested you. This is a field of unlimited rewards for a genuine artist, once intelligence and the unaccountable wealth of the country begin to command real talent. One of the finest

architects in the country Lloyd Wright[2] is living and working in Los Angeles. I do not think he is finding an outlet for his capacities but the time may not be far away when such men will be recognized. If architecture appealed to you there might be a splendid opportunity to serve an apprenticeship.

My interest in mural painting, definitely related to architecture, has led me lately to think of returning to Los Angeles if I could get work with Wright. Are you familiar with the work of Rivera and Orozco[3] in Mexico City? This is the finest painting that has been done, I think, since the sixteenth century. *Creative Art* for January 1929 has an article on Rivera[4] and *The Arts* October 1927 has an article on Orozco.[5] I wish you could see these and also an article by Benton in *Creative Art* December 1928.[6] Here are men with imagination and intelligence recognizing the implements of the modern world and ready to employ them. In Mexico the dominant mood is one of hope and vitality and is inspired with the desire to once and for all break the bonds of ignorance and slavery that have cursed the people for so many centuries.

It is a beautiful spectacle – the recrudescence of passion and strength in a long enslaved people. But do you recognize that it is the priesthood that have gone down to bitter defeat and that while there is a certain fascination in the apparent peace and calm of their life – they are nevertheless an entrenched power using the weapons of superstition and ignorance to impoverish the people and keep them in subjection, and as such are no different than the forces you rebel against in our more modern world – the timidity and fear of political factions, chambers of commerce, boards of education and greedy wealth. We are though no longer a people who can be suppressed by superstition and while in the few years of our national life clever and brutal men have secured control of the wealth of the country the machine which has secured them their wealth can no longer be controlled by mere clever strength but requires more and more a higher order of intelligence and technological training. And it is for those with training and vision, the artists and thinkers, to direct the expending of this vast wealth and energy.

Do not believe so easily that you are ill placed in this world and that there is nothing you are fitted to do. There are many

pursuits supremely worthy of our best efforts and for which the qualities you possess are a first necessity. Finding your way may be difficult but in the end the turmoil of uncertainty will be only a part of experience. Do not believe in an easy way to freedom. The way to freedom physical or spiritual, to be enduring, must be won honestly.

It would be well to finish school if you can find it at all possible or tolerable not because it means anything in itself but because groundwork is necessary however ineptly it is provided. Unless you feel you may be able to get it solely on your own account. I would leave religion out of your reading program until your emotional adjustment to life is more stable. Psychology is valuable reading – so is sociology and the latter is apt to be a bit more realistic and so temper the vagaries of the former.

I would be very glad if you would write me in greater detail of your interests.

Notes

1 This letter is a draft of a response to a (lost) letter from Jackson.
2 Frank Lloyd Wright (1867–1959), American architect.
3 Diego Rivera (1886–1957) and José Clemente Orozco (1883–1949), Mexican painters known primarily for their mural paintings.
4 Walter Pach, "The Evolution of Diego Rivera," *Creative Art*, January 1929.
5 Anita Brenner, "A Mexican Rebel," *The Arts*, October 1927.
6 Thomas Hart Benton, "My American Epic in Paint," *Creative Art*, December 1928.

Jackson (California) to Charles and Frank (New York)

Los Angeles
October 22, 1929

Dear Charles and Frank,
I am sorry for having been so slow with my correspondence to you. I have been very busy getting adjusted in school,[1] but another climax has arisen. I have been ousted from school again. The head of the Physical Ed. Dept. and I came to blows the other day. We saw the principal about it but he was too thick to see my side. He told me to get out and find another

school. I have a number of teachers backing me so there is some possibility of my getting back. If I cannot get back I am not sure what I will do. I have thought of going to Mexico City if there is any means of making a livelihood there.

Another fellow and I are in some more very serious trouble. We loaned two girls some money to run away. We were ignorant of the law at the time. We did it merely through friendship. But now they have us, I am not sure what the outcome will be. The penalty is from six to twelve months in jail. We are both minors so it would probably be some kind of a reform school. They found the girls today in Phoenix and are bringing them back.

If I get back in school I will have to be very careful about my actions. The whole outfit thinks I am a rotten rebel from Russia. I will have to go about very quietly for a long period until I win a good reputation. I find it useless to try and fight an army with a spitball.

I have read and re-read your letter with clearer understanding each time. Although I am some better this year I am far from knowing the meaning of real work. I have subscribed for the *Creative Art*, and *The Arts*. From the *Creative Art* I am able to understand you better and it gives me a new outlook on life.

I have dropped religion for the present. Should I follow the Occult Mysticism it wouldn't be for commercial purposes. I am doubtful of any talent, so what ever I choose to be, will be accomplished only by long study and work. I fear it will be forced and mechanical. Architecture interests me but not in the sense painting and sculpturing does. I became acquainted with Rivera's work through a number of Communist meetings I attended after being ousted from school last year. He has a painting in the Museum now. Perhaps you have seen it, *Dia de Flores*.[2] I found the *Creative Art* January 1929 on Rivera. I certainly admire his work. The other magazines I could not find.

As to what I would like to be. It is difficult to say. An Artist of some kind. If nothing else I shall always study the Arts. People have always frightened and bored me consequently I have been within my own shell and have not accomplished anything materially. In fact to talk in a group I was so fright-

ened that I could not think logically. I am gradually overcoming it now. I am taking American Literature, Contemporary Literature, Clay Modeling and the Life class. We are very fortunate in that this is the only school in the city that has models. Although it is difficult to have a nude and get by the board, Schwankovsky[3] is brave enough to have them.

Frank I am sorry I have not sent you the typewriter sooner I got a box for it but it is too small I will get another and send it immediately. How is school going?[4] Are you in any activity? Is Mart still in the city? We have not heard for a long time in fact the letters have slacked from all of you.

Sande is doing quite well now. He has an office and handles all the advertising.[5] He continues to make his weekend trip to Riverside.

Affectionately,
Jack

Notes

[1] Jackson attended Manual Arts High School in Los Angeles.
[2] Diego Rivera, *Dia des Flores*, 1925. Los Angeles County Museum of Art.
[3] Frederick John de St. Vrain Schwankovsky, the art teacher at Manual Arts, was a member of a theosophical society devoted to the promotion of metaphysical and occult spirituality.
[4] Frank was taking journalism courses at Columbia University in New York.
[5] Sanford worked for the *Los Angeles Times*.

1930

los angeles
january 31, 1930[1]

dear charles
i am continually having new experiences and am going
through a wavering evolution which leave my mind in an
unsettled state too. i am a bit lazy and careless with my cor-
respondence i am sorry i seem so uninterested in your helping
me but from now on there will be more interest and a hastier
reply to your letters. my letters are undoubtedly egotistical
but it is myself that i am interested in now. i suppose mother
keeps you posted on family matters
school is still boresome but i have settled myself to its rules
and the ringing bells so i have not been in trouble lately. this
term i am going to go but one half day the rest i will spend
reading and working here at home. i am quite sure i will
be able to accomplish a lot more. in school i will take life
drawing and clay modeling. i have started doing something
with clay and have found a bit of encouragement from my
teacher. my drawing i will tell you frankly is rotten it seems to
lack freedom and rhythm it is cold and lifeless. it isn't worth
the postage to send it. i think there should be a advance-
ment soon if it is ever to come and then i will send you some

18

drawings. the truth of it is i have never really got down to real work and finish a piece i usually get disgusted with it and lose interest. watercolor i like but have never worked with it much. although i feel i will make an artist of some kind i have never proven to myself nor any body else that i have it in me.

this so called happy part of one's life youth to me is a bit of damnable hell if i could come to some conclusion about myself and life perhaps then i could see something to work for. my mind blazes up with some illusion for a couple of weeks then it smolders down to a bit of nothing the more i read and the more i think i am thinking the darker things become. i am still interested in theosophy and am studying a book light on the path[2] every thing it has to say seems to be contrary to the essence of modern life but after it is understood and lived up to i think it is a very helpful guide. i wish you would get one and tell me what you think of it. they only cost thirty cents if you can not find one i will send you one.

we have gotten up a group and have arranged for a furnace where we can have our stuff fired. we will give the owner a commission for the firing and glazing. there is chance of my making a little book money.

i am hoping you will flow freely with criticism and advice and book lists i no longer dream as i used to perhaps i can derive some good from it.

i met geritz[3] at a lecture on wood block cutting he asked about you and sends his regards

the fellow you mentioned of coming here has not arrived
Jack

Notes

[1] This letter is typewritten entirely in lower-case letters.
[2] Mabel Collins, *Light on the Path* (first edition 1888, London: George Redway).
[3] Franz (Frank) Geritz (1895–1945), artist and printmaker.

1931

Jackson (Missouri) to Charles (New York)

[June 10, 1931]

[postcard]
Between St Louis – K.C.
Charles,
Seeing swell country and interesting people – haven't done much sketching – experienced the most marvelous lightning storm (in Indiana) I was ready to die any moment. This Missouri State is most impossible to catch a ride in – and there's four thousand turns on the highway. Tried to catch a freight in Indianapolis and got thrown out of sight the damned thing was going too fast – spent one night in jail – haven't seen Tolegian[1] in five days – think he's ahead of me.

 Jack

Note

[1] Manuel Jerair Tolegian (1911–83), American artist. He and Jackson planned to hitchhike from New York to Los Angeles. Their paths separated because Jackson rode freight trains and Tolegian was frightened by that idea.

New York City
July 22, 1931

Dear Mrs. Pollock,

It made me so happy to have a letter from you, for I think you show an uncommonly generous spirit in welcoming your son's wife so heartily; a spirit that I have grown up to believe rather foreign from the ways of mothers.

I am eager to meet you and Charles' father, for there are hundreds of things I want to know about him when he was a little boy – things I never can make this reticent man speak about. And I think we will like each other – you and I – for, after all, as Charles' wife I am interested in what is of chief interest to you – making him happy. I can't put into words the certainty with which I watch Charles' work develop; I <u>know</u> that he is doing tremendous things and that time and his unflagging efforts will prove to others, than just those who love him, that his painting is an integral part of the art of America today.

So positive am I in this belief that my own work is of far less importance to me than the hope of furnishing Charles whatever outward encouragement and aid he needs to advance toward full growth in his art. I suppose I am most in love with what he does; in truth, I fell in love with his work first.

But don't get the notion that I am a woman who believes feeding the spirit is more important than feeding the stomach of an artist. I do hope Jack will give you authentic (if his words of praise were not rank flattery!) reports of our culinary bouts in Charles' studio all winter. And I think you'd marvel at the manner in which I pour iron tonics, cod liver oil and other "builder-uppers" down your oldest son; for I want to put some weight on him. I hope to send him back to you next summer, if I can't bring him, plump and strong. But he's a hard man to fatten, as perhaps you know. Any motherly advice?

Frank dropped in for a moment yesterday and is beginning to show excellent results from his tonsil operation. I am very

fond of the other Pollocks that are in New York and if the contingency of the family that I know now in any way represents the whole tribe – I can enthusiastically state that I'm delighted to be a member of it.

As I have only been back in the city for about ten days – having spent a number of weeks with my own family in Chicago, where they are summering – it behooves me to buckle down to work and drag in some necessary funds. Charles and I were quite mad and darted upstate to an enchanting little town, Newburgh, filled with ancient Colonial houses and streets that wander crazily and rockily up and down hill, to get married and loved it so much that we just stayed on, spending and spending. But it was pretty well worth it.

Do feel that any time you want to write me, and particularly if these careless boys in New York neglect you, that I will be happy to hear from you and will answer promptly.

 Sincerely,
 Elizabeth

Note

[1] Elizabeth Feinberg, Charles's companion, was a writer and freelance journalist (as Elizabeth England).

Jackson (California) to Charles and Frank (New York)

[1931]

Dear Charles and Frank,
My trip was a peach. I got a number [of] kicks in the butt and put in jail twice with days of hunger – but what a worthwhile experience. I would be on the road yet if my money had lasted. I got in Monday afternoon exactly three weeks after starting. The country began getting interesting in Kansas – the wheat was just beginning to turn and the farmers were making preparations for harvest. I saw the negroes playing poker, shooting craps and dancing along the Mississippi in St Louis. The miners and prostitutes in Terre Haute Indiana

gave swell color – they're both starving – working for a quarter digging their graves.

I quit the highway in southern Kansas and grabbed a freight – went through Oklahoma and the panhandle of Texas – met a lot of interesting bums – cutthroats and the average American looking for work – The freights are full, men going west men going east and as many going north and south – millions of them. I rode trains through to San Bernardino and caught a ride to Los Angeles.

Tolegian made the trip in 11 days he got a through ride from Pueblo to L.A. I guess he had a fine trip – neither of us did much drawing – Tolegian went to work the day after arriving – there is some chance of me getting on there.

Dad, Mother and Mart are living in Wrightwood – Dad and Mart work in Big Pines – Sande and I will go and see them over the weekend. Sande and Don Brown[1] have a swell place – it is near where Caro lived, a marvelous view over the city and rolling hills to the east. Sande says Caro is in Frisco. Betty got a job there so they moved up.

Frank, I hope your tonsils don't give you too much trouble and that you will feel better. Wish the hell you fellows could have come out this summer – it's sure swell out – fresh air and sunshine.

Jack

Love to Elizabeth and Marie[2] –

1300 Montecito Dr

P.S. Sande tells me to tell you to send on the pictures C.O.D. – and that he will write soon –

P.S. Sunday morning in Wrightwood – Sande, Loie[3] and I came up last night. I forgot to mail your letter in town. Mother, Dad, and Mart all look fine – were all eating raw food – it seems to be the dope – Mart's looking very good and is doing pick and shovel work on it. Will write later.

We all send our love,

J

Notes

[1] Brother of Alma Brown, Marvin Jay's future wife.
[2] Marie Levitt, Frank's future wife.
[3] Arloie Conaway.

Jackson (California) to Charles (New York)

[1931]

Dear Charles,
I meant to write much sooner.

The folks have probably told you that I have been cutting wood – I have finished up the job today – and after figuring things out there is damned little left – barely enough to pay for my salt – at any rate I'm built up again and feel fine. I wish you and Frank could have gotten out for the summer – it's quite a relief. I guess the short stay in the country helped. I haven't done any drawing to speak of though. Some more study with Benton and a lot of work is lacking – the old bunch out here are quite haywire – they think worse of me though.

Sande and Loie were in San Francisco to see Rivera's mural[1] – but found it impossible, it being in a private meeting room for the Stock Exchange members – they also saw Hayden[2] for a moment – Sande as usual was in a hell of a hurry so did no good there. After we left last year San did some interesting watercolors – but didn't do anything through this winter.

I don't know what to try and do – more and more I realize I'm sadly in need of some method of making a living – and it's beginning to look as though I'll have to take time off if I'm ever to get started. To make matters worse I haven't any particular interest in that kind of stuff. There is little difficulty in getting back there – and I suppose I can find something to do – what is your opinion? The trip through the country is worthwhile regardless of how I might have to make it. I landed here with a dime but could have made the trip easily on ten dollars.

Mart is looking fine and is interested in singing – he intends going to school this winter and to live on three dollars a week – the raw food method – he and dad work on a few peanuts and grain – fruits and vegetables. It's swell stuff – Sande has improved immensely. Dad still has difficulties in losing money – and thinks I'm just a bum – while Mother still holds the old love –

Love to Elizabeth – and wish you both the most of happiness –

Jackson

Tell Frank if there are any old rags – dirty socks – suits and underwear – he had better put in his order – I think Mart is wearing a suit he bought in Chico[3] – and Sande wears them out as fast as he gets them.

Notes

1 *Allegory of California*, 1931, in the dining room of the San Francisco Stock Exchange.
2 William (Bill) Hayden, a friend of the Pollock brothers.
3 Northern California. The Pollock family lived in Chico from 1917 to 1919.

1932

[February 1932]

Dear Dad –

I have waited so damned long to write to you, Dad, I guess there is no need of making excuses.

Guess it's pretty boresome being in camp all alone and not working – well if i were there, we could try our hand at checkers – or talk about the ideal life and civilization.

Suppose you still get the *Nation* there, I thought that article by Ernest was very good, the best of the bunch – "If I were a Constitutional Dictator" I think – the one by Chase was good I think –. It's looking as though we're going to be enlisting for the capitalist government. The Manchurian business[1] is beginning to be involved.

Things are about the same here – I'm going to school every morning[2] [Art Students League of New York] and have learned what is worth learning in the realm of art. It is just a matter of time and work now for me to have that knowledge a part of me. A good seventy years more and I think I'll make a good artist – being a artist is life its self – living it I mean. And when I say artist I don't mean it in the narrow sense of the word, but the man who is building things, creating, molding the earth, whether it be in the plains of the West or

in the iron ore of Penn[sylvania]. It's all a big game of construction – some with a brush – some with a shovel – some choose a pen. Benton has just gotten another big mural job – for the Whitney Museum of American Art. Mural painting is forging to the front – by the time I get up there, there ought to be plenty of it – Sculpturing I think though is my medium. I'll never be satisfied until I'm able to mould a mountain of stone, with the aid of a jack-hammer, to fit my will. There are to be some mural jobs for the new Radio City which is under construction – that's the new artists job to construct with the carpenter, the mason.

The art of life is *composition* – the planning – the fitting in of masses – activities.

Well, Dad, I've started so many letters and then let them lay in the desk that I think I'll really get my self together and send this one which I started some weeks ago.

It is very cold here now – seems to me the coldest yet this winter. Certainly tough on the poor old fellows out on the bread lines, and no place to flop.

Benton is ill with the grip or typhoid fever – I haven't heard yet – hard luck to get sick just as he gets a job – hope he is better soon.

It's getting round about the time when we all wonder what we're going to do this summer – none of us, I think, has more than a vague notion of what we should like to do. It looks as though we will just have to wait and see what turns up. Chas will come out West if he is fortunate enough in getting the scholarship, otherwise it is very doubtful. Frank I think, intends coming. He is still at the library at night and peeling spuds. He had a cold last week but is well now. I certainly would like to get out there too – but I've got to think of next year here. I would like to get work in a rock quarry – or tomb stone factory – where I could make a little money and at the same time learn something about stone and the cutting of it. I'm about as helpless as a kitten when it comes to getting my way – with jobs and things – there seems to be nothing definite as to what we each will do. If I am unable to make out here I will try and get a lot of drawing done on my way west. I suppose a little later we will have more of a notion of what we can do.

27

Was glad to read [*illegible*] letter. He seems to be developing an interest. I don't suppose Jay is having too easy a time of it this winter – do you hear of him much?

Got a very interesting letter from Mort – glad he is finding him self will write to him – didn't get Sande's letter yet – this is kind of a funny family you've got dad – every so often one of us has a revolution all his own – kinda interesting to see what we'll all settle down into in the end. I've got a long way to go yet toward my development – much that needs working on – doing every thing with a definite purpose – without purpose for each move – there's chaos.

I still tamper with the mouth harp can't play a damned thing – much – but it kinda puts me to sleep at night and I kinda get a kick out of it. Charlie B [Brockway?] dropped in on me again, from England, for a few moments the other night – but haven't seen him since don't know if he has gone back on another trip or if he is working in Boston.

Well Dad I took time out to eat about two pounds of fresh cooked spinach – sure like it. Will close for this time – and will write more often. I'm usually in such a turmoil that I haven't any thing to write about and when I do after I've written it – it looks like all bunk. Got Mother's letter some time ago with the token – I shouldn't allow it I guess –

Love
 Jackson

49 East 10th Street
New York City

Notes
1 Manchuria was attacked by Japan in September 1931.
2 Jackson had gone to New York with Charles and was studying at the Art Students League.

Sanford (California) to his brothers (New York)

April 6, 1932

to you who are in new york[1]

i rather believe it is hell and everything that i have not written to you brotherly speaking, however i will be damned if i will apologize.

things in los angeles go on in the same monotonous if not mediocre manner. the idea seems to be keep from going hungry. with you in new york i suppose the chaos is much nearer. and probably more obvious.

your packages were received some eons ago Charles and we were happy to get them i have, however, been unable to dispose of either of the lithos. One couldn't sell gold to the morons in this town for a dime a pound.

what are you doing Frank? are you writing. and do you have any classes at columbia? how is Marie, is she still in n.y.? you being a literate Frank it would seem we would have more letters from you.

Jack how are you finding Benton this year even more interesting i imagine. i am anxious to see some of your work. i see Phil[2] occasionally and Ruben[3] seldom. Phil is having to work and seems to feel it a terrible injustice for an artist like himself to have to slave. it is rather humorous, however, he is good and will eventually make a painter i believe. Ruben is doing fine. he is the most promising young painter i know. i believe he is studying with Fidleson[4] in Pasadena. Don Brown is doing almost no writing but seems to be growing in his quietness.

this week i am off work. enjoying the sunshine and the nothingness of it all. loie is here with us for the week she is doing some writing and drawing.

i have paused to enjoy one of mothers most delectable dinners – asparagus on toast with chicken hearts and in the end strawberries and rich cream. am i cruel? if i am come west. a blanket request and invitation for all of you to enjoy the summer with us in western sunshine, the land of tomorrow (page mr. hoover) and rattlesnakes Elizabeth . . . so come let us play with them.

this must be finished either before i sober up and destroy the same or get so drunk i won't be able to find the mailbox.

believe it or not a brother of yours,

Sande

Notes

[1] Charles, Elizabeth, Frank, Marie, Jackson.
[2] Philip (Goldstein) Guston (1913–80), Canadian-born American painter.
[3] Reuben Kadish (1913–92), American painter, sculptor, and printmaker.
[4] Lorser Feitelson (1898–1978), American painter, muralist, and teacher. Reuben Kadish attended Feitelson's life-drawing classes at the Otis Art Institute in Los Angeles and encouraged Philip Guston to work with him as well.

Jackson (New York) to Stella (California)

[April–May 1932]

Dear Mother

Got your two letters last week with the money. Thanks a million. Much rather have you use it though. We also got letters from Dad and Sande – was very glad to hear from all of you. Sorry to hear Sande is being layed off part of each month. He is fortunate though in having work at all. Conditions here are unbelievable families without clothing, food and housing.

Sande didn't say in his letter if he heard Thomas Craven[1] lecture there or not – he should have. I meant to write him about it, he is one critic who has intelligence and a thorough knowledge of the history of art. I heard that he was made quite a joke out there which is not unlikely for the element of painters found out there. The reproduction he sent of the rejected painting was good sign of some sort of interest in life out there though.

I'm coming along I guess – painting and sculpturing is life it self (this is for those who practice it) and one advances as one grows and experiences life – it doesn't exceed ones experience. So it is a matter of years – a life. I have much to learn technically yet. I am interested and like it which is the main thing.

Tolegian hasn't any definite plans yet I guess – probably would like to go home for the summer though. If I'm able to

30

find any work here I will stay – Mrs. Benton said she may be able to find me something nothing definite though. I still have my blue coat mother – it is in poor shape. I will bring it out or send it and you can use it for quilting. I hardly think it worth while fixing it – I am quite well fitted out in clothing.

Charlie B was here about a month ago he had just gotten in from England. Said he would be back the next day but hasn't been back since. I guess my welcome wasn't what he expected.

I'm really ashamed of myself. I started this letter after I had received yours but failed to finish and send it. Everything is about the same here no new prospects. Frank I think got the car today. Will probably go to the camp this Sunday with Charles to get it in order for the summer. I haven't any new prospects for a job as yet. Have made application for a job next winter at the league – am doubtful about getting it though. Well there really isn't much more time until we will be started expect to leave, I think, the twenty ninth. Marie will certainly be tickled to get away and she needs the rest badly – Frank too will find it a big relief. We are having swell weather now – it is nearly nine (day light saving) and barely dark.

Chas has snap shots so will send them later.

Benton is busy in murals and will be working on them through the summer I think.

Well there seems nothing to write of – so will close and will probably see you all soon –
Love
Jack

Friday the 6
I'm still trying to get this off meant to at least send a card for mother's day – have sort of revised this letter torn it out in spots – there isn't much more time here now – certainly will be glad to get away – think I will be able to do a little more with the country out there this time.

Will close now and get this out tomorrow for certain. –
Love
Jack

Note
[1] Thomas Craven (1888–1969), American art critic and art historian.

Jackson (New York) to Stella (California)

[September 17, 1932]

Dear Mother –

I'm starting out badly again. Chas went to the country today to break camp – Eliz. had dinner here tonight – and has gone home now – I have been reading the paper.

Chas has a better place this year two large rooms – suitable for painting in and a bed room – on a happy Italian street. We have the place most in order now – and ready for work. I haven't seen Benton yet. Eliz. has a place on the same street near here – which makes it convenient for Chas. I suppose Frank is well on the way. If he was able to find a car to drive through. He should write us –.

The trip was well worth while got quite a lot of drawing done and saw plenty of interesting country people and things. Arkansas and Tennessee I liked especially well.

New Orleans is a very interesting city – the people move around with the speed of the north – forgetting the intense heat. We spent most of our time at the banana industry on the Mississippi – the negro – swell stuff.

The jam and <u>cookies</u> certainly hit the spot, but is certainly going. Chas and Eliz think its great – Well a bath and to bed with an early up.

Love
Jack

Tuesday – [September 20]

Have failed to mail this – will go out and do it now.

School opens the third. Am anxious to get started again – have been working on sketches this week. Will be more careful on writing after this.

Jack

Jackson (New York) to Stella (California)

[October 1, 1932]

Saturday night –
Dear Mother
I guess it isn't quite my turn – but the jam is on its last stretches. I mentioned that I could make some nearly as good – they took me up on it and will buy the ingredients if I'll put them together. If they're not too long will you send formulae for tomatoes – plum, and apple – these are all comparatively cheap here.

Frank is working at the library[1] and restaurant already and is going to take a small room on the same floor here. Tolegian made the trip in fast time five days and six nights I think. School will start Monday with no regrets on my part. Am glad Mart got a few days with pay – and that Sande is enjoying the fresco class – will write them next. I got the suit in fine shape – haven't had the occasion to wear it yet have only been uptown once, that was to school. I put out a big washing today the fourth one so far – I've got the damper on me this year everything clean as a whistle. Good for me I guess – will write more later.
 Love
 Jack

Note
[1] Frank worked at the Columbia University Law Library.

Frank (New York) to LeRoy (California)

[1932]
New York
October 23

Dear Dad,
I have been carrying a postal money order in my pocket for nigh on to a week, awaiting an opportunity to write you.

My day is a long one. I arise at 7:30, take a subway uptown, eat my breakfast, peel 100 pounds of spuds and do other odd jobs until 10:30 whence I go to the library until one. My afternoons are free. I intend doing a deal of reading, though up to now I have done little of it. Political rallies of a socialist nature, and a few free lectures have taken much of my spare moments. It will be interesting to note that Columbia University has voted socialist in a poll conducted by *Spectator*, the campus daily. I believe the vote in the law school was close to two to one. Thomas[1] had a commanding lead over Hoover and Roosevelt[2] in the college. Only in Barnard College, the Columbia school for girls, was Thomas and the socialist ticket voted down. There Hoover won handily. This is accountable for the simple reason that women are notoriously conservative, and have been since they won their right to vote.[3] At Barnard they are especially apathetic. Most of the girls come of wealthy families, and the rich are staunch supporters of the present administration. My associates in the library are likewise voting for Hoover. They are so positive that I have taken forty-five dollars in wagers with them. I am confident that Roosevelt will win, and even suspect that Hoover will meet an embarrassing landslide.[4]

I did take that room which I spoke of next to Charles' studio and though it is small it is going to be quite satisfactory. I bought a chest of drawers in an old junk shop for five dollars, cleaned the varnish off, and discovered that it was a fine piece of black walnut. I sandpapered it and applied linseed oil, and made a fine thing of it. I shall get some curtain material and make some curtains. Elizabeth gave me a small bed, a chair and a table. I shall hang some of Charles' pictures and really, I think, I shall have a cheerful room.

Charles has just been notified that his one night a week teaching job is to be suspended because of lack of students. That's a hard blow since it was worth $60 a month to him. I guess you know that he was cut on his daytime job to $70 per month. That will be the amount which he will have to get along on. It's a slim amount, though he will manage, and that is about all we can expect in these times.

Jack has fared rather better than usual. He has been making picture frames and bookcases for Benton. He has more real

pocket money than he has had in a long time. Benton was very pleased with the work Jack did this summer. He thinks it is quite original and possessive of fine color.

I am in fine health, and have no trouble arising in the morning without an alarm clock. Knowing myself it even amazes me that I am able to do it. Since coming here I haven't used any sugar. My cereals and coffee are taken plain. That may be accountable for my improved condition. I must keep in shape to keep going.

I understand that Mother has been up with you, and I have no doubt but that your job has been made more pleasant. I am sending along the thirty dollars which I am sincerely grateful for the loan of.

I hope I can write again, and have something more interesting to say, but for now this must do.

As ever,
 Your son
 Frank
46 Carmine St.
Elizabeth and Charles send their regards.

Notes

[1] Norman Mattoon Thomas (1884–1968), American Socialist leader. He assumed leadership of the American Socialist Party in 1926 and was repeatedly (1928, 1932, 1936, 1940, 1944, 1948) the party's candidate for president. He polled his highest vote in 1932.

[2] Franklin Delano Roosevelt, thirty-third President of the United States (1933 to 1945).

[3] Women won the right to vote in the United States in 1920.

[4] The United States presidential election of 1932 took place as the effects of the 1929 Stock Market Crash and the Great Depression were being felt intensely across the country. Roosevelt did win by a landslide.

1933

[February 3, 1933]

Dear Dad

Friday evening – have just finished a big wash about seven sheets and a few towels and ends. Life here differs little from what we had up in Santa Ynez valley. The same old house keeping with a pot bellied coal stove – the only difference is that N.Y. is about ten times dirtier. But I like this life, its hard on the bums existence. After all they are the well-to-do of this day. They didn't have as far to fall.

Benton has a huge job out in Indianapolis for one of the State buildings – two hundred running feet twelve feet high. The panels are to be exhibited at the Chicago World Fair when finished in May. After a life time struggle with the elements of every day experience, he is beginning to be recognized as the foremost American painter today. He has lifted art from the stuffy studio into the world and happenings about him, which has a common meaning to the masses.

Of course Benton had to give up his class. We have a substitute whom I think little of, and I probably won't stay with him long. Tolegian is studying with John Stuart Curry.[1] I have joined a class in stone carving in the mornings. I think I'll like it. So far I have done nothing but try and flatten a

36

round rock and my hand too, but it's great fun and damned hard work. If I'm able to learn anything about it I'll take it full day and stick with it for three or four years – then the rest of my life.

Frank has a very uninteresting job – but seems to manage to keep up under it. He is gone all day and half the night with it. He is doing quite a lot of reading on contemporary happenings. I think he intends trying to go west this summer again. Chas of course wants to get out if he can raise the money. For my self I'll probably try and stick through. Think it will do me a lot of good and possibly give me a better footing for the following year. Chas is working along and improving doing some lithographs too.

Well Dad by god its certainly tough getting laid up. I hope you are better now. It was a long stretch too, you had better take it easy for some time and for heck sake don't worry about money – no one has it. This system is on the rocks so no need to try to pay rent and all the rest of the hokum that goes with the price system. Curious enough the artists are having it better now than before. They are getting more aid – the pot bellied financiers are turning to art as an escape from the somewhat blunt and forceful reality of today. Fat women, lean women, short and tall come with their dogs to lose themselves in the emotional junk of the artist – unfortunately thats the kind of stuff they want – they don't have to think when they look at it. Stuff that has significance is too near reality – it bothers them – tells them something – possibly it is just a matter of time – maybe not – when there will be a demand – for the real stuff – after all that isn't my worry – mine is to produce it.

Writing a letter is a hell of a job for me – suppose I should make more of an effort. Well here is a try at one.

We have had extremely fine weather as a matter of fact it has, for the most part, been like spring – a bit chilly at times, but just enough to put some pep in a fellow.

Its past my bedtime so – my love to all.

Jack

Note
[1] John Steuart Curry (1897–1946), American Regionalist painter.

Arloie (California) to the brothers and Elizabeth
(New York)

March 6, 1933

Dear boys and Elizabeth,
I know it is useless to offer consolation.[1] We have lost a
friend and a father. But terrible so it is to have him leave us, I
cannot wish him back – to linger in suffering, without hope.

Your mother is more than brave. She has seemed to me
the spirit of all Motherhood and Womanliness. We, who are
with her, will try to comfort and help her in every way we
can. We shall do all, in our feeble power, to make up for the
forced absence of the rest of his children.

There will be a vacant space in all our hearts, [–] but I
cannot feel that he has reached the End. He has only passed
beyond our understanding.

With love,
Arloie

Note
[1] LeRoy Pollock died March 5, 1933, at 8.30 p.m.

Marvin Jay (California) to his brothers and Elizabeth
(New York)

March 6, 1933

Dear Brothers and Elizabeth,
We are sorry Dad couldn't remain in our midst – hope that
he is happy where he is.

He was a great Father and it is only now that we realize
his loss. His unbounded strength became his weakness and
downfall – an over-taxed and developed heart. We never told
him the seriousness of his disease. He took it all in a fine spirit
and fighting – without a murmur until Sunday noon when he
was in great pain and felt the critical time was near.

We were with him all day as he felt the need of someone

near. Dr Rynin came at 6:30 and administered morphine. Shortly after, Dad dozed off – woke up coughing at 8:30 and passed on without a word. Pneumonia had set in which complicated things and brought the end sooner.

Mother is very brave – but feels a great loss.

Sandy and Arloie are helping. Dad belonged to a Mortuary Fund with the county. This will defray all expenses.

There is a small insurance with the New York Life that will care for Mother's needs until we find some kind of work.

Mr. Stains, Dad's boss, has promised to do all he can towards getting me on with the county. Then there seems a very good prospect of a new Roto [rotogravure] plant here and a job for me. In any case we will manage in good shape.

Thanks for the money you sent. Received your telegram. Feel sure that Dad is better off gone – he was given every care and many doctors agreed it was fatal.

Hope this finds you all well. Mother, Sandy and Arloie send their love.

Marvin

Jackson (New York) to Stella, Sanford, Marvin (California)

[March 8, 1933]

Dear Mother, Sande, and Mart –

I really can't believe Dad is gone. With all your letters we were unable to fully realize the seriousness of his illness. I wish we could go there – it is hard for you three to have to shoulder everything – and being there makes it much harder. Please, mother, don't let yourself get too upset – it is one thing unavoidable in life, but of course not as young as dad. I am glad, tho, that he was not bed fast for long periods, and didn't have to suffer great pain. I had many things I wanted to do for you and Dad – now I'll do them for you, mother. Quit my dreaming and get them into material action – no need of making matters more hard now. I am at a loss to know what to say or do – it is all such an uncertain fact.

You must let us know of the finances. I suppose there is

little or none. But Frank and Charles will be able to help –
I'm still lazying with no definite indication of my earning
anything thru my work.

Tolegian felt deeply and sends all his sympathy. This is
poorly put – but will let it go – and will write soon.

A heartful of love and feeling,
 Jack

Elizabeth (New York) to Stella (California)

New York City
March 9, 1933

Dearest Mother,
Although I never had the joy of knowing Charles' father, I
feel a genuine loss with you and your boys. Ever since I've
known Charles I have felt a very real knowledge of you and
his father, for he has spoken often of both of you, building
in my mind a clear picture of two strong, courageous and
self-sacrificing personalities, who made no demands upon
their children but trusted unasking in a love they knew was
theirs. This to me, bred in a Jewish home where there is the
characteristic unhealthy, possessive, choking clannish love
that my people give and demand, has been a miracle. I even
have envied Charles' love – which was so deep for you and
his father but which he never felt the necessity to under-
score to you with constant repetition and material proofs. I
wished that I might feel as free and easy and comfortable in
an elastic, large relationship between my parents and their
children. So, now that his father has gone, I understand how
intensely Charles is suffering.

As he is the only one that I know intimately, I can only
speak of the genuine depth of his grief. He is hurt deeply; for
he has spoken over and over to me of the fine character of his
father, of the nobility of the man. It is doubly painful in that
his father was so young a man and still so vigorous and alive
in his mind.

You, I have known through your sons, before this as a

remarkably brave and serene person. I have marveled that a woman who has seen a family grown to manhood through her work and sacrifices could be so uncomplainingly brave when they went out into the world and made a life entirely for themselves. This is a new kind of motherhood to me. Now, in a crisis of loss, which I don't think any of us can even pretend to understand, your sons are depending upon you not to fail them with that courage and strength they have grown to believe is peculiarly your own. They seem to feel that in your bravery they will continue to find the living spirit of their father; for, after the years you two spent fighting shoulder to shoulder against the problems of living, they have begun to see you as kindred souls, knitted into unity through your common will to breast every problem. Your sons try to fathom the loneliness that is going to be yours; they can offer so little to substitute for the companionship and affection you knew in your husband; but they hope to lighten your heart by their genuine affection and the intention to sustain you.

Surely, you will come to see a living immortality of the one you have lost in these five men who stand as memorials of your love together. Such a magnificent immortality is left to few. And of the five, not one has taken a stride to lessen the progress of his father; they are all good men, every one of them. Again, I can speak knowingly of but one of the men you and your husband brought into this world – your oldest boy. In Charles, your husband must have realized well that he had fathered a unique and special personality; one who bore the fruits of his father's deepest longings for a broader and richer experience. From all Charles has told me, his father looked toward a finer world, a kinder place for mankind, than the world in which we live; his father had seen his own youth pass and approached maturity realizing that it depended upon a new generation to brace themselves for a change. In Charles' fine mind and fine spirit, your husband must have known a great comfort; for Charles represents the most noble qualities of a new generation. In Charles will flower all that his father nourished as roots and seeds; this I promise you. Surely such knowledge as this should salve your wound and give you a new hope for tomorrow.

I know all of your sons are fine men; but of one of them,

with whom I live in the glare of truth-seeking knowledge, I can give you uncompromising guarantee that your husband has fathered a great personality, that your husband and you brought into the world a man who will carry on in actual achievement all that your husband wanted in his secret heart.

That pioneer vision and nobility which characterized your husband has passed on, unlessened, to Charles. As he has your serenity of spirit and your sense of reality so Charles has his father's magnificent will to work and his desire to consummate a spiritual enrichment. With the inheritance from you and his father, he is going toward a fine goal. Take courage from this; it is a kind of immortality for the one who has gone, that his best and realest integrities are perpetuated in the daily life of one whom he fathered.

We are thinking of you constantly. I am certain that Frank will be with you this summer and, if some miracle of finance occurs in our fortunes, Charles, too, will come West. I do not know what are Jack's plans.

Be brave, hold fast to the many blessings you have yet in five strong, devoted sons.

Fondly to you and your boys, I am,
Your daughter
 Elizabeth

Frank (New York) to Marie (California)

[1933]
New York
March 12

My Donya love,
Dad's gone now. A few days before I had your letter saying his life would not stretch far. But I didn't think the end would come so soon. In fact I couldn't really believe that it would come at all. Oftentimes I have thought of him twenty or thirty years hence, hale and hearty, digging in a patch of potatoes or milking a cow reminiscent of younger days when he was

raising crops and boys down in Arizona. But his life has been cut short, and hurt as we are at our loss, we are trying to be brave as he would want us to. Dad came of pioneer stock. He was honest, and fearless and went through life receiving many hard knocks, but always without a whimper, and that is the way he died. We boys owe him much, and we are proud of our heritage.

You asked me to come home dear and I appreciate the goodness in your heart, but feel that I should stay it out until June. Somehow I've got to manage to make a living this summer out there. Things I guess don't look bright.

Earthquakes, and moratoriums are knocking the stuffings out of that country. You must tell of your experiences during the quaking hours.

I'm going to leave this letter brief and go to bed.

With my fond love,
 Your Frank

Do you see Mother often? You should be of help to her, a comforting companion.

Dad thought very well of you Marie. He thought you were unusually clever and intelligent, – and I helped his opinion along by boosting you to the skies.

 FP

Stella (California) to Charles, Elizabeth, Frank and Jack
(New York)

March 17, 1933

My Dear Sons and daughter Charles + Elizabeth Frank + Jack With a very sad heart I will try to write a little to let you know we are alright. I know you are anxious to hear from us. but I can't answer your good letters will do that later. The earthquake started at six P.M. Friday evening[1] that was the hardest one but they kept coming all night we stayed up until one thirty I couldn't stay up any longer. as that was a very hard day for all of us and I was all in by that time. have had light shocks three and four times a day or night since had one

43

at 7:45 this morning. I have been so shaky just have to hold myself down. didn't do much damage in L.A. Long Beach is hurt the worst of any place, feel so sorry for the people out in tents – tonight as it is raining.

I am sorry you boys could not be at home but knew it was impossible. so glad you sent a telegram for Dad's birthday[2] and wrote him later he enjoyed hearing from you boys did him so much good for he was proud of each one. Was so glad he was home we opened up the day bed put on an extra mattress and had lots of pillows to prop him up if he wanted to be. had the bed across the east windows in the dining room where he could see the snow capped mountains with the beautiful green hills below sunshine fresh air and flowers as you all know he loved the out of doors and was near us all the time was perfectly happy never complained. such drenching night sweats and running a temperature all the time was sure hard for a man of his age.

He listened to Roosevelt's speech Saturday morning[3] and thought it was wonderful. tuned in for the news and music at different times. listened to the Tabernacle Choir from Salt Lake[4] Sunday morning about noon Sunday he said he could hardly get his breath and that is the only thing that seemed to be the trouble. Marvin went for the doctor about six. cleaned his teeth while Marvin was gone said how much better his mouth felt but just as Marvin and the doctor was opening the door he says to me, Mother I don't think I can last till morning wanted to say more I know he intended to. He was conscious until the last and passed away in my arms looked so peaceful was so hard to part with him but so glad he did not have to suffer for years there was nothing could be done to help him he wanted to go if he had an incurable disease. He is at rest in a beautiful quiet mausoleum near the hills.

Marvin spoke of cremation but I couldn't think of having Dad's body cremated with only a handful of his ashes left. He had a memorial fund which will cover expenses $500.00 which they paid promptly and I am so thankful for that. Has some insurance but I have not got that yet. Got compensation until the first of March. haven't got all of that yet.

Was hard on us last week with all the banks closed[5] but we managed to get through everybody was so nice to us. We had very brief services with just the organ there were lots of beautiful flowers the Boys got a pillow of roses and sweet peas for the family those were his favorite flowers.

Dad enjoyed the flowers at home so much. Frank and Jack know we have some lovely roses sweet peas nasturtiums and others.

Lots of friends came to see him and always enjoyed seeing them. Marie and Arloie came over and were so kind to us Mrs Miller came over too.

Poor Sanford he was over at Arloie's was just ready to start home when Marvin called them was hurt so terribly to think he wasn't home was just paralyzed with grief. I think he has wished for you boys to come home and Elizabeth too, a dozen times today he says Mother urge them to come home. And we do want you to I am so glad I have five boys and a daughter to love and know they love me.

Dad and I had planned to drive back some time to see you if he got well and able to work again for he wanted to see Elizabeth so much.

Marvin went to work Monday morning with the boys Dad worked with. I am so glad for him while I hated to see him start on road work think he will get something better soon he will be home tomorrow evening will be glad to see him as we are so lonesome. Thanks for loving words.

 love to all,
 your mother

Notes

1 The magnitude of the Long Beach earthquake (March 10, 1933) was 6.3 on the Richter scale.

2 LeRoy was born on February 25, 1877.

3 Franklin Delano Roosevelt's inaugural speech as President of the United States.

4 The Mormon Tabernacle Choir in Salt Lake City (Utah) had a very successful weekly radio broadcast, *Music and the Spoken Word*.

5 On March 6, 1933, just after his inauguration, President Roosevelt responded to the banking crisis that followed the stock-market crash in 1929 by declaring a four-day national bank holiday.

Jackson (New York) to Stella, Sanford, Marvin (California)

[*March 25, 1933*]

Saturday

Dear Mother, Sande, and Mart –

We got your sweet letter early in the week, mother – I can only wish that we were there with you, and know how hard it has been for you all – too how far and ungrateful I must seem – it is of the utmost difficulty that I am able to write – and then only miles from my want and feeling. I always feel I would like to have known Dad better, that I would like to have done something for he and you – many words unspoken – and now he has gone in silence – am glad tho, mother, that he is at rest – far from the toil he knew – and in memory there is solidity, reason and purpose and you. We will all try and come home this summer, there is only a little over two months – I hope most that Charles and Elizabeth will be able to come – Frank definitely is coming – so mother, it won't be much longer.

Hope you are more rested now, and am glad Arloie and Marie were with you. And all gratitude to you, Sande and Mart, for shouldering all the responsibility – hope you don't have to stick long with that job, Mart, I guess tho you are very fortunate in getting it in these times. While your out of work Sande keep close to your art. Would like to see what you are doing now – the experience with Siqueiros[1] must have been great – am anxious to see the job. I think I wrote that I am devoting all my time to sculpture now – cutting in stone during the day and modeling at night – it holds my interest deeply – I like it better than painting – drawing tho is the essence of all.

Love –

Jackson

Note

[1] David Alfaro Siqueiros (1896–1974), Mexican painter, was in Los Angeles to paint a mural: *Tropical America*.

*Sanford (California) to Frank, Jack, Charles and Elizabeth
(New York)*

[April 1933]

Dear Frank Jack Charles and Elizabeth,
Only a word in this moment of deep sorrow – our wonderful
Father has gone on to a realm of rest. He was a man whose
strength was only surpassed by his courageous, trusting judg-
ment of human values he was honest and sincere. His absence
will leave a gap in our lives which can only be filled by our
untiring efforts toward those cultural things which he, as a
sensitive man, found so sordidly lacking in our civilization.

Our beautiful Mother is bearing up in a strong courageous
manner – She is a most inspiring person. The emotional strain
is tremendous – She found tears and consolation in your tele-
gram and seems to find strength in her indomitable love for
her sons.

These hollow words seem stolid –
love –
Sande

Frank (California) to Charles (New York)

[1933]
Los Angeles
August 24

Dear Charles,
I might have written sooner, for what I have to say can
scarcely be put within the boundaries of a single letter.

The trip was uneventful except for a morning's drive
through the Mennonite country of western Pennsylvania. The
Middle West was at grips with a torrid heat wave. Hot winds
raced across the vast wheat fields, and the grain planted
but never to be harvested was prematurely yellowing under
the fierce sun. The farms appeared to be abandoned. Twice
when we were in trouble and needed water for our motor we

47

pulled in at farmyards. There was not a sign of life. Chicken feathers were flying helter-skelter. At the back of the first house I called through the door, slightly ajar, and out of the darkness came a squeaky voice followed by a withered little woman who stumbled in hesitancy, and then kept saying over and over again as though talking to herself, "Yes, I guess, I guess you can have some water." Out of the cistern I drew the water caught from the roofs last summer. My only inclination was to pour it back, for these farm-folk are ready to believe that the Gods will cut them off from their drinking water.

Some minutes later from out of the same darkness came a man and his son. They were both definitely hunched, and stood with their hands in their pockets wondering, I suppose, about my companion with the broken English in knickers and straw hat. At the same time I was ruminating about their habits and existence. When queried about the crops and prevailing conditions, they had nothing to say; or else having something cared not to say it. At the second house, not many miles distant, the experience was similar. The same door ajar, the same darkness; but the voice of a man, stronger than that of the wizened woman, who never moved but only directed me to a tank of water. To me both places pictured defeat in the parched country where living loneliness dwells.

At the close of the first day we halted at a farmhouse by the road where hung a sign "Tourist's [sic] Welcome." A widowed woman, of Dutch ancestry, and her daughter of two dozen years lived there. It was a grand old two-story house filled with fine pieces of early American furniture such as cherry tables, carved four-poster beds, simple straight-back maple and pine chairs, and bric-a-brac. The very thing the New York collectors are hungering for. I imagine it represented the furniture in use in that part of the country for a hundred years and probably longer. A modern chest of drawers of the skyscraper type given the daughter for Christmas was the only thing that marred the setting. On its top stood two volumes, *Heart Throbs*, and *More Heart Throbs*.[1] We spent the evening on the porch talking to these women and I learned a sprinkling about the Mennonites. After arriving home, I looked up their history.

They are a nonconformist religious sect. For centuries they were persecuted and harassed. In the first quarter of the 1700s a small group from Switzerland and Holland migrated to America. They settled in what is known locally as Round Valley where we stayed the night. In the latter part of the same century still others, particularly from Germany, at the invitation of Catherine the Great established a colony in the southernmost part of Russia in what was to become known as the granary of the world. From her they received freedom of worship and exemption from the army. During her reign they flourished, but Alexander I, on his ascendancy in 1801 withdrew their favors, and they were forced to abandon their adopted country. Coming to America they joined the first settlers in Round Valley. Some went into the wheat regions of Canada. The most conservative faction remains in Round Valley tilling the soil with the crude tools of by-gone days, never permitting the introduction of power-driven farm machinery. None of the modern conveniences are used in their homes. Their floors are carpetless, their windows without blinds. They still cling to early customs of dress. The men's suits are buttonless. Instead the hook and eye is used. The family names of Zooks and Yoders and many others of the first settlers are still found there.

It was Sunday morning and nine o'clock when we left the farmhouse. For a number of miles we passed surreys, buggies and carts carrying families, couples, and a pair of young bucks. The men all wore similar clothing of a dark shade. Their hats were broad and oval crowned. Their beards were full (a young man must have a beard to be eligible for marriage). The headdress of the women consists of a narrow cloth like a dust cap. Rounding a curve we saw a string of carriages coming from the opposite direction. The two groups converged at a by-road that led over the hill. To me these simple devoted people on their way to worship presented an unusual picture in present day America. I thought of gobblers and Thanksgiving, for there is a striking resemblance to the early Puritans, except that the latter were clean-shaven.

We drove the Mojave Desert at night to escape the heat, and it was breakfast time when I reached home. Mother didn't look nearly as well as when I left her last summer. She had

recently had the grippe and the March ordeal left its mark. Since I'm home she was forced to bed with a severe attack of stomach trouble. We had a doctor for her. Afterward she watched her diet and now is quite well. She possesses a vast store of energy and I can't help but admire her industry. She's canning and sewing and doing the house work. Sandy and I help her with the laundry which isn't much of a task now that she has a machine. She appears happy and contented. Her longing for Dad is hidden; she never complains. She would like to go into Oregon or Washington and rent a little place.

Mart is still working. He has taken Dad's place in its entirety. He works and provides for the family, never seeing his check. Friday nights he comes home and after dinner goes to that class in numerology or something. He has done a lot of studying on the nineteen chemical types of people and their various constitutions. He wants to get a job in Chicago so that he can study with the founder, Rocine.[2] I wouldn't quarrel with him, but it seems an empty thing to devote one's life to. There is some chance that Sandy may get on at the plant again by October. Meanwhile he stews, and paints and wastes his time.

The country doesn't seem to be moving out of the morass of the Hoover regime. The only noticeable change is purely a psychological one. All through the country the consensus of opinion is that if Roosevelt can't pull us out of the mess nobody can. True he is trying, but that would hardly be an attribute, if it were not for the lethargic years of his forerunner. He has been forthright and sincere, I believe, and has acted with a kind of two-fisted boldness which the average American likes. But for me I am skeptical about his program. Should it work which I grant it might, it can at best be only a temporary thing because he doesn't pretend to alter the faltering basic structure of our system. Since the ignoble death of the London Conference[3] Roosevelt has adopted the policy of economic nationalism. Rightfully believing that one of the major problems before the world is the deficiency of purchasing power relative to production he has sought to cure such a deficiency by issuing more money to producers. In this way credit created and passed through production will generate purchasing power in the form of wages, salaries, and profits.

Time will prove, I think, the naïve fallacies of this hypothesis, because it seems obvious that to stimulate production as a means to increase consumption is to put the cart before the horse and to insure progress, if at all, in the opposite direction from that intended. The chances are the danger will go unseen and we will be in the thick of our worst as well as our fifth winter of discontent.

Here in Los Angeles the merchants are shouting that they have fallen in line with the administration's new Magna Carta of American business and are marching forward with Roosevelt. The airwaves of the radio are jammed with the ballyhoo of the NRA,[4] and columns of space in the newspapers are devoted to swings of progress. There is a definite need for a newspaper in this town with an intelligent editorial policy to lead the people with some degree of sanity. I have yet to read a dissenting opinion in a local paper. I know of numerous cases of abuse, and though not of a startling nature, they show how American businessmen under the guise of the Blue Eagle, are working fewer men than before, and requiring those still employed under reduced hours to complete the same quota of work or stay until the work is completed without over-time pay.

The State having chewed away the surplus left in the treasury when Rolph[5] took office finds itself head over heels in debt and sinking helplessly. At a special session of the legislature a 2½% sales tax was enacted and immediately put into effect. At the same time they adopted a graduated income tax. The moneyed interests of the State led by Hearst[6] began to storm. Needless to say their cries were heard in Sacramento, and Rolph wiped their tears away with a pocket veto.[7] The sales tax, wide open to graft, is burdening an already impoverished buying public; and that combined with Rolph's action on the income tax augurs well for a change at Sacramento a year from next November, if a movement afoot to recall him doesn't do it beforehand.

The City and County of Los Angeles has felt the pinch of these desperate times, and the politicians accustomed to squandering money recklessly are pitifully unable to cope with the situation. From every side they are being pricked. The assessed valuation of local property has fallen far below

51

its 1928 level. To meet the mounting expenditures the Board of Supervisors, able to see in only one direction, have announced a considerable increase in the rate on taxable property. At an open hearing of the Board an angry group of property owners vehemently protested against the proposed increase, and charged the officials with mis-management of county finances, and offered that it was high time to whittle the budget. Mr. Quinn the chairman of the Board of Supervisors had never been face to face with a thing like this before, and hem-hawed and choked on his words as he said they were doing the best they could.

Poor Mr. Shaw the New Deal mayor[8] just frets when faced with a committee of indigent citizens. One-time Supervisor he has risen to the high estate of chief executive of the city, and it hurts him terribly to be sought after by the lower crust. He doesn't know what to say to them so just passes the buck. For about eighteen months part-time jobs have been created and paid for out of an allotment of RFC[9] money. Water drains and scenic drives in the parks constituted most of the work. Each married man was to get thirteen days work in each month at $3.20 per day (supposed to be $4, but political grafters are reputed to be getting the 80 cents) and each single man eight days at the same rate. Throughout the city and county unemployed relief agencies[10] were established to parcel out the work. They are staffed by the nice-sounding name of welfare workers, and lesser politicians caught in the trap. After chasing hither and yon you find your proper district agency and your plight is heard. You sit at the end of the desk of the social worker and she asks you questions and fills in a four-page printed form. Your history, your parents' history, where, when and by whom married. (To be sure of legitimacy.) Institutional history to discover whether you have been in prison. I went through it. What humiliation. I complained that I wasn't requesting charity but only a job. This doesn't concern you, but we have to fill out the form to have a complete record I was told. The primary reason was to catch up on deportable Mexicans. On the wall hung a chart and she ran her finger down one of the columns showing me how three were to live on 38 dollars a month. I never got a work order because Sandy had had one the month before,

and many men were overdue a month on their orders. Now the funds have dwindled and the workers have been cut to $1.60 on a six-hour day. A one-day strike for $4 was held and a committee went to Shaw, later reporting to a mass meeting. The mayor answered that soon all financial assistance would be withdrawn and the soup kitchens opened again. I would like to see an audit of the books.

There is nothing to tell about myself. Suffice it to say that I am mighty confounded in these times, and know not whither to turn. I want to do, to produce, to live with a gusto that is so lacking in my life. Any interest or plan that I've had seems to have been thwarted. Now I haven't anything. I'd like to be on some path that led somewhere, but untrained as I am I haven't much choice. I would tackle a country newspaper job if it offered me color and experience, but there are none in this section worth connecting with even if it were possible.

I ask your forgiveness for this belated and incongruous letter, and remain

Sincerely,

Frank

Extend to Elizabeth my regards, and say hello to Jack who I heard, through Tolegian, is in town.

Notes

[1] *Heart Throbs* and *More Heart Throbs*, popular books of sentimental prose and poetry.

[2] Dr. Victor G. Rocine (1859–1943), was a professor and lecturer, a specialist in food chemistry and inventor of "human chemical types."

[3] The London Conference of 1933 was the World Monetary and Economic Conference, which had as its object the checking of the world Depression by means of currency stabilization and economic agreements. Unbridgeable disagreements made the meeting a total failure.

[4] National Recovery Administration (see Glossary).

[5] James Rolph, Governor of California, 1931–4.

[6] William Randolph Hearst (1863–1951), newspaper magnate, was founder of the Hearst Corporation, a major American media organization. He aroused the fury of the American left by supporting Nazism in the 1930s. Orson Welles used many elements of Hearst's life for creating Charles Kane, hero of the film *Citizen Kane*.

[7] "Pocket veto" (see Glossary).

[8] Frank Shaw, Mayor of Los Angeles, 1933–7.

[9] Reconstruction Finance Corporation (see Glossary).

[10] Government agencies created to alleviate hardship among the poor and unemployed. See Glossary for Federal Emergency Relief Act.

Los Angeles
October 30, 1933

Dear Charles,

I have your letter of two weeks ago. It is good to know that you have settled in a house with sufficient space and light. And at last Elizabeth is rewarded with something like a kitchen. I had hoped Jack would spur out for himself this year but I suppose conditions make the present set-up the wiser.

Mother is well. Mart still has his job and though he has never complained, it is recently apparent that much of the sting has been taken from it, for he has a girl of whom he is fond. During the summer he had several notes from Betty,[1] still in Chico, and she planned a trip here early next month, but yesterday Mart wrote advising against her coming.

It has never been made exactly clear to me, but I believe Uncle Frank was never notified of Dad's death, but learned of it through a letter to Betty several days afterward. A letter followed from Aunt Rose[2] expressing their sorrow and a desire to have him come down, but I think the letter went unanswered. I could be more exact, but when I asked Mother about it I could see the cropping-out of the old bitterness so I was satisfied not to know more.

I read the LIPA[3] brochure with profit, the League has gone considerably to the left since its beginnings, and I was really surprised to find them speaking so frankly and convincingly for the overthrow of the capitalistic State. However, I believe, they will be forced to go even further and admit that our chances of changing the system by means of the vote are slight, and that nothing short of an armed revolution will attain the desired ends. The socialists have ever believed that evolution by education would bring about the desired society, but what are their results. They were completely squelched in Italy and more recently in Germany by the Fascists. Circumstances here in America are similar and unless there is a well-organized movement of the communist order with a rigid set of tactics our fate will be as theirs has been.

Sande and I have been attending a series of Marxist lectures sponsored by the Pen and Hammer, a literary branch of the local John Reed Club.[4] Given by Harry Carlyle, an Englishman, they have proven stimulating and interesting and exceptional in merit. There will be ten lectures in all covering the history, economics, and philosophy of the capitalist society, the rise and growth of socialism and communism. Outlines and bibliographies are given. About one hundred and fifty persons attend, many of whom are professional people, lawyers, doctors, teachers, architects, etc.

There are a number of strikes in the State. About 10,000 cotton pickers in the San Joaquin valley, 5000 garment workers here in Los Angeles, besides an outbreak in the meat packing industry.

Do you know what steps are being taken to unify the various factions of the left movement? Does the LIPA propose to enter a Farmer-Labor party[5] in the State elections prior to the general elections in 1936? It appears that La Guardia[6] has at least an even chance of being elected mayor. A year ago it appeared impossible. Perhaps he is a likely candidate for President on the F-L ticket in '36. The article in the *Modern Monthly*[7] of September on the need for such a party was excellent.[8] I haven't seen *Common Sense*[9] in this town. I am not sure that they can be bought here.

I was terribly sorry to learn of Rita's mishap.[10] Please say something to her for me. What of Benton's murals? You have never mentioned them.

 Regards to all,
 Frank

Notes

[1] Betty Nelson, the adopted daughter of "Uncle" Frank, LeRoy's adopted brother.

[2] "Uncle" Frank's wife.

[3] League for Independent Political Action (see Glossary).

[4] Pen and Hammer Club, John Reed Club: left-wing discussion groups. Philip Guston and Reuben Kadish began attending meetings organized by the John Reed Club (named after the American journalist and well-known revolutionary). When Siqueiros was in Los Angeles in April 1932, he addressed a meeting of the John Reed Club in Hollywood, presenting his approach to art in a paper he titled "The Vehicles of Dialectic-Subversive Painting." The influence exerted upon young painters by Siqueiros and the Mexican

muralists was considerable. When José Clemente Orozco began painting his *Prometheus* mural at Pomona College, Philip Guston and Jackson Pollock were there to watch.

5 See Glossary.

6 Fiorello Henry LaGuardia (1882–1947), Mayor of New York City, 1934–45.

7 *Modern Monthly* was an independent radical journal, the unofficial organ of the American Workers Party. Max Eastman and Edmund Wilson were on its editorial board.

8 Benjamin Gitlow, "A Labor Party for America," *Modern Monthly*, September 1933.

9 *Common Sense*, a Socialist magazine founded in 1932 by the League for Independent Political Action (see Glossary).

10 Rita Benton suffered several miscarriages between the births of her two children.

1934

Stella (California) to Jack Charles and Elizabeth (New York)

[January 1934]

Dear Jack Charles + Elizabeth,
Wednesday morning 8:30 your letter came this evening as the mail man lives the second house from us other wise we wouldn't have had it until tomorrow. Was glad to hear from you hope you get a job, and Charles too. Frank and Sanford haven't been able to get on there is a lot of crooked work here among the CWA.[1] Uncle Sam is going after them have two women in jail and after the rest of them hope they put them where they belong. Sanford worked at the plant today and three hours Monday, helps some. I am so ashamed I haven't answered Charles letter before this. The rains didn't hurt us any and we have been having grand weather ever since. More like May than Jan. Los Angeles has sure been hard hit this year Earthquake then Griffith Park fire[2] over one hundred were burned to death the million $ hill firm that destroyed the watershed back of Montrose and Glendale that is why the floods was so terrible through that section lots worse than ever was told in the papers over three hundred killed lots of bodies they never will find. washes fifty feet deep over six hundred homes perfect wrecks. Everything gone and no jobs

and nothing to start with again we are still having quakes about every so often and I wouldn't be surprised if we would have a big one any time and I would sure hate to be down in the city. I am glad we are on the hill even if the house is sliding downward. Marvin is still on the job and looks fine and in good spirits even if we do spend all his hard earned money. have to start paying rent too, don't know how. Phil [Guston], Don [Brown], Stark,[3] Rube [Kadish] and Harold Lehman[4] were here for dinner last Friday evening. They have a club meet every Friday night.

Phil Geise died some time ago.

Are you planning on coming home this summer or is that too far away for you folks. January is almost gone and Feb is a very short month wish I could give you a cake for your birthday[5] hope you will soon be o.k Charles sweets are not the only thing that causes acid stomach starch is almost as bad. nice you could have your mother with you Elizabeth. Send your wine sauce recipe some time when you think of it I need to have some good ones haven't had any good wine for so long and I have lost my recipes. had some things I wanted to give you and Charles if you come out this summer will have to wait until you do come maybe you wouldn't care for them. The Boys and myself are going down town in morning so will mail this note.

Wishing you a happy birthday Jack.[6]

Loie was [here] a week ago yesterday she was here for dinner getting along fine.

Everybody O.K.

Love to all, your Mother

Write when you can always glad to get a line

Notes

[1] Civil Works Administration (see Glossary).
[2] The Griffith Park Fire, October 3, 1933, started at the bottom of a slope and a number of men were ordered – or volunteered – to fight the fire. A sudden wind change sent a shaft of flame up the slopes of Dam Canyon, burning 29 workers to death and injuring more than 150 others.
[3] Leonard Stark, photographer and cinematographer, was photographer for the film *The Salt of the Earth* (1954).
[4] Harold Lehman (1913–2006), American painter and muralist.
[5] Charles was born on December 25, 1902, in Denver, Colorado.
[6] Jackson was born on January 28, 1912, in Cody, Wyoming.

58

New York City
February 11, 1934

Dear Frank,
Am disappointed at not hearing from you. What's up?
Christ something must be happening out there what with
lynchings,[1] quakes, floods and strikes. I've read several
reports of conditions in the Imperial and San Joaquin
valleys[2] – in the radical press of course. Economic align-
ments are becoming clearer from one end of the country to
the other and California is not to escape. I imagine all of
you are having a hell of a time. Mother reports that neither
you nor Sande were able to get on the CWA. What is the
situation. Jack and I were both turned down here by the
PWAP.[3] Jack has tried the College Art and may eventually
get something. I don't know why we were turned down
except we both got our names in late and the Whitney is of
course favoring their own crowd. And I don't know whether
we will get another chance if and when new appropriations
go through Congress. This thing is going on of course. There
is no stopping it now.

I finished up the design for the projected Greenwich
House[4] mural but was unable to do anything more about
it. It's the best I've ever done. Have a picture in the current
Pennsylvania Academy show.[5] Sold a drawing last week
and went out and bought a suit – the first in three years.
Elizabeth makes some occasional money and though we
started the winter pretty nearly at scratch the first three
months were fairly easy due to her efforts in real estate and
my special class; now we are poorer than we have been in
years.

Elizabeth is becoming more radical every day and wants
now to go into the Midwest and organize.[6] We are both at
the moment considerably interested in the American Workers
Party.[7] We recently met Arnold Johnson[8] the National
Secretary of the Unemployed League[9] which is the base for
the organization of the AWP. The Communists have been a
valuable stimulant to the growth of a revolutionary radical

movement in this country but for my part I am pretty well convinced they will never be able to develop the kind of leadership necessary to effectually organize the American worker. In fact I doubt whether they can do it in most other countries.

What about the PWAP in California? How is Mother? and Mart and Sande? I hear Siqueiros is in N.Y. I'm still waiting to hear from Mart and Sande.

Chas

Elizabeth has just finished a grand play titled *Men Grow Taller*. It's the best thing she has yet done. Hope it gets put on.

Notes

[1] On November 26, 1933, a mob – described by newspaper accounts as a well-dressed, after-theater crowd – invaded the county jail in San Jose, dragged out two accused kidnappers and murderers and hung them from trees in the city's principal park.

[2] These were early attempts to organize Mexican agricultural workers into unions: thousands of Mexican and Mexican-American cotton pickers were demanding higher wages and better working and living conditions.

[3] Public Works of Art Project (see Glossary).

[4] See Glossary.

[5] The Pennsylvania Academy of the Fine Arts (Philadelphia), 129th Annual Exhibition, January 28 to February 25, 1934.

[6] Elizabeth was interested in organizing workers into unions.

[7] See Glossary.

[8] Arnold Johnson (1904–89) joined the Socialist Party in New York in 1929 while he was still a divinity student.

[9] See Glossary.

Marvin Jay (California) to Charles (New York)

[April 23, 1934]

Dear Charles,

We are eating regularly and shall continue to manage by some means.

Frank has ten days labor with the power company, obtained through our district Councilman. One of us should get on with the PWA.[1]

The County pays our rent, public utilities and some foods.

I bought a milk goat this week and will get some chickens and rabbits when I earn a few more dollars. With milk, eggs and meat from our backyard ranch we can manage until something can be done about this rotten situation.

Sandy is working with Phil [Guston] and Rube [Kadish] on a mural at the Workers' School.[2]

[Marvin]

Notes
[1] Public Works Administration (see Glossary).
[2] Workers School (see Glossary).

Charles (Pennsylvania) to Elizabeth (New York)[1]

[June 7, 1934]

Scranton
Thursday
Dearest Elizabeth,
We stopped last night just outside of this place. Have been working today – made the first drawings so far. Grand stuff. Jack had some friends up this way and we stopped over Tuesday night, had dinner and breakfast. We traded the rear end of our car for one in better condition Jack's friend had and also got a good tire in the bargain.

So Wednesday we worked on the car – had lunch and left about 3:00. Last night we slept out for the first time and began work this morning in earnest. The car is in perfect shape now and I think we may try to make it West. In which case we will stop in Chicago and see your family and from there north. But first I intend to spend a few days in this coal region.

Will you write me Gen Del [General Delivery] Wilkes Barre. What about your play[2] and will you go to Vermont? What about the apartment? In all probability I will be in Wilkes Barre Friday or Saturday. Please write.

Also would you call Lovestone[3] and get the names he offered me. They may help me some.

Can't write more now.

Love,

Charles

Notes

[1] These 10 letters, dated June 7 to July 26, written by Charles to Elizabeth, recount the cross-country trip (from New York to Los Angeles and back) made by Charles and Jackson in a 1926 Model T Ford they bought for 15 dollars (and sold for twice that to a New York policeman on their return). The purpose of the trip was to visit their mother for the first time since their father had died the year before.

The itinerary was as follows: Pennsylvania (Scranton, Wilkes Barre, Nanty Glo, Pittsburgh); West Virginia (Wheeling, Parkersburg); Virginia (Homestead); Tennessee (Knoxville); North Carolina (Elizabeth); South Carolina (Charleston); Kentucky (Pikeville, Shelby Gap, Harlan); Alabama (Gadsden, Birmingham, Bessamer); Louisiana (New Orleans); Texas (San Antonio, Houston, El Paso); Arizona (Phoenix).

[2] Elizabeth was working for a drama unit that preceded the Federal Theatre Project, a New Deal project (founded in 1935 as part of the W.P.A.) to fund theater and other artistic performances.

[3] Jay Lovestone, born Jakob Liebstein (1898–1990), was, successively, a member of the Socialist Party, a leader of the Communist Party, and the founder of the Communist Party (Opposition) C.P.(O.) (see Glossary).

Charles (Pennsylvania) to Elizabeth (New York)

[June 11, 1934]

Nanty Glo
Monday
Dearest Elizabeth,
We were caught in a downpour here last night but made out swell compared to the night before when we were forced to eat cold dinner and make a lean-to against a country school back house. Grand country and having a swell time. Cashed the first check here this morning. We're going through Pittsburgh after all and then Wheeling. Expect to spend most of today here working. People have been very friendly all along.

Are you having a good time? Do hope the plans for the

play go through. Do you miss me? You would simply perish if you saw the way we travel. Had an opportunity this morning to clean up a bit and change clothes. We go to bed about 8:30 and are up most times by 4:30. Some nights last week we nearly froze.

Lots of love,
Charles

Please write me at Wheeling W. Va.

Charles (West Virginia) to Elizabeth (New York)

[June 16, 1934]

On the Road South of Parkersburg W. Va
 Friday
Dearest Elizabeth,
I got your letter at Wheeling and also the one at Wilkes Barre but not the one at Pittsburgh. We had a rather difficult time there and I'm a little disappointed at the results, though I did get several good drawings I expected more. In the first place getting through traffic there was terrific – Next we were forced to camp nearly 15 miles out of town. However the camp was pleasant. Met a swell bunch of negroes and an Italian miner who turned out to be radical. We usually collect an audience wherever we stop. In the next place the steel plants are inaccessible. We made a tour around several of the steel towns near Pittsburgh but nowhere could we get close enough to the works to make drawings. At Homestead one night we attempted to make a drawing of the entrance to the plant with the men going off shift and created a hell of a disturbance. The company Police got nervous and sent one and then another detective over to see what we were doing. Finally just as I decided to get out two city police came up. They searched us and conferred with the company dicks and questioned us and told us to beat it. We were of course on a public street.

I talked with the city police later and one of them said – "you picked a hell of a time to come makin' drawings

around a steel plant with everybody nervous and waitin' for things to break." They admitted that they were in hot water because they were watched by their superiors and by the Company [but] at the same time they knew all the men in the plant and didn't want to see trouble. I thought of remaining for the beginning of the strike but the event seemed too uncertain. You observe decided differences in the character of the people even in so short a distance as N.Y. to Pittsburgh. Everywhere they have been friendly. The kids, even in the most poverty stricken sections, are especially likeable.

Well a fellow came up to us on the street yesterday and said – I can see you are farm workers can't you put me next to a job. I want to work bad. So I guess we pass.

I miss you like everything. Wish you were with me. Already I'm beginning to look forward to seeing you. If you can possibly manage it leave the office. I'm a little uncertain just where I'm going but please write me at Knoxville Tenn.

Lots of love,
Charles

We were up at 5 here this morning.
I'll mail this at the first town.

Dearest
We came down through mountain country and if I had mailed this at Elizabeth it would have been delayed so carried it on to mail here in Charlestown. We were up at 4:30 this morning and have just come into town, it is not yet 9 and the town is alive with people and it turns out there is to be an NRA parade and grand celebration with Johnston[1] present, and the blue eagle etc. There are miners and farmers everywhere. Think I'll spend the day here.

We were obliged to ferry the same river 3 times yesterday. These ferries are really rafts and are propelled across streams by manpower with the aid of cables. For which service they collect 20 cents. This was an expense I hadn't counted on but the trip was worth it.

Love,
Charles

Note

[1] General Hugh Johnson (1882–1942) was chosen by Roosevelt to preside over the N.R.A.

Charles (Alabama) to Elizabeth (Vermont)

[June 1934]

Gadsden Alabama
 Sunday
Dearest Elizabeth,
Came in here early last evening. Found a place to camp near a water supply and put in for the night. It is really difficult finding campsites. Washed clothes and bathed and felt better. It has been frightfully hot.

Monday we were in Pikeville Kentucky. The town square was fairly crowded with people and I discovered it was court day so we stayed on to attend the trial of a man accused of shooting and killing his brother in law. It rained during the day. Rain had gotten us up the previous night. Anyway we drove on to Shelby Gap where finding a school building on a hill with space under the floor we stopped.

I approached a house in the hollow nearby to ask permission. The man was friendly and said "shore hit was alright" but after a bit he advised me to get between the school building and his house because he said whiskey was sold nearby and there was "fellers drivin' up in cars" etc. Anyway he wouldn't feel quite safe where I was asking to stay. He was a character and in an hour or two of talk he had me feeling kind of uneasy. "Still" he said "if anyone bothers you just call my name and I'll do what's right." Well we had supper and were talking some more. It was just a little before dark – when a car stopped out in the road and a man got out with a 30-30 rifle in his hand. He walked back the road a piece and stopped at a house there where he began abusing his wife and insulting the other people about. I didn't sleep too well that night. The next morning the woman sent us some Johnny cake[1] and I made a drawing of the man.

That day we made Harlan and stopped a few miles outside the town on the bank of the Cumberland River. Here we went swimming, washed clothes and made supper.

While we were cleaning up two men on the opposite bank called and asked me to bring the boat, fastened on my side, over to them which I did. One of them went on his way while the other stopped and talked. You remember the mine trouble they had in Harlan several years ago.[2] Naturally I had no intention of bringing up that subject but inevitably through talking about conditions we came around to the question of labor. It appeared that he himself was a radical or at least a strong union man for he said he was blacklisted in all the mines.

Anyway in a little while he spoke up and said he could see we were strangers and that he would advise us to keep our mouths closed in Harlan County. He expressed surprise that we had gotten through the town of Harlan without being searched. We talked a good deal more and I have never slept so uneasy in my life as I did that night.

I got your letter yesterday in Knoxville and it made me a bit unhappy and uneasy. I begin to wish I were back home. Elizabeth sweetheart I miss you and care for you more than you believe. Please be careful what you do. I suppose you must be in Vermont now. Are your expenses being taken care of? I hope you won't really be disappointed in the cast you get. Have you had to make many changes in the script? When will the play open there and how long will you remain in Vermont?

I don't know precisely where I will go from here but will you write me at New Orleans. And write soon.

I think of you constantly.

Love,
 Charles

Notes
[1] A cake made with corn meal.
[2] A violent strike that lasted 13 months in the coalmining country of Harlan, Kentucky.

Charles (Louisiana) to Elizabeth (Vermont)

[June 1934]

New Orleans
Sunday
Dearest Elizabeth,
Came into N.O. Friday and so disappointed not to find a
letter from you and Saturday the post office closed in the
afternoon so that if your letter came I missed it. I do hope it
will be there Monday. I miss you so much and it is so long
between letters. From Gadsden where I last wrote we went to
Birmingham and camped outside that city in Bessamer, a steel
and iron town. I saw much but was unable to get near enough
to any of the workings to make drawings. These places are
the most depressing kind of industrial towns. Though all of
Alabama is depressing enough. It is a poor State and shows
its poverty at every mile. Mississippi is but little better, there
is incredible poverty everywhere. I saw Negro sharecroppers
plowing cotton with steers.

New Orleans is really an interesting town. Living here is
incredibly cheap – both food and rent. Though the town is
attractive there does not appear to be much spirit.

We got off on the wrong foot however from the very begin-
ning. First of all the night before we made town we were
consumed by mosquitoes and spent the entire night fighting
them. The next night in New Orleans we were robbed. We
hadn't believed it would be possible to camp in the city but
when looking around found what appeared to be a good
place near the French Market. We drove in there this first
night and went to bed. We were both dead tired and went fast
asleep.

Everything loose of course was carefully locked in the car,
just the same when we awoke about five in the morning the
rear end of the car had been opened and our stuff thrown
about everywhere. When I put my pants on (they had been
placed across the head of my bed but hung over slightly
on both sides) I discovered the thief had even cut out my
pockets. You can imagine how we felt. Fortunately I had but
little change in my pocket, about fifty cents, my money was

67

under the mattress. Money was really all the thief wanted. Though he did take the frying pan – two pots – the pail which we recovered – Jack's extra pants and shirt. He took my fountain pen and one pencil and the small mouth harp.[1] Why he should take only one I can't imagine. Also he took the keys to the car.

Of course we were fools. But I don't understand how neither of us woke up. Well after that we took a room.

I wonder if you received my letter. Perhaps you are still in New York.

Dearest

Got your letter this morning and delighted that it was so long and cheerful I really don't think you could wish for more for your play. How I would like to be there when it opens. Are you still revising it? When will it be taken to N.Y? I gather you didn't rent the apartment. I hope Roedel[2] was willing to wait for the rent.

The trip has been so far perfect in every way but sweetheart I wish I were with you – I miss you so awfully I want so much to talk with you. Have you time to be just a little lonely?

Love and affection,
Charles
Write me at El Paso

Notes

[1] Another name for a harmonica. Thomas Hart Benton was an exceptional harmonica player and many of his students and friends gathered to play with him – from Bach to ballads; they were called the "Harmonica Rascals." Jackson, Sanford, and Charles all played the harmonica; Charles also played the banjo, and Benton's wife Rita played the guitar and sang.

[2] Roedel was the owner of the New York building in Greenwich Village (46 East 8th Street) where Charles, Elizabeth, Jackson, Sanford, and Arloie lived, successively, between 1933 and 1942.

Charles (Texas) to Elizabeth (Vermont)

[July 4, 1934]

Houston
Sunday
Dearest,
Made enquiry here about PWAP work. What I have just seen here in the Post Office is lousy. I met some artists in New Orleans. One offered us a studio for our use.

Met a Mexican there who was just finishing a piece of sculpture for the PWAP and was given the name of another fellow to look up in Alpine Texas. The mosquitoes have been fierce the past week. Will write you from El Paso.

Love,
 Charles

Charles (Texas) to Elizabeth (Vermont)

[July 9, 1934]

El Paso
Sunday
Dearest,
Arrived here about two hours ago. It is Sunday the Post Office is closed and the town appears almost deserted. The stores too are closed and it is impossible to buy food – except tortillas and some kinds of fruit. I am a little tired today – and sunburned. We were seven days getting through Texas. It has been dry and hot, but the heat is bearable. The corn every-where through Texas is burnt, even the sunflowers in some sections were withered. Eastern Texas to San Antonio one sees a good many Negroes. Indeed most of the cotton seems to be worked by them. West of San Antonio there are few Negroes but a majority of Mexicans.

In both cases however, as well as with most of the whites, they are poverty stricken. Even though this is beautiful country life for these people is indescribably barren and

69

harsh. Some of the towns I liked immensely, especially some of the smaller ones. San Antonio I liked too. Of course I have redesigned and rebuilt all of them and probably it is merely my conception that I am impressed with.

I see tremendous possibilities. I do wish you were with me. There is so much I wish you could see. I am spending less time on the road now so as to spend as little as possible. In Tennessee I bought a large bag of corn meal and we prepare Johnny cake for our meals. So far we haven't tired of it.

I'll stay here until morning – get the mail – I hope there will be a letter from you – and then leave for Los Angeles going through Phoenix.

How are the rehearsals going – are you working hard? Doesn't it give you a bit of a thrill to have the play in production? Are you having a good time? What are your plans after Aug 3? Are you going to run short of money?

Monday morning – early
Found your letter – was so afraid I would miss it. I can't stay here as long as I would like. Your report of progress on the play is gratifying.

I have seen very few papers on the trip and consequently I have a very hazy idea of what is occurring in Germany or anywhere else. I certainly miss *The New Masses*.[1] This morning's paper says a general strike threatens in San Francisco.

Write me at Los Angeles
1300 Montecito Dr.

Lots of love,
Charles

Notes
[1] *The New Masses* (1926–48) was an American Marxist magazine. Among the regular contributors were Upton Sinclair, Dorothy Parker, Langston Hughes, Ernest Hemingway, Max Eastman, Dorothy Day, Eugene O'Neill, and Theodore Dreiser.

Charles (Arizona) to Elizabeth (Vermont)

[July 13, 1934]

Phoenix
Thursday
Dearest Elizabeth,
I miss you terribly. It seems months since I left you though we have been separated little over a month.

Came in here yesterday morning almost before daylight and drove into the yard of some old friends. It gave me a great pleasure to drive suddenly into the Salt River valley from off the desert. The temperature ranged around 115 the whole day previous driving through the desert mountains.

Of course things have changed and it is difficult to recognize old places that you picture perfectly in your mind – and sometimes so disappointing.

Our old place is a wreck – nothing remains but a shell of the house – and my memory. These people where we are staying have lived here continuously and they have treated us royally. I am eating my fill of watermelon. Tonight we eat with a Japanese family who were our neighbors. The babies I remember have grown up – two beautiful girls and a handsome boy. Tomorrow we eat with other friends and leave probably Saturday morning early about four – will be in Los Angeles late Sunday or early Monday. Will write a long letter from there.

 I love you,
 Charles

Charles (California) to Elizabeth (Vermont)

[July 17, 1934]

Los Angeles
Monday
Dearest Elizabeth,
The first half of the trip is completed. Arrived here Saturday surprising everyone. But at the end I am lower in spirit than

I have ever been. Our difficulties have weighed on my mind continually. I have tried not to notice the coolness in your letters but it was no use until now. I feel desolate and distressed beyond measure. You do not know how alone I feel and how I need the strength of your love.

I long for you sweetheart. I recall the countless happy days we have had together to ease my heart but I must have some word from you, some assurance that you love me – if only a little bit. I will move heaven and earth to make it complete again. I will not let you go from me. There was no letter from you this morning.

I am anxious to return home. I shall not remain long here. I do want to know what your plans are after the play opens and how your money is holding out. Please write me sweetheart in detail if you can possibly find a moment's time. My funds have held out very well. There is some possibility I may undertake a mural here in the Workers School.

All reports indicate the strike situation in this section has reached important proportions. The general strike went into effect this morning in S.F. and it may spread southward.

I love you,
 Charles

Charles (California) to Elizabeth (Vermont)

[July 26, 1934]

Dearest Elizabeth,
Expect to start the return trip soon. I have enjoyed the rest here and also done some work. In particular, some fresco experiments. Not too successful technically but satisfactory enough to encourage me to go on. The family are in bad shape but it could be much worse. They have a beautiful house and grounds. Rent is 15.00. They were until this week receiving relief (food, rent, etc.) but Frank got a pick and shovel job Tuesday and that kills the relief. Mart was married last month and is living in Long Beach.

Everyone here has turned definitely left. Frank in par-

ticular. He was for a time doing work for the *Western Worker*.[1]

The terror in S.F. has been thorough.[2] The *WW* offices and printing plant were completely destroyed. I have heard that none of the important leaders were caught. But if they are safe they are so effectively hidden not even the party here can locate them.

It is difficult to know even approximately what is happening or to know whether the strike may be called successful.

I would like to have gone to S.F. but it was impossible. The car needed overhauling and I have stayed very close to the house in order not to spend money.

I hope Hart's[3] having to return to N.Y. before rehearsals are complete won't damage your production. Will you have a better cast to work with in N.Y? I wish I could be with you when it opens. I too am lonely and distressed in spirit, but I am lonely for you only and I am most anxious to return and see you. I beg you again sweetheart not to leave me and not to make it impossible for us to come together again.

Love,
Charles

Notes

[1] The *Western Worker* of San Francisco was a Communist daily newspaper.
[2] The 1934 San Francisco general strike was begun by the longshoremen and lasted 83 days. It resulted in the unionizing of all the West Coast ports in the United States.
[3] Moss Hart (1904–61), playwright and scriptwriter. His play *You Can't Take It with You* (1936) won the Pulitzer Prize.

Charles (New York) to Frank (California)

[August 21, 1934]

Wednesday
Dear Frank,
I meant to write before this but just couldn't find the time. Even though we got in here Sunday morning. The car functioned perfectly. But we did have to buy another tire in Nebraska. That retread was a poor buy. We didn't spend much time on

the road and so I actually reached N.Y. with twenty-five to the good. That's something I can crow to Elizabeth about. Elizabeth looks grand and has had a swell summer.

We missed some of the worst drought country but what we saw was bad enough. The contradictions in the farm situation are bound to swell the leftward movement this winter if not create serious food rioting. Southern Iowa looked particularly bad from Davenport to Mt Pleasant. Not a blade of grass to be seen anywhere.

Tell Mother it was most unfortunate that we got into Tingley when we did. Grandma was more feeble than I had expected so that at best our visit wouldn't have meant much, but then she had a violent headache and so of course we didn't stay. And then as she had probably learned Les's[1] brother-in-law had just died which in the circumstance made it difficult for us to do more than just say hello.

I visited the *Farmers Weekly*[2] and met both of the editors. Both seem to be swell guys. I explained what my interest was and we talked around the subject for a while. I doubt whether I could do much for them except purely illustrative drawings. For anything else one ought to be working on the spot with them. Really I hadn't much to offer. I am not a political cartoonist[3] and my ideas are very vague. They are having a struggle making the paper go. I feel certain you could send them anything you have and they would be glad to get it, particularly from the Southwest.

I will send you a batch of stuff in a few days.

The money enclosed will complete the payment for the frame for Mother. I wish you would see to it that Mother has her teeth attended to. As soon as we are straightened out here I will send something to be paid on Jinso's[4] account.

Our best to all,
 Chas

Notes

[1] David Leslie McClure, Stella's brother.
[2] The journal *Farmers Weekly* was launched when farming was beginning to emerge from the Great Depression that followed the Wall Street Crash in 1929. Unemployment was high among the million and a quarter rural workers, three-quarters of whom were laborers. The first edition appeared on June 22, 1934.

3 But Charles did, later (1938), become a political cartoonist for the United Auto Workers paper in Detroit, Michigan.
4 Jinso Matsuda.

Stella (California) to Charles, Elizabeth, Jackson (New York)

[August 30, 1934]

Dear Charles, Elizabeth and Jack,

You boys will wonder what has happened to us since you left for home for I don't think any one has wrote. So glad you got home O.K. and didn't have any trouble with your Ford, know you are glad to be home again. Your letter made quick time, left New York City 12:30 noon and at 5 the next eve we were reading it, don't seem possible. I was in bed three and a half days last week with the flu but alright again. Frank and Sanford had bad colds but feeling better, Frank is still working three days. Will take civil service [exam] soon for clerk job. Marvin and Alma are here this week. They are O.K. except slight colds. Marvin says to tell you he is getting more revolutionary every day and he will write you a letter some day soon. He is reading *Breakdown* by Robert Briffault.[1]

The quilting frames are fine certainly did a swell job. I will see what I can do in the quilting line.

Many thanks to you. my teeth are all fixed up again. Tried to get Fines to tell me how much my bill was but he wouldn't say, he seems to be quite busy. Is the best dentist I ever had. Elizabeth I am glad you had a nice summer but sorry you could not come to Calif with the boys, would love to see you. And hope times will change. Looks like Upton Sinclair is going to have a chance to try his plays in Calif. No telling what will happen between now and November election, there will be lots of dirty politics played before that time. The *Literary Digest*[2] came out the last of the week with Sinclair's picture on the front sheet. Monday not one could be found, every one had been taken off the news stand and he sure told it over the radio in his speech Monday night – and he is going to Washington to talk over plans with the President.

I am glad you boys stopped to see the folks, had a letter from Les[3] telling of his brother-in-law's death and you boys being there. they feel bad about the way things were but that was something that could not be helped and I know you boys were glad to get away. Things must look terrible, they did to me three years ago.

Write and tell me something of your trip. what do you think of Utah Charles? Did you see the tabernacle. Did you leave your corduroy coat here on purpose Jack, if you want it I will reline it and send it to you. haven't seen anything of Tolegian since you left. Frank has gone to a meeting tonight. tomorrow is his last day for work this week and I am glad for him, he sure has a slave job. I got some Indian seed and he planted, it come up fine nice and green and several inches high. still have string beans and the squash is running every direction and lots of lovely squash on the vines now but not ripe enough to use.

Well the rest are all going to bed and as it's most ten will say good night and love to all.

Your Mother

We sure missed you, was so lonesome after you left. I felt so sorry for Sanford he broke down and cried he hated to see you leave would like to of gone with you.

Notes

[1] Robert Briffault (1876–1948), *Breakdown: The Collapse of Traditional Civilization* (New York: Brentano's, 1932).
[2] A general interest weekly magazine founded in 1890.
[3] Stella's brother.

Charles (New York) to Frank (California)

New York
September 21, 1934

Dear Frank,

I have meant to write you before this but have been so very busy. But the apartment is in shape. We spent a good three weeks painting and fixing and one thing and another and

more money than we should. But the place does look better. Jack, you have heard, has taken a place of his own. He seems happy about it and I think it is a good thing. He is optimistic about getting relief and I hope it does come through. He is anxious for Sante to come on and everything depends on this.

I have a batch of *Farmers Weekly* to send you. I met Bert[1] and Hall[2] in Chicago. They seemed swell fellows but the Weekly is a pretty poor job. Of course they're handicapped. But their main disadvantage is the idiotic line of the party.

We both intend becoming more active this winter. I'm sending you the pamphlet *What is the Communist Opposition*[3] and an issue of the weekly. The issue just out carries some important analyses of the break in the line of the [—]. I'll send it on later.

Is Mother well? How's the pick and shovel job? Tell Mart I mean to write soon. Has he heard from N.Y? Tell Sante I hope he can come on here soon.

 Chas

Notes

[1] In 1929 or 1930, Herbert Putz (1904–81) became active in the Communist Party; he adopted the name Erik Bert. From 1934 until 1936 he edited the *Farmers National Weekly*, the official paper of the Farmers National Committee for Action. In 1941 he joined the staff of the *Daily World*, a position he occupied for the rest of his life.

[2] Gus Hall (1910–2000) was an American Communist, founder of the United Steelworkers of America union. He was a longtime director of the American Communist Party and ran for President of the United States four times.

[3] Bertram D. Wolfe, *What is the Communist Opposition?* (Second enlarged edition. Communist Party of the USA (Opposition), New York, December 1933).

1935

Charles (New York) to Frank (California)

New York
February 13, 1935

Dear Frank,
Received your letter a few days ago. First we all send you our congratulations and best wishes.[1]

I will send 50.00 next week. I have to wait for a check to clear. Of course I should have been contributing before now and I'll do what I can henceforth but I don't know how much you can count on after June 1st. As you know I haven't any income that I can depend on during the summer and in addition I have to continue gathering material[2] if I expect to sell. I mention all of this so you will see how I am fixed.

Eleanor[3] is renting a room from us now and she will take the apartment during the summer if we both go away or if I go alone. This helps a great deal but then Elizabeth's brother is here looking for a job. Still things here could be a hell of a lot worse.

As you probably know Sande is also getting relief and they are both hoping to get jobs soon. These jobs may or may not materialize. It seems clear that the authorities are stalling hoping they won't find it necessary to act.

Thank God you got rid of that pick and shovel job. What

are you doing now? Mother writes that you are working terribly long hours. By the way will Mother stay on where she is? How is Mart doing is he getting relief? What does the situation look like to you out there? Is the Party getting anywhere – has the change in their line reached the coast yet? What is the attitude of those you talk with in regard to those on trial in Sacramento?[4] Labor is unquestionably coming to life. The question is can the Communist Party meet the situation – not eventually but in the immediate future. I think there is a chance they may be able to do this (certainly no other organization is worth considering) but only if they come to maturity soon.

I have had the [*Workers*] *Age*[5] sent to you for 6 months. I hope you find it instructive, are you receiving it?

Benton has just returned from an extensive speaking tour which was most successful. He has been getting lately a tremendous amount of publicity and due to these several factors he has several large jobs promising and he is considering removing to the Midwest. This of course is what we all want to do. He says there is a tremendous interest in mural painting. Here there is much talk but nothing happens and much of the excited air is a reflection of the general unrest.

I recently sold some things to a friend of ours who is working in Hollywood. He is mildly interested in the left movement – you'll find him interesting if you have time to get in touch with him.

<div align="center">
Lester Cole[6]

6070 Milner Road

Hollywood
</div>

Write soon –
 Chas

Notes

1. Frank had recently married Marie Levitt.
2. "Gathering material" meant going out and making drawings (of things and people) for future paintings.
3. Eleanor Hayden was a doctor, Bill Hayden's sister.
4. Sacramento Criminal Syndicalism case. So-called "Communist" labor unionists were accused of criminal syndicalism (advocacy of unlawful means – acts of violence – to bring about a change in industry or government).
5. *Workers Age* was the newspaper of the Communist Party (Opposition).

[6] Lester Cole (1904–85), American screenwriter, best remembered as a member of the original "Hollywood Ten," one of the first people in the film industry to be blacklisted by the House Un-American Activities Committee in 1947.

Frank (California) to Charles (New York)

[1935]
Glendale
April 19

Dear Charles,
Need I say Marie and I are happy and getting on well?

We both work in Glendale so have taken an apartment here. It's quite satisfactory. There is hardly any compensation in our jobs – colorless routine clerical jobs pertaining to relief. However sympathetic one's heart may be, the constant sight of sorrowed faces and broken spirits is an unwholesome diet. Ever the more so when one realizes the shortsightedness of most of these people, and the long task ahead before the new day. Some good is being done by a new group which is organizing the unemployed and relief workers. Quite naturally it is headed by the communists. Recently this group, which has as its main task, the gaining of back pay, increased budgets and clothing for near-naked children, jammed the Board of Supervisors' chambers and demanded the placing of six of their members on the Citizen's Relief Committee.[1] Their fight was waged with real brilliance. From morning till night they had the Supervisors up against a bitter wall. This is no boast. The chief argument of the Supervisors was that the County would be cut from its supply of Federal Relief moneys if the relief workers and unemployed were placed on the committee. These workers figured this was the Supervisors' strongest point so had communicated with official Washington. At the most telling point an extremely capable woman leader took the floor in rebuttal and produced a telegram from Fed. Am. Hopkins[2] blasting the beautiful lies built up by the senseless Supervisors. Though they even then didn't gain their

80

demands, the workers there that day received a political lesson never to be forgotten – and one recounted with spirited enthusiasm to thousands of other workers at local and neighborhood meetings.

Really one can see progress made on many fronts. For instance, a fortnight ago there was a united front meeting at the Philharmonic Auditorium. It brought together church groups, utopians, [—], student and various other unions and groups. Aside from representative speakers on the platform, a judge, and a State assemblyman spoke. It was my guess that the latter would be tagged a red in any company. I couldn't believe it possible to hear a representative of the people, of this State anyway, talking about the need for the overthrow of capitalism and the likelihood that armed force will be necessary. In the face of the constant red-baiting[3] attacks by the Hearst and Chandler[4] press, this meeting struck me as something of an achievement. The house was filled to overflowing and Gallagher[5] the principal speaker of the evening spoke to hundreds locked out in the street.

I was stunned to read the narrow attitude Benton has taken on the Marxist position. It's a pity how the Communists have hounded him out of New York. It looks like he is to be addressed <u>Mr</u> Benton from now on. I think both he and Mencken[6] have something in common, as Marie has suggested. Both have done plenty of hollering about the system in the past, but now that a significant movement is afoot to make a real basic change in that system these fellows gulp their words and say in effect – "we didn't mean anything like that." I'm glad Benton has made plain his stand. He ought to get some lucrative commissions now. Am sending along the *Times* excerpt in case you haven't seen it.

We had the very fine experience of hearing Strachey[7] twice. Certainly he is an able thinker and a valuable credit to the leftward movement. Likewise we had the pleasure of seeing Hull[8] in an excellent production of *Tobacco Road*.

In a recent letter to Mother you mention wanting to reach me that I might take some pictures to your acquaintance in Hollywood. Send them along; I'll gladly do it. As regards the money – hell, I don't know what to say – you've sent enough for the time being anyway. Mother appears not lonely: she's

too busy making quilt tops. I'm receiving the *Workers Age* as I stated before, thanks again.

Affectionate regards to all,

F and M

P.S. The local Chamber of Commerce halted the dust storm at the border.

820 So. Maryland Ave.
Glendale, Calif.

Notes

1 See Glossary.
2 Harry Hopkins (1890–1946), was executive director of the New York State Temporary Emergency Relief Administration, then he established the Federal Emergency Relief Administration (1933–5). Later he was the head of the W.P.A. (1935–8).
3 Red-baiting consisted of accusing someone of being Communist.
4 Harry Chandler was William Randolph Hearst's son-in-law.
5 Leo Gallagher (1887–1963) was a Los Angeles lawyer who specialized in workers' rights and was known for defending labor unionists, minorities, and the poor.
6 Henry Louis Mencken (1880–1956) – H.L. Mencken – was a journalist, satirist, social critic, cynic, and freethinker, known as the "Sage of Baltimore" and the "American Nietzsche."
7 John Strachey (1901–63), British political thinker and politician.
8 Henry Hull (1890–1977), actor, created the role of the shiftless sharecropper Jeeter Lester in *Tobacco Road* (1933).

Charles (New York) to Frank (California)

New York City
June 5, 1935

Dear Frank,

Guess you wonder why I haven't written. Well you know me. The truth is there isn't much to write about. We are more broke than we have ever been, notwithstanding which and partly because of, we just bought a 1929 Ford touring car for $65 (in perfect shape. It had just been driven from Los Angeles) and we are going out to Chicago tomorrow for a week. We are taking Sande with us. Hope he will escape the wrath of the relief people. For the rest we expect to stay in the city with maybe weekends at the beach and if things don't go

completely haywire Jack, Sande and me will make some short sketching trips.

I set myself down this afternoon with the intention of getting off a real letter but was interrupted and now it is late and we want to get away early in the morning.

I can see that you were upset by Benton's remarks to the press. Well I have been more than upset on several occasions this winter. A good deal that he has had to say and many of his actions have been indefensible. In a way I can understand it. I know that he is hopelessly muddled but I for one expected more from him. It is no secret that he has contributed a great deal to my development. I had an unbounded admiration for him as a man and as an artist – I still have in a measure, but in saying this I indicate that something has gone. I don't hold Benton himself wholly responsible for all that has occurred – I think that the CP's[1] approach has been stupid and I think that some of the individuals concerned have had a malicious intent in their attack. In the end they have not succeeded in clarifying any of the issues involved which one certainly has the right of demanding from communists. Benton of course is aware that the young people around him – his former students – are going left and it has hurt him.[2]

As far as I personally am concerned I am rather glad that he has gone west and that I am not going with him. Though it certainly gave me a rude shock that he preferred not to take me as his assistant. I believe he is going to have a hard row to hoe. He won't have things all his own way, however class antagonisms are not sufficiently keen to know which way he will go. Two things are certain. One is that he is not a fascist and the other is that he remains the one man in this country who can offer us something substantial in the technique of painting.

I have tried my hand lately at cartooning. My intention is to make *The New Masses*. Those I have made are not quite Nasts[3] but still I think they have some merit. Limbach[4] came in and saw some of my work and professed (sincerely I think) to like it. But when I went to *The New Masses* with some drawings they were – to say the least – not encouraging. I am certain that word has gotten around that I have or have had

some connection with the CPO,[5] so they are obliged to turn me down. I intend to keep at them.

Do you see the *Daily Worker*[6] out there? It is improving rapidly. I don't ask you what you think of the [*Workers*] *Age* for I don't think so much of it myself. Outside of the theoretical articles – and there are too few of them – and one or two other items the rest is not as good as it ought to be. Let me know what you think of it and the CPO position anyway.

We were all pleased that Mart turned down that scab job. He will be in the movement over his head before long. I've a notion he would make a good organizer. What are you doing? Are you reading – taking any courses?

Let me hear from you. Regards to Marie.

Chas

Frank –
I can't find your address and it is late so I'm sending this in care of Mother.

Notes

1 Communist Party.
2 Until the end of the 1920s, Benton was resolutely left wing. But after years of observing rural "middle America" he expressed doubts and began describing Marxism as just a dogma.
3 Thomas Nast (1840–1902) was a German-American caricaturist and editorial cartoonist, considered to be the father of American political cartooning. Charles Pollock's political cartoons were influenced by Nast and by Honoré Daumier.
4 Russell Theodore Limbach (1904–71), printmaker.
5 Communist Party (Opposition).
6 The *Daily Worker* was a newspaper published in New York City, beginning in 1924, by the Communist Party U.S.A., a Comintern-affiliated organization.

Thomas Hart Benton (Missouri) to Charles (Washington, D.C.[1])

[November 30, 1935]

Dear Pollock,
I think you can get in touch with Don Brown by writing to Marshall, Texas (General Delivery). Don's folks live there

and Don himself lives just over the line in Shreveport. I have forgotten his Shreveport address so I think it safer to write to the little town.

Talent in this part of the country is almost completely untrained. I have a few promising young people but it will be several years before they develop. Meert[2] is turning out to be a good teacher but I wish I had you as well. In fact I wish I had the whole gang out here.

The supporting background of our institution here (the Art Institute) is completely conservative. The rich are the rich. There is more black Toryism here than I ever dreamed could exist in Missouri. Respectability among the respectable is something beyond words. Yet there are interesting people about and outside of the cultivated and genteel groups a lot of salty characters. I am learning things but am in no position to say anything about this society as a whole.

Physical living here is all that could be desired. Plenty of open space, trees and a lot of farm produce at low figures. The country <u>looks</u> prosperous though we have 70,000 applicants for old age pensions in the State. That figure may not seem big to you but it is appalling for this part of the world.

I'll know more about my State after I have made my tours in search of my mural stuff. I am still on the geometry of the job – trying to design it.

I have absolute liberty in my work. There is a lot of interest in what I am going to do but Lord knows what will finally be thought of my finished work. One of the Senators said to me, "Well Benton, we appropriated the money for you to put up a mural – some other Legislature will have to raise the money to take it down!"

Let me hear from you now and then.

Regards to Elizabeth and any others that I know.

Benton

Notes
[1] Charles went to Washington, D.C., in 1935 to work for the Resettlement Administration (see Glossary).
[2] Joseph Meert (1905–90), American artist, a friend and colleague of Jackson's.

1936

[1936]
May 28

Dear Mother,
We received your letter yesterday. Sorry Sande and I couldn't send something out for the dinner.[1] We were busted at the time. We thought about you and sent a big kiss. I suppose Sande has told you he and I are working with Siqueiros.[2] We made the main May Day float for the CP. It was a grand thing to see 16 feet high and 18 feet long mounted on a Mack truck. Our group is to be the official workshop of the party.

Sande and I want to take a run down and see Chas as soon as we get our car out of storage. I would like to see Arloie come to N.Y. Think it may be possible a little later. After reading about the Black Legion in Michigan[3] there can be no doubt about fascism in America.

Love
Jack

Notes
[1] Stella Pollock was born on May 20, 1875.
[2] Sanford and Jackson worked in Siqueiros' studio preparing a papier-mâché float designed by Siqueiros.
[3] See Glossary.

Sanford (New York) to Stella (California)

New York
June 29, 1936

My dear Mother:

These are hurried, almost hectic days for us here in N.Y. We have been working night and day on Art propaganda for the convention of the Communist Party which came to a beautiful and dramatic close yesterday afternoon at Madison Square Garden. I hope very much that all of you heard the acceptance speech of Browder and Ford. If so, my voice was one of the near thirty thousand you heard acclaiming those two great men.

I was sitting within ten feet of the N.B.C. microphone and should like to have said "Hello Mother."

There is no possible way for me to describe the impressiveness, inspiring beauty, discipline and solid unity of the convention. It was, by far, the most tremendous moment in my life.

We of the Siquieros workshop, made two very profound portraits twelve feet high of Browder and Ford[1] which were unveiled when the two men were nominated. Tumultous applause followed for one solid hour.

So much for the convention.

Starting today, the workshop will make a large float for the League against war and fascism[2] for their anti-Hearst campaign which begins July 4. We are going to make a head twenty-four feet high of Hearst and Hitler as twins sitting on a canon.

This will be placed on a boat and paraded back and forth in front of the millions of people who will be on the beach at Coney Island. The League is commencing a fight to the finish of this fascist bastard.

Rita Benton came through town the other day. She stayed overnight with us and then Jack and Tolegian drove her to Martha's Vineyard where she will spend the summer. She and T.P. are swell and they seem to like Kansas city fine. Tom will work on his murals throughout the summer.

I have managed to save a little money and plan to send for

Arloie. Perhaps you have seen her and she has told you of our plans. We expect to be very happy together and will work hard to get something worthwhile done.

Much love mother and our best to [everyone],
Sanford

Notes

[1] Earl Ford (1891–1973) and James Browder (1893–1957) were candidates for President and Vice-President on the Communist Party ticket in 1936. Ford was the first African-American on a presidential ticket in the twentieth century.

[2] See Glossary.

Arloie (New York) to Stella (California)

July 20, 1936

Dear Mother,

I hope you will forgive me for not getting a letter to you before. My time and mind have been so full, that the two weeks I've been gone seem an eternity and but a day.

I found both Sanford and Jack in excellent health. Jack was at Martha's Vineyard when I arrived so I did not see him until last night. His weekend did him good, I'm sure, he is quite brown.

My trip was most pleasant. Although we passed through exceedingly hot country the train was comfortably cool. The ride from Chicago to New York was more tiresome than the first part of the trip.

I enjoyed my stay at my sister's very much. I wish you might see Billy.[1] He is just about my ideal of a little boy. All of Marietta's[2] children are nice. I particularly liked the oldest girl.

New York is fascinating. I'm sure I shall like being here. So far I've hardly had time to get settled, what with going places and seeing Sande after so long. (He and Jack are gone, at the moment, to a meeting at the workshop – that's why I'm getting a chance to write this!) I think I shall join the Workers School in a few days.

Our apartment is much larger than I had anticipated. It is arranged something like this:

Now I'm sure you know exactly what it's like! Anyway, the rooms are all nice size. The living room exceptionally large, perhaps 20′ by 16′. Of course the whole thing needs paint. We hope to do the kitchen at least before winter. I imagine we will practically live there then, as there is a big coal cook stove with which to supplement the steam heat.

We got our license last Friday. We'd intended to be married on Saturday morning but somehow couldn't make up our minds as to whether to go to the City Clerk or to find a minister. Both seemed cold and uninviting. We shall do one or the other in a few days, however, since we haven't the money to go to Connecticut.

How are you all? Tell Marvin and Alma to write. How are they? Have you heard from the San Francisco branch of the family?

You write soon – we all love to hear from you –

Affectionately,

Arloie

Notes

[1] Arloie's nephew.
[2] Arloie's sister.

July 27, 1936

Dear Mother:
Saturday at noon you legally came by your fourth daughter.

We were married by the City Clerk, with Jack as witness, because we had neither time nor money to get out of town. The ceremony was brief and simple, which was as we wished and now, with that settled, we are ready to begin seriously living as full a life as we are capable of.

And what an interesting place for living this can be!

The place is so large as to make familiarity of the whole impossible. In my case, of course, I have only first impressions of exteriors. One of the most distinct of which is the material evidence of extreme wealth and miserable poverty.

We have taken several rides about Manhattan in the Ford and on buses. One evening we rode out Riverside Drive atop a bus. On the right rose pretentious apartments, some flush with the sidewalks, tall and austere, others were set back behind mounds of grass and curving drives, a further mark of distinction. On the left lay the river bordered by a sidewalk and balustrade; there were the people. We got off the bus a mile or so beyond Grant's Tomb and began to walk back. Women with babies or dogs; men in small clusters smoking, talking; young lovers walking and girls giggling in pairs, with groups of half-bold youths to be passed . . . The whole impressed one of small-townishness. The same scene to be found in any town park on a warm summer evening.

Yesterday we drove along the waterfront. Longshoremen crouched in black doorways waiting for an hour's work. Tramps washing socks on deserted piers, one holding a red bandana by two corners, flag-wise, to dry. We walked out on a condemned dock and sat at its rickety end to watch the river and the boats. We were not alone. Half a dozen boys and men lounged about in bathing suits. We watched them dive into the river and swim out to ride the swells made by a passing tug. (Grand sport if one did not know the water to be polluted!)

Later we passed through the lower East Side. Humanity

was represented in the streets at every age. There were babies in buggies and old women squatting on boxes. Again the feeling of the community. I was struck by the number of potted plants festooning the fire-escapes up and down those canyons of red brick. It is their one chance for a bit of living green, I suppose. I noticed the same thing in Harlem.

At dusk last night Sande and I rode down to the Battery. I shall never forget the sensation of being so utterly alone. There was not a car. Only dim lights glowed at the intersections of the narrow, one-way streets. No people were about save an occasional night-watchman seated on the sidewalk in the light from a doorway. We turned down the alley that is Wall Street. It was dark there and stifling. I looked up and there at the end, silhouetted against the pale sky was a steeple. We drove on, turned a corner, and saw a churchyard, its gravestones grotesque in the half-light.

Both Sande and Jack are well. At the moment Sande is away working, Jack is in the living room playing the harmonica. He, being on an easel project, works here, which makes it pleasant for me. (I haven't heard how he likes a woman underfoot all day.)

Tell Mart and Alma to write and give them our regards. I have so many letters to write, I get scared thinking about them. (I haven't written to anyone except you and my folks.)

Are you well? I hope so. Do let us hear from you often. We would all like to give you a big squeeze.

Love,
 Arloie

Dearest Mother:
Arloie has been with me for two weeks and needless to say we are extremely happy. Everything is working out perfectly and we are certain we will get along swell. As she has told you we were married at City Hall last Saturday morning. The ceremony was simple and merely a matter of form to satisfy the babbits so prevalent in our society.

We are all anxiously watching the progress of the heroic Spanish Workers in their battle with the fascists. There is to be a huge demonstration here this afternoon in support of the Peoples Front. Siqueiros is of course very excited and would

like to leave for Spain immediately but work here keeps him.

Had a note from Chas. We expect him in N.Y. this weekend.

Jack keeps well and is working steadily. I have gotten transfered to a job more to my liking so am quite contented on that score.

We should like to hear from all of you.

Sincerely and with love

Sande

Elizabeth (Washington, D.C.) to Stella (California)

Washington
August 27, 1936

Dear Mrs. Pollock,

I just received the letter you wrote and am going to send it to Charles, who is now in New York working on a job. The reason he has been so shamefully delinquent in writing you – and I really don't think it is a legitimate excuse – is that he's been working every free minute he has had in an effort to make contact with the Committee for Industrial Organization[1] and that meant drawing innumerable designs to submit to them. He has been trying to put over a poster campaign and has made considerable headway in interesting them. Then, he was fortunate enough to meet one of the big union shots in the new American Labor Party,[2] formed for New York State, which is fighting Landon[3] and running Roosevelt. As it happens the man he met is not only a big trade union official, but one of the CIO (industrial organization) heads and also leading the new Labor Party. This chap liked C's work and wired C to come to New York at once and design a set of posters for the new Labor Party.

Charles immediately applied for his vacation leave and left on Monday for New York City, where he very likely will be the next month. He is staying with the boys and Arloie. I am sure he'll write you himself about what he is doing.

I did not go over with him because I'm working very hard on a new play and want to finish it. Being alone will mean I can concentrate all my time on my work. We'll probably get a weekend together as N.Y. is only four hours away by train.

I liked Arloie tremendously when I met her. She is a grand and sensible person and Sande is very lucky to have such a splendid wife. She speaks of you constantly and most affectionately, as if she felt you were her own mother. She is such a swell cook that I don't think I'll ever be able to please Charles again after he's eaten her meals for a while.

Yes, we do know some Coles out in Calif. In fact, Lester Cole, a writer for the movies, is an old friend of mine. We only met his wife when he came east a couple of years ago and bought some of C's stuff.

We've had some bad hot weather here but it's been rainy for a couple of days and I'm very grateful.

Our plans are extremely uncertain. We don't know whether the election will end C's job or not. And everything depends on that. Right now we are sub-letting an apartment from a man who works in C's place. He and his wife have taken a summer country house.

We have one large bed-living room, a nice kitchen with refrigeration. We share the bath with two working girls who have the other large room. It is really very private for the other room lies across a large hall and we rarely see the girls. The bath is off the hall, between our separate rooms. We are getting it really cheap for this town, where everything is hair-raisingly high. We pay $40 a month. By your Calif. prices that's high, I suppose.

The boys looked well and seemed very happy when we saw them. You should see what excellent housekeepers they are. Jack is an A-1 housekeeper, very neat. Jack's work is improving amazingly; he is going to be a magnificent painter one of these days. It, the work, is entirely different from C's in style. Jack's is much more imaginative and unrealistic and I like this about it.

I must get down to my own work now. I hope you will hear from the boys soon. I want you to know that I've stopped hounding them about neglecting to write you. I made myself a pest for a while and don't think it got any results. Perhaps

men just don't think of these things the way we do. They are devoted to you and speak of you constantly, but letter writing is something entirely too burdensome for them. I think you should bawl them out right good once – it would wake them up. They have an idea – I've heard them say so – that you don't mind that they rarely write. You might jolt them out of this notion

Kindest regards to everyone and our love to you,
Elizabeth

Notes

[1] See Glossary.
[2] See Glossary.
[3] Alfred Mossman "Alf" Landon (1887–1987) was a politician, member of the Republican Party, Governor of Kansas from 1933 to 1937 and candidate for President in 1936 against Franklin Delano Roosevelt.

Sanford (New York) to Stella (California)

New York
August 31, 1936

Dear Mother,
Jack and I returned yesterday from a week spent at Martha's Vineyard with Rita Benton. The Island is beautiful and it was a real pleasure to do nothing but swim, lay in the sun and eat like a horse. Tom has been working on his mural in Missouri all summer. This week he is coming east for a short vacation. Rita plans to meet him here in N.Y. I think Tolegian is returning also. I rather imagine we will have an old-fashioned get-together.

Arloie is gradually adjusting herself to her new environment and I believe she will be happy with me. This week she has taken a job on trial with a rental agency. She has to do a great deal of walking and is pretty well tuckered out by nightfall. Her cooking wasn't worth a damn the first two weeks but both Jack and I believe we can detect a slight improvement and we feel that given ample time it will become tolerable.

Charles is here with us supposedly taking his vacation. In reality he is working to beat hell on some political posters for the Labor Non-Partisan League[1] which is a labor organization backing Roosevelt. It is a good opening for Charles which may lead to Farmer Labor Party work.

He is somewhat disappointed with his Washington job due to the insurmountable maze of red tape involved in getting anything worthwhile done. If this work in N.Y. shapes up well he will probably quit in Washington.

Well there is a twinge of fall in the air these mornings. It wont be long until we dig in for another winter. Jack and I feel rather sure of our jobs so we will have our sowbelly and beans right regularly. (Unless, of course, Hearst's echo Landon gets in . . .[2] which might not be so bad either, for then we could start the shooting.) I can't see that he has a chance so we are not really very frightened. How do people there feel about the political set-up?

I am overdue on the job so will have to quit.

Our best to everyone and much love to you, Mother.

Sande

Notes

[1] See Glossary.
[2] William Randolph Hearst backed Alf Landon in the 1936 presidential election.

Charles (New York) to Stella (California)

New York City
September 1, 1936

Dear Mother:
Elizabeth has sent me your last letter and we were all glad to hear from you and know that you are well. Elizabeth said she had written so you must know that I came down here in order to make some Trade Union posters. I have been trying for some time now to interest the C.I.O. in the idea; and though one must fight to break down preconceptions and

95

prejudice I hope eventually to succeed with them. I wasn't able to make anything that would satisfy the people here so my time has been largely lost.

I expect Elizabeth to come down for the weekend and we return to Washington after labor day.

Jack and Sande spent four days at Martha's Vineyard with Mrs Benton. The trip did them good – both of them could stand more sun and fresh air.

Arloie looks very well and seems quite happy. She made a decided hit with Elizabeth. Elizabeth particularly liked her intelligent understanding. Arloie will surely be a great help to Sande.

We are glad to hear what Mart is doing. I wonder if I don't owe him a letter? I am particularly glad to hear of his organizational activity, but I wonder if he is still as sold on the Party Line as he was. I talk with a lot of Party people here and they seem to be hopelessly confused.

Are Frank and Marie active? Send us their letters – we like to hear what they are doing.

We all send our love –
Charles

Sanford (New York) to Stella (California)

[September 27, 1936]

Dear Mother;
Just a note additional as evidence that I am still on my feet and going strong. Loie has covered the household news rather completely I feel, so there is no need to go into that. I don't believe she mentioned though that the entire Benton family were here with us for a few days a week or so ago. We had a party for them one night. There were about forty people (notables and otherwise) in our apartment. We played the harmonicas and had a rollicking good time in general. It was good to see Tom again and to hear his Missouri anecdotes. He is working awfully hard on his mural . . . Expects to be done with it by Christmas.

Charles is still on the job in Washington. A gallery owner came here to see his work, so he may have a show this fall.

Jack and I are still on the job and feel relatively secure until the elections. Should Landon get in it is pretty damn certain there will be retrenchment and millions of us will be economically cooked. In which event there will be plenty of hell to pay.

I am anxious for Roosevelt to get his campaign underway so that we can see what he will be able to do to these Hearst scoundrels.

Well Mother the wee hours are slipping up on me so with your indulgence I will call it quits.

Much love to you Mother and our best to everyone.

Sanford

Charles (Maryland) to Stella (California)

Potomac, Maryland
October 2, 1936

Dear Mother,

Are you surprised at the new address?

We have just moved out in the country, 14 miles from Washington. The housing problem is fearful in Washington and we were lucky to find this place. It was quite by accident too. The man who owns the place, a small farmer, is working with some CCC camp[1] and wanted to have his family near him on the job. We happened along looking for a place just as he was ready to rent. – The house is good size, has a hot-air furnace, electric stove and frigidaire. We have some chickens, a garden and a garage. The garden of course won't last much longer for frost will surely be along soon.

Elizabeth is having the time of her life. She has always preferred living in the country and last year at Brookwood[2] spoiled her for good.

Just as we are getting settled here I have to leave town. I am leaving today or tomorrow for Reedsville, one of the

Resettlement Communities in West Virginia, and from there go to Tennessee for two or three weeks. I expect to enjoy the trip but I hate to leave Elizabeth here alone. It will be inconvenient for her to get supplies but otherwise she doesn't seem to mind very much. She is working hard on a play. I will try and get one of our friends to stay out here while I am away.

We can't tell anything at all about the job – it may last and it may not.

Would you believe it – I have bought me a second hand 5 string banjo and I am set on learning how to play it.

I expect to find some good players in Tennessee who can show me something about it.

I haven't heard from Jack or Sande since I left N.Y. The posters I was working on there for the American Labor Party didn't go over although I got paid for one of the designs.

We are anxious to hear how you are. Hope you are well as always. And how about Mart and Alma and Frank and Marie? Please write when you can. Are you going to be comfortable this winter?

 Love,
 Charles
Mail address
R#1, Rockville Maryland

Notes

[1] Civilian Conservation Corps (see Glossary).
[2] Elizabeth had spent part of the year teaching at Brookwood Labor College (see Glossary).

Sanford (Pennsylvania) to Stella (California)

[October 8, 1936]

Dear Mother:
It is true as our news reporter has told you, we are camped in the fertile rolling hills of Pennsylvania nigh on to the banks of the Delaware. The country hereabouts seems an endless

succession of Autumal colored hills and valleys interlaced with immaculate Dutch farms. The farmers are reaping buckwheat, husking corn, butchering pigs and sowing winter wheat. There is a general feeling of hustling to get crops in and bins full of spuds and apples before winter sets in. The whole feeling is one of richness and simple security and it is not difficult to understand that these wholesome people don't give a damn who's in the White House or what the situation is on the Manchurian Border. For them such things are abstractions.

It is, of course, a grand revitalizing experience for us to get out of New York. Jack will have to go in to the city but once a week and Loie and I expect to spend four day weekends here so it will work out swell.

We were sorry to hear that you may have to move, Mother. Is it definite? And do you have any plans? Let us know what comes of it.

Well Roosevelt has finally gotten his campaign underway. He is proving to be a pretty shrewd son-of-a-gun in letting Landon defeat himself with his blatherings but we noticed that he wasn't jailed for vagrancy at Syracuse. Being a Communist it would seem the Republicans would have taken care of that. Without having any illusions about the man we hope nevertheless he is re-elected. And by nineteen forty the Farmer Labor Party will have come to maturity and will be strong and beautiful.

Jack and I took a trip over to Bethlehem the Steel Town, yesterday. On the street corners and in the saloons we could sense a strong undercurrent among the steel workers and a feeling that there is going to be hell to pay soon. We saw the meeting halls of the C.I.O. and the Workers Alliance.[1] The Party is doing excellent work in these mining and mill towns.

Incidentally every Landon billboard we saw was very handsomely splattered with red mud.

According to what I've read things are getting pretty hot on the West Coast. We hear a good deal about Bridges.[2] He seems to be the John L. Lewis[3] of the West. I think we can expect a lot from the two men in the next few years. Particularly in relation to the Labor Party.

I reckon this will have to do. Got to get out and chop some wood.

Much Love to the all of you.

Sanford

Notes

[1] See Glossary.
[2] Harry Bridges (1901–90), Australian-American union leader in the Longshoremen's union.
[3] John L. Lewis (1890–1969), American leader of organized labor who served as President of the United Mine Workers from 1920–60.

Arloie (New Jersey) to Stella (California)

October 8, 1936

Dear Mother,

Here we are in the middle of a rainy morning, surrounded by woods and fall fields!

Jack found this old farm several weeks ago. It is only two hours from New York (which makes it ideal for our purpose), but it is honest country. There are apple and pear trees in the door-yard, and beyond the fields, in most any direction, are patches of wood-lots, multi-colored at this season.

The house itself is very old, and built of stone with walls (Sande's idea) 2 feet deep. There are three rooms. A good-sized living room with recessed windows and a low ceiling, and a kitchen, (beyond a tiny door and down two steps) make up the ground floor. Upstairs there is a bedroom.

If there is no privy on the place, and we draw our water with a bucket, we do not mind because there is clean air to breathe and good earth to walk on. And important to us is the fact that the rental is five dollars per month!

We were glad to get your letter last week, and thanks for enclosing Frank's note. We haven't heard from them directly – but then we haven't written, either. It is good to know you are all well. I hope you don't have to move. Have you found out whether the people intend to buy?

100

The news of Don [Brown]'s marriage was rather a surprise. We send him our congratulations and good wishes.

The boys had a letter from Phil [Guston]. He expects to arrive in New York the middle of this month. We shall be glad to see him. Did he see you before leaving?

My job ended the first. It didn't pan out so well financially, but I made enough to buy a couple pairs of good shoes.

The boys are busy painting and shooing flies. I just paused to ask if they had any special message for you. Sande said, "Tell her we love her" – which I guess is about the most direct way of expressing their feelings.

We are all well. Being in the country is doing both Jack and Sande a tremendous amount of good, both mentally and physically. Jack plans to stay up here as long as he is able to get in and out. Sande and I hope to come out as many week-ends as possible. This week Sande was able to get away, so we are staying five or six days.

We had a card from Elizabeth just before we left town. She and Charles are settled in the country near Washington. I'm glad they found a place, because they both seemed tired of the city when we saw them this summer. They have invited us to see them, but it is doubtful now whether we will be able to make it.

Give our regards to Mart and Alma, and write soon.

Love from the three of us,
 Arloie

Sanford (New York) to Charles (Maryland)

Manhattan
October 29, 1936

Dear Charles,
In the first place I feel I owe you an apology for being such a stinker in not writing you months ago.

I approached Barron in your behalf shortly after receiving your letter. He remembered you and said he was interested but that for the next full month he would be so busy as to

make an appointment impossible and that either one of us should write or phone him a month hence. A thing I haven't done but will do, upon hearing from you whether or not you should send a few more paintings up. As you know Elizabeth took several back with her, leaving but seven here which I feel you would want Barron to see.

As for the varnish ... I have made it up and can either send it to you or shall we wait until you come up or we go down?

We too, have had a letter from Mother to the effect that she will have to move and we have been rather upset as to what to do. I wrote her just before receiving your letter and sent her fifteen dollars. I told her I felt it unwise for her to go to Oregon (she has some romantic notion about going there) and that we would get our heads together to find a solution to the problem.

I will give you an idea of the situation here so that you can do your own weighing.

As you know Jack has taken a place in the country. He has a swell little farmhouse near Frenchtown, sixty miles from N.Y. His rent is but five dollars a month ... however, until Loie and I can find some better arrangement, he has to help with the rent here and of course running two kitchens is a bit more expensive.

Jack had the misfortune of colliding with some bastard and as a result the old Ford has been permanently lain to rest. The other man's car was damaged to the extent of eighty bucks which it appears Jack will have to pay.

So it doesn't seem we can expect much financial aid from him.

Incidentally, no one was hurt.

Now as to what is going to happen on the Projects[1] ... who can tell. They have commenced a re-investigation of every Project worker. I know of some cases where workers unable to meet the rigid requirements, have been fired. The Artists Union[2] is fighting it but how far we will get is unknown.

It seems reasonable to believe that after elections, Roosevelt is certain to retrench in favor of the reactionaries.

But it seems to me that it is the same old question of inse-

curity and it will not really matter whether Mother is here or in the West, we will have to find some way to assist her. So I feel Chas, that, unless she feels your suggestion in relation to Mart is a better one, we should arrange for her to come.

Now as for how much practical help we can be. We have just sent her fifteen. I think that through some means or another we can in the next three weeks raise thirty dollars.

Loie tells me that she came to Chicago on the Union Pacific's Challenger[3] ... they have a separate coach for women ... the train is air conditioned and Loie is certain she would be perfectly comfortable. The meals are good and only a dollar a day where if she took a Pullman the meals would be three dollars and of course the extra expense of the Pullman. From Chicago she could take a Pullman for the one night and the total would probably be no more than sixty-five dollars.

However these things are relatively simple.

We will leave the decision up to you and Elizabeth. If you decide we should send for her, it will be fine with us and we will help with every dollar we can rake up.

Incidentally we have heard indirectly that Rodell's lease on this building is up in December. Do you know any thing about it Elizabeth? And do you think we have any business in asking him.

Let us hear what you write Mother, and instruct us as to how much and when we should have the money.

Sincerely,
 Sanford

Give our best to Steff[4] and tell the rascal that he might favor us with a letter.

Notes

[1] Works Progress Administration/Federal Art Project (see Glossary).
[2] See Glossary.
[3] The Union Pacific Company at one time owned 105 locomotives. Built between 1936 and 1943, the *Challengers* were nearly 122 feet long and weighed over 1 million pounds.
[4] Bernard Joseph Steffen (1907–80), American printmaker. He studied with Thomas Hart Benton at the Art Students League.

[Recto, Sanford]

New York
November 7, 1936

My Dear Mother,
We feel ashamed of ourselves for not having written to you
weeks ago. And too we are sorry we are late in sending your
money order. No doubt you have read in the papers of the
Administration's attempt to dump WPA workers in the river.
Well New York workers have their own ideas about the
matter and are, to quote the *N.Y. Times* "making it embar-
rassing for the Government." The Artists have made headline
news by staging a sit-down strike and being forcibly evicted
and clubbed by the police.[1] Congressman Marcantonio[2] is
defending us in court and is making jackasses of our enemies.
There is planned and will be a continual succession of strikes
and demonstrations the size of which N.Y. has never seen
until the order for firing is rescinded. We feel confident that
N.Y. workers will rise as one man to defeat Roosevelt's
bowing to the wishes of the reactionaries.

Well Thanksgiving has passed and Christmas is on the
immediate horizon. The Bentons were up to their usual gen-
erosity by sending us a handsome Missouri turkey. We had
friends in who with our aid devoured the bird and trimmings
with great dispatch. We had asked Charles and Elizabeth
down but they were unable to come.

Mother we haven't had a letter from you in a good many
weeks. I suppose you have moved by now. Will your new
place be comfortable? Is Marvin working and how about
Frank what is he doing?

Due to investigations we have had to divide the apartment
into three parts. Jack lives in the front section, Loie and I in
the kitchen and bedroom with Phil stuck off in a dinky room
at the end of the hall. Officially, we have no truck with one
another. It seems rather silly but one has to do all kinds of
stupid things to appease the whims of petty politicians on the
Project.

Phil hasn't found work yet. He is trying to get on the

Project but so far has failed. They like his work but due to curtailments are unwilling to place him.

So far we have had a very pleasant winter with no snow to speak of and very few cold days.

Our landlord has put a new radiator in the apartment so we will be very comfortable. Loie seems to have adjusted herself to our weather and with a few more much needed clothes she will get along fine.

This will have to do for this time Mother. Hereafter we will try to do better. Loie sends her love and says she will write soon.

With much love,
 Sande

[Verso, Jackson]
Dear Mother,

I'm going to write soon. – We're getting along so-so. Have given up the place in the country for the time being. Plan to get out the first of spring if we can't get west. I'm seriously considering of going to Colorado for a place to live and paint in the very near future – am terribly tired of N.Y.C. Hope you have gotten moved to your new house.

Do you still plan coming to town this winter – ? Hope we can manage for you to come the rest of the way East –

Love,
 Jack

Notes

[1] On December 1, 1936, 219 artists occupied the downtown administrative offices of the Federal Art Project to protest against massive work dismissal orders. When they refused to leave until the work dismissal orders that had been issued were rescinded, New York City riot police were called to clear the premises. The artists locked arms with each other and refused to leave. The police attacked with billy clubs. It became a total disaster. At the downtown police station, surrounded by news reporters and photographers, booking went on endlessly because they identified themselves as famous artists and police clerks were having trouble writing names like Fra Philippo Lippi. One Chinese artist insisted that his name was Moishe Himmelfarb. There were not enough cells so they were held in a large waiting room until the arrival of the Artists Union lawyer. The trial lasted over a week; to keep alert most of the artists brought their sketchbooks and drew steadily. At the end of the trial the judge asked to see the sketchbooks and made a long speech before delivering his verdict. The Mayor had the lay-offs annulled.

[2] Vito Marcantonio (1902–54) was a radical left-wing activist and Congressman. Originally a member of the Republican Party, he later joined the American Labor Party.

Charles and Elizabeth (Maryland) to Stella (California)

Rockville, Maryland
November 11, 1936

Dear Mother,
Well, what a relief – the election is over and we can now have some idea of where we are for the next four years. Certainly there is much that we can't see, but the main outlines are clear. It has been a great victory for Roosevelt and his policies[1] and surely signals a significant point in our history.

When you delayed answering our last letter we thought perhaps you were waiting to see how the election went before making up your mind to come east and stay with us awhile. And when it went as it did we thought surely you would say you would come.

Maybe it is wise to wait a little. Washington is full of rumors about what is impending for Resettlement. Nobody seems to know anything for certain and it may be a month or two yet before anything is done, but we are just as likely to get cut out as not. If this happens we would be strapped for sure, though I expect something would turn up. Elizabeth has just finished her play, which she hopes will make something.

Anyway I think you should get your clothes in shape and go ahead with plans to visit your mother as you suggest. What do you need in the way of extra things? Will you let us know?

I haven't seen Jack since he moved into the country, but I don't think you need to worry about him there. I expect it is a good thing for him. He was growing awfully stale in the city and I think it had begun to worry him. Certainly the country ought to be good for his health though he might not be getting the best of attention in the way of food. I don't know how he gets around, and back and forth to the city. It's too bad he smashed up the car.

I'm working hard, but wasting myself on a great deal of piffle.

We are awfully happy with our place. The country is very beautiful just now – much more interesting in general than farther east – last night we had the first heavy frost.

Say hello to Mart and Alma and tell Mart to write. I'd like to hear about what he is doing. Also say hello to Frank and Marie. Haven't any of the Pollocks a thing to complain of or report?

Love,
Charles

Dear Mrs. Pollock,
I've just censored this and want to add that you are not to worry about Jack for it's the best thing he could do, going to the country and as he draws his regular check just the same, I'm sure Charles is wrong about his not having good food. Jack has become a fine cook and there's no reason he's not eating well. He had grown to hate New York, as I have, and he's not alone where he is from what I gather – seems there is some other chap there, also. We think you'll enjoy going to Iowa and you must let us know about the ticket, etc., so everything will run smoothly.

Elizabeth

Note

1 The United States presidential election of 1936 took place when President Roosevelt had started putting into operation his New Deal policies to help the country out of the Depression. Roosevelt, running against the moderate Republican Alf Landon, won 60.8 percent of the popular vote, taking all but two States (Maine and Vermont), thus winning one of the greatest landslides in American history.

Charles (Maryland) to Stella (California)

Rockville, Maryland
November 30, 1936

Dear Mother,
Well here it is past Thanksgiving already and it will be Christmas before we can turn around. I hope you didn't have

107

Thanksgiving dinner alone. Were Mart and Alma with you? Elizabeth and I had dinner alone and I painted most of the day. In the evening we went to a movie. We had expected guests, but they were unable to be here. The boys asked us to come over. Steff went and remained over the weekend. He reports that they had a fine turkey, supplied by Mrs. Benton, and lots of good food. We were sorry not to be with them.

Jack, Sande and Arloie all seem to be well though I guess they are a little worried because of the cuts which are being made all down the line in the WPA projects.

Elizabeth has finished the play that she has been working on and has sent it off to her agent. It is the best thing she has done yet and I hope she finds a producer. If she gets a sympathetic production I am sure it will be a success.

I have been very busy, but not with anything that I care much about. I find that I have almost stopped painting. There is some hope that I will get a mural job in one of the Projects, but I can hardly find time to work on the designs. Have I sent you any of the music sheets[1] we are publishing? This is something that I am really interested in and I think we are doing something effective. As soon as the next group come from the printer I will send you the series. Seeger and myself are thinking of the possibility of finding a commercial publisher for a similar series when things blow up here. I am not expecting anything to happen soon and, in fact, I rather think that we may last until the end of the fiscal year, that is July 1937.

I wish you would tell us, in your next letter, what your plans are for visiting your mother. Wouldn't you like to be with her at Christmas time? Are the arrangements about renting your house still good? The time will pass before you know it and it is just as well to make plans now.

Well Mother I have been in a conference all day and it has worn me out so I must get to bed.

For the first time in years I am actually putting on a little weight. I have gained four or five pounds in the last month or so. I don't really know how to account for it.

Write soon.

Love,
 Charles

Note

[1] Charles Seeger (1886–1979) was an American musicologist, composer, and teacher. From 1935 to 1937 he was head of the Special Skills Division of the Resettlement Administration, where he was asked to train and place professional musicians in communities of displaced and homeless people who had been re-settled in government-run homesteads throughout the South. Seeger was recommended for the job by Charles Pollock who was a casual acquaintance he had met through Thomas Hart Benton. When Seeger began the project of reviving and printing folk songs, he asked Charles Pollock to design the song sheets.

Charles (Maryland) to Frank (California)

Rockville, Maryland
December 28, 1936

Dear Frank,

I guess you think I am a hell of a guy for not sending any sort of Christmas message. I have been trying to get a letter and a print off to you and Marie for ten days, but I have been rushed trying to finish a new set of song sheets for the Division and trying to finish a new lithograph for a New York show. I sent off the print and a collection of the song sheets today.

These song sheets are about all that I have done that I get any satisfaction out of. I am working with Seeger on them. If the job blows up we would like to try publishing a series of the same sort, but with more workers' songs if they can be found. I have an idea that the right songs presented in this way would go over big with workers. Of course neither of us have any business sense or organizing ability and we may not be able to swing what we have in mind.

Everybody is in the dark as to what is going to happen to our Division. Resettlement is going into Agriculture it seems clear and we may or may not go along. And if we do go with Agriculture conditions of work may be so much less favorable that it will be impossible to remain.

Agriculture is an old-line organization and a very conservative outfit. I can't see that they will have much use for most of the stuff we do or that they will give us much leeway.

I have managed to make a few lithographs and have several out in shows. Have you seen the Artists Congress show or the book?[1]

Christmas was about as usual here. The weather was exceptional – very warm and mild and remains so. We had a very nice dinner and I worked part of the day.

How are you and Marie? What are you doing? Are you with WPA or the State organization? What is the situation in San Francisco. What are the effects of the strike on the city?

We both send our love and wish you both a happy New Year. And how about writing occasionally?

Chas

Note

[1] *America Today: A Book of 100 Prints* is an anthology of socially conscious prints by American artists chosen by the American Artists' Congress and intended for simultaneous exhibition in 30 American cities in 1936.

1937

Sanford (New York) to Charles (Washington, D.C.)

New York
January 22, 1937

Dear Chas,

We are very glad and excited that Mother is going to come east. I am sure it will be a thrilling experience for her and will certainly be pleasant for all of us.

I have written Frank and forwarded your letter. I told him that Jack and I would raise thirty dollars by the first. I feel as you do that even though one hundred is not a great deal of money, she can get by comfortably on it. Arloie came on the Challenger and she said it cost her no more than a dollar and a half a day for three good meals and tips.

Do you think that providing Frank can make it for twenty or twenty-five, our thirty will be enough? If not let us know and we will try to do better.

Jack and I are in a group show at the Municipal Art Gallery beginning Monday. Should we be fortunate to sell we will of course send her more.

There is nothing of much interest going on here. It seems that we can be pretty certain of our jobs until June. Had a hell of a big demonstration a few weeks ago of all WPA workers.

111

The Artists Union made about thirty floats many of which were very effective.

Siqueiros left this morning for Madrid. He has been appointed Chief of the Graphic division of the Bureau of Propaganda.

What do you think of the Moscow trials?[1] It's an enigma to me as to what in hell it's all about. What does Lovestone attribute it to?

Had a letter from Steff a few days ago ordering twelve harmonicas. He spoke very enthusiastically of the community and the people down there.

Incidentally when Steff was here we became acquainted with Rebecca Tarwater.[2] We think a lot of her and enjoy her singing and banjoing a good deal. She has been in for dinner a few times.

How are you doing with your banjo Chas? Have you driven Elizabeth to the streets with the damn thing yet?

After hearing her play wouldn't be surprised if I get me one.

Give us a letter and let us know if you think thirty dollars will do and when we should send it.

I realize that it is damn little and we feel ashamed of ourselves for not being able to do better.

Write soon,
Sande

Notes

[1] The Moscow Trials were a series of three trials of political opponents of Joseph Stalin. The first trial was held in August 1936, at which the defendants were all sentenced to death and executed. The second trial, in January 1937, involved 17 lesser figures of which 13 were eventually shot and the rest received sentences in labor camps.

[2] Rebecca (Becky) Tarwater (1908–2001), folk singer known especially for her interpretation of the song "Barbara Allen."

Sanford (New York) to Charles (Maryland)

New York
January 30 [1937]

Dear Chas,

I have found one of the prints you want and will hold it for your instructions. I hope something good comes of it.

I am glad you are working on designs for a mural. What kind of walls do you have and of what size? Let's hope it goes through for I feel that the problems involved in tackling a wall will be excellent experience. In what medium will it be done? Have you learned anything about fresco from that Swede down there? Phil Goldstein [Guston] is still with us. He has done a few fresco panels which were excellent. He has gotten on TRAP[1] and is waiting to be assigned to a wall.

Lehman's job[2] is in the nasty stage of being before the stinking Art Comm. We have had an advance assurance that it will be passed so we hope to get started soon. I am in hopes of getting a vast amount of fresco experience out of it.

Irrespective of what the press has to say it seems to me the flood is raging on. It is pretty obvious that a hell of a lot of things are being hushed up by the papers. We probably will never know the full extent of damage done and the number of lives lost. It is a decided understatement to say the Government's hands are bloody. They are guilty of mass murder.

Here in N.Y. we are enjoying weather which one would ordinarily expect in May. This is actually a spring day with the thermometer registering around sixty-five.

We sent Mother the money the first part of the week and have been anxiously waiting word from her as to when she will leave. I don't imagine we can expect to see her much before another month. All of us are tickled as hell at her coming and are certain she will enjoy it immensely.

Jack has a car out in Penn, which we hope to get going within the month so that we can get down there.

I am enclosing the formula you asked about.

Sincerely,
S.

Notes

[1] Treasury Relief Art Project (see Glossary).
[2] Harold Lehman was working on *Man's Daily Bread*, a massive (20' × 70') mural for the cafeteria of Riker's Island Penitentiary in New York.

Frank (California) to Charles (Michigan)

[1937]

Dear Charles,

Just better than two weeks ago I got Sande's letter, including the one you had written to Jack. Toward the latter part of that week I sent Mother $25 in accordance with your wish. This was only $15 in addition to the $10 then due her, which amount I send twice each month. It was a meager amount, but the best I could do. Had I known sooner, I could have sent a more substantial amount. From the outset, when first I learned that you had invited her east, I wondered how you proposed financing the trip. I reasoned that a onetime threadbare artist (still the artist I hope) may well feel in affluence with his boondoggling stipend.

In any case I'm pleased at your considerance of Mother. Marie and I saw her at Christmas time. She seemed well, and though she was uncertain about her trip, I know she was eagerly looking forward toward the journey, and the visit with all of you.

The most important news here on the coast is the settlement of the maritime strike.[1] After one hundred days surcease, the embarcadero is alive with activity. The holds of ships are gulping up their stagnating cargoes, and in turn are being gorged with still other cargoes for the Eastern world. The ship owners appear happy and Diana Dollar[2] can have her belated honeymoon.

It's been a costly strike. It is estimated the shipping interests lost billions of dollars in business; much of it difficult to regain, some probably lost forever. This is particularly true of coast-wise shipping. The railroads cut heavily into their contracts. One wonders what boobs these ship owners are,

Dear Chas — Tell Elizabeth the suit is a pretty good fit — and thanks. I haven't much to say about my work and things — only that I have been going thru violent changes the past couple of years. God knows what will come out of it all — its pretty negative stuff so far. I'm glad you are back in the painting game again and wish you luck on the Social Security job — I haven't been up to any of those competitions. Will try when my work clears up a little more. Phil Guston and his wife have been winning some of the smaller jobs. I'm still trying to get back on the project and it doesn't look any too damned good. At best it will be another four or five weeks, and then it may be the army instead.

Jack

That child of yours is really a beaut.

Letter from Jackson Pollock to Charles Pollock. c. 1940
Reproduction courtesy of the Pierpont Morgan Library, New York

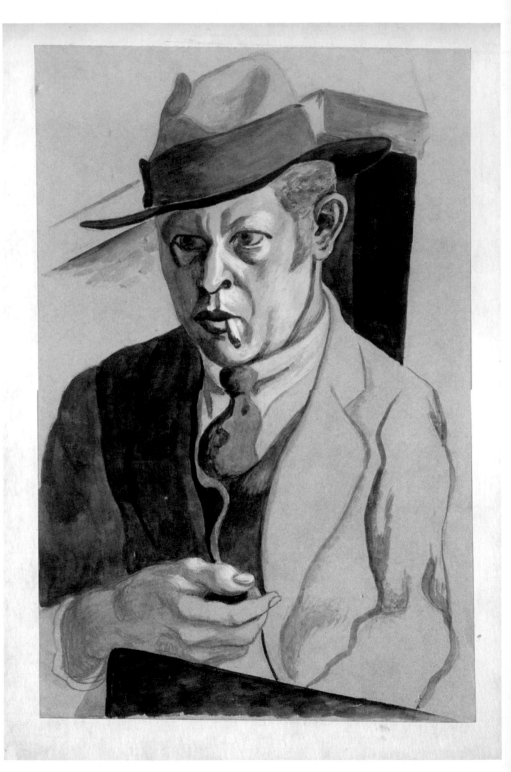

Self portrait. Private collection, 1930

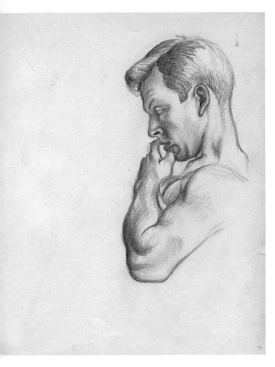

Marvin Jay.
Sketchbook, 1929–1930

Mother. Sketchbook, 1929–1930

Father. Sketchbook, 1929–1930

Menemsha.
[Martha's Vineyard],
1930

Three workers. 1930

Sluice mining. Pennsylvania or
West Virginia, 1934

Mining scene 2. 1934

Chicago 1. Private
collection, 1933

Chicago 2. 1933

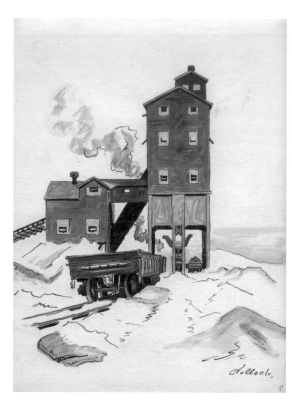

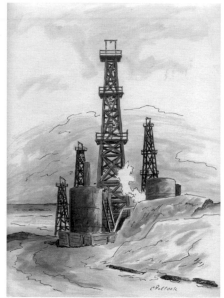

Oil wells, Oklahoma.
Private collection, 1934

Mine shaft. Pennsylvania
or West Virginia, 1934

Workers. 1934

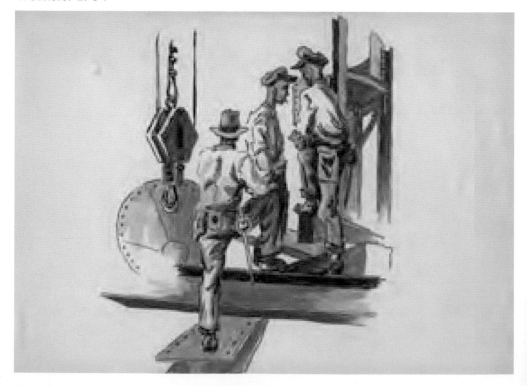

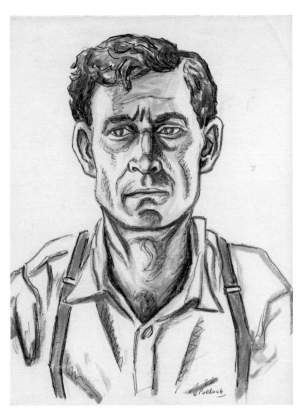

Portrait 1.
[Chicago World's Fair],
1933

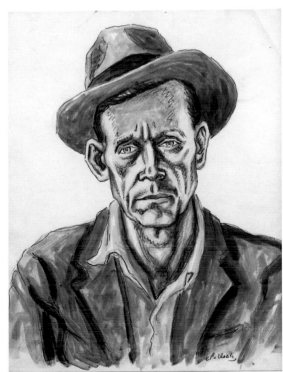

Portrait 2.
[Chicago World's Fair],
1933

Song sheet.
[Resettlement Administration],
1936

Political cartoon.
[United Automobile Workers'
Journal], 1938

not to be able to foresee that these losses mount higher than the cost of a negotiable settlement before the strike begins. Of course they were bent on breaking the unions and the unity of the workers, but there again they proved blind to these ever-changing times. They misjudged the astuteness of the rank and file leadership.

Frankly, I believed the strike would be of short duration, because I knew the maritime unions had grown in numerical strength and unity since 1934. Further, I had no notion that the shipping interests could withstand such losses as this strike entailed. True some of the smaller shippers are choked out by the slow process of strangulation. But in large part my opinion proved lacking in certain basic facts; namely, that the ship owners, too, had learned through experience of the 1934 cessation, the necessity of building a strike fund to combat the strike. This they did. In addition they had also learned through experience something of strike strategy. That's why there was no attempt to run in strikebreakers. They relied on the policy of arousing the sympathy of the citizenry. But their appeals went for naught. They poured forth reams of copy slandering the union leaders, but the unions proved able to cope with them. The latter group used the radio extensively. Often three and four times each week. Ultimately, I believe, the offshore business interests were instrumental in settling the strike. Their losses were large, because of lack of commodities. This was particularly true at Christmas time.

The payroll losses are irrecoverable. However, the strikers consolidated their gains of 1934, and in some instances extended them. They certainly proved their unity and this is important. A week ago the Vandeleur machine[3] was broken. A bakery wagon driver was elected president of the San Francisco Labor Council. A number of rank and filers were elected to the executive board. The Labor Council is the coordinating body for the multiple unions. Heretofore this body has been important by reason of the vote it controls, but the old guard leadership, by devious ways, was able to swing the labor vote to the entrenched interests. That day is passing. Now that leadership is being displaced from top to bottom with younger and progressive new talent. The new president

is 32. I believe they will have their own candidates in the local field in 1938. The Council represents a membership of upwards of 80,000. Their vote and the vote they control, if properly channeled, can prove decisive. Mayor Rossi[4] and his group knows this. That's the reason the Council election results proved so nauseating.

There is a great deal to write about (my letters are infrequent), but now it's late and I'm tired. The Moscow trials upset me for a couple of weeks. I fail to comprehend how such learned men as Radek, Sokolnikov, and before them Kamenev and Zinoviev could consort with the bitter enemies of the Socialist State. They are all men who have weathered the revolution, and have played important parts in the shaping of the new State. Who are we to trust? How can we know the truth, if those most able to supply us with knowledge are proved traitors? I'd like to know.

Your Christmas message and lithograph reached us. Thanks for your thought. We like your "Sharecropper at the Well." It has a depth of feeling and a lucidness in the medium more pronounced than in your earlier work. Incidentally, our place really looks like a picture gallery. Bentons, Pollocks, Kadishs, and Goldsteins [Gustons]. We'd like something of Jack and Sande's.

Marie and I have been thinking of arranging a show here for you. Would you be interested? Would Benton? I really think we can do it. There are some fine galleries and patrons, too, but no critics of consequence. If you are interested we'll investigate.

The most important work being done hereabouts is that being done on the WPA. The Federal Theatre is doing extraordinarily well. It's the only theater with a punch, and it's getting support. Luckily, the Project has a fine director in Bill Watts, and social minded. *Battle Hymn*[5] is now showing.

What of Elizabeth's new play? Does she have a prospective producer?

Marie and I wonder about your country place. After these years in the city you must welcome its peace and beauty. One day we plan to seek a hilltop that sweeps a valley not far away.

Best wishes to both of you from both of us.
[Frank]
2955 Clay Street
San Francisco

Notes

1 The second maritime "big strike" of the 1930s (the first was in 1934), a 100-day walkout that began on October 30, 1936, saw the split between the Sailors' Union of the Pacific (S.U.P.) and the Communist "ruling cadre" in the West Coast maritime movement come into the open.
2 The Dollar Steamship Company, established in 1901 by a Scotsman, Robert Dollar, had a fleet of ships, all with women's names. *Diana Dollar* was built in 1921.
3 Edward Vandeleur, unsuccessful candidate for president of the California State Federation of Labor.
4 Angelo Joseph Rossi (1878–1948) was a United States political figure who served as mayor of San Francisco from 1931 to 1944.
5 *Battle Hymn* (Michael Gold and Michael Blankfort), an epic drama of pre-Civil War days, was produced by the Federal Theatre Project of the W.P.A.

Charles (Maryland) to Frank (California)

Rockville Maryland
February 25, 1937

Dear Frank,

I was very pleased with your letter. It has been a long time since I have had any word from you and I wish we could find time to write more often.

As you must know Mother is on her way here. She wrote shortly after her arrival in Tingley and announced that she planned to leave there on the 24th and come directly here. I have been expecting word from her as to when she expected to arrive but have had nothing up till now. I rather expect her tomorrow or Saturday. I am sure she is going to enjoy herself. We are anxious to see her.

Your contribution toward the trip was certainly generous and more than could have been expected of you. And I think Jack and Sande did all they could. I feel that I might reasonably have been expected to do more than I did because of the fact that I have a better income. But the truth is, though we

live as modestly as possible, we just manage to get through each month. We do very little entertaining and rent is only 30.00 but living costs are unusually high. We have contributed several sums to the Medical Committee for Spanish Democracy[1] and one or two other causes. Also as I think of it I have spent more on lithographs this year than ever in the past. Of course I hope to make a return on this investment. Since July I have been sending 25.00 each month to Elizabeth's mother. They are both in rather poor health and though they seem to want to open a new restaurant they are now without income. I sent Mother 25.00 on January 1st, 30.00 on the 15th of that month and 25.00 again on the 1st of February.

While Mother is in the East it won't be necessary to send her anything because she will be taken care of here.

Now to other things. The most important thing for me just now is the mural design I am working on for one of the Resettlement Communities in West Virginia. If there were any real certainty that it would go through it would be the grandest opportunity possible. The space is ideal – as good or better than anything Benton has had. There is approximately 2000 square feet. Four panels 15 ft. 6 inches high. I have been doing nothing else at the office since the first of the year. I have just finished the set-up[2] for the first panel. I will make a black and white and color sketch and then send my design through the mill. My intentions are fairly simple so far as content is concerned but then any dramatic mural statement is likely to shock those who think they know what people want.

I intend using the people of the community as models and incorporating them as individuals into my design. This will make the whole thing more meaningful to them.

Before I started work on the mural I spent several months designing the song sheets. We are held up on the series for the present, but I hope we may be able to continue as soon as certain details about printing are straightened out.

Meanwhile Seeger and I have been going over in our minds the possibility of doing something of the sort with Union songs for Union distribution. Haven't been able to do anything with the trade union posters, but I haven't given up my

idea that this field ought to be developed by painters. The real problem is to get around the lag in the leadership here. Part of it is true lag – the other part is that they are swamped with the problems arising from the success of their organizing campaign. But it is just because Labor is making such a supreme effort to do what has never before been done in this country that they should realize the valuable aid posters and other means of pictorializing and dramatizing their struggle would give.

Labor is on the move. We met some of the fellows from Flint who were here testifying before the La Follette committee.[3] They were an interesting bunch. Two of them had been "hooked" and they were here to tell what they knew.

We too were very much upset by the recent trial. It is almost beyond understanding how men of the caliber of those involved could permit themselves to become party to such conspiracy. I am not at all convinced that the trial was above board, but then I am not so much concerned with the legalities, or lack of them, as I am with certain other implications. Trotsky was long ago discredited. I do not think all evil should be laid at his door but insofar as the conspirators were Trotskyite the logic of their position would necessarily lead them to sabotage terroristic methods. But in an undemocratic party there is no room for constructive criticism and there is, I think, great danger that all criticism of whatever sort will be labeled Trotskyite. Indeed this is already happening in Spain and elsewhere. Also, though Russia's course has been disconcerting on a number of points, there is no question but that it is still a Proletarian State. Inner-party democracy may not be so important in Russia but outside of Russia, in the various parties, it cannot be got along without. And no one can convince me that it exists. And its lack is leading the CI[4] further and further from a revolutionary goal or, rather, it is leading them into positions which make that goal impossible of achievement. This is a basic thing and I feel that there is no real hope until the parties are reconstructed with inner-party democracy and collective leadership of the CI.

I don't know, it has been so long since I have talked with you, this may sound like heresy. I hope not. Frankly I think the CPO has the only sound theoretical and practical

approach to the problem and I believe that their influence will ultimately prevail.

If you are at all interested I would like to send you the *Workers Age*. It carries the best theoretical articles to be found in the left press. I am serious about this. Let me know your reactions. Mart of course is convinced, or was the last I heard from him, that Lovestone is every sort of a scoundrel, but this is simply the voice of the party speaking.

Huby[5] and his wife were here for a few days. Huby's new book is out.[6] Maybe you have seen the reviews. They had nothing but praise for the fine job he has done. I am about three-fourths through it and I must say it is really good. Don't fail to get it somehow and read it.

About the exhibition. If you think you can manage it without its becoming too much of a burden of course I am interested and I am sure Benton would be too. Lithographs are the only things that could be sent out economically and I haven't enough for a complete show so better make it a group thing.

Elizabeth has finished her play and is just now waiting to hear from her agents before going over to N.Y. to discuss it with them. I feel she has done a swell job and I think she is pleased too.

Please let us know what you and Marie are doing. How you like S.F. etc. Found any interesting people there? What kind of job have you?

Elizabeth sends her very best.

Chas

Notes

[1] Medical Bureau to Aid Spanish Democracy; see Glossary.
[2] These were small-scale clay sculptures, sometimes painted and lit, that served as models for mural sketches and designs.
[3] The La Follette Committee was a government body established to investigate tactics that employers used to avoid collective bargaining.
[4] Communist International (see Glossary).
[5] Leo Huberman (1903–68), was a Marxist author, co-founder (with Paul Sweezy) and longtime editor of the magazine *Monthly Review*.
[6] *Man's Worldly Goods: The Story of the Wealth of Nations* (New York and London: Harper & Brothers, 1936).

Detroit, Michigan
June 13, 1937

Dear Frank,

Maybe you have heard from Mother lately and so you have already learned that I am here in Detroit working for the United Automobile Workers.[1] I came here the first of last month, took three weeks leave that I had coming from the office, and helped get the weekly newspaper started. Then I returned to Washington and resigned. Elizabeth packed up our stuff and shipped it on here and we have just today gotten settled in our new home.

I am sending you under separate cover a bunch of our papers. It isn't as good as I hope it will be, but it is improving every week and before long I hope it will be first class in every respect. Even now I think it is a better-looking sheet than most labor papers.

I am assistant editor, but in addition to work on the paper I intend to promote as intensively as possible the use of posters, murals and all forms of graphic art in the development of propaganda and education. This will include photography, the motion picture, the animated cartoon and strip film.

As you will see I am already drawing cartoons for the weekly. They are not too good as yet, but I think I can improve. Of course the press work and reproduction is far from good, but this is also being improved.

I am really excited about the possibilities of work with the Auto Workers. Of course I will be drawing constantly and I feel that my work will improve.

There is a good chance that the *Auto Worker*[2] will expand very soon. Our hope is to increase the number of pages in the news section and to add a special feature section.

In the issue of the 12th we ran a story on the settlement of the Richmond Ford strike[3] which I got from the first issue of a labor paper published in Oakland.

I am wondering if there isn't some way for you to break into the labor press there in your section; also if you might not send us some stories from there. Do you have any time

for this? At the present we have no policy on payment for correspondence. Most of our stuff we get from our organizers or from the national press, but I feel definitely that the labor press must develop its own correspondents and sooner or later we will have to pay for this. Meanwhile if you can find a way to establish yourself it would be a good thing.

Let me hear your ideas on this.

By the way Mother showed me the pictures which Stark took of you, Mart and Mother. Do you think he would be willing to trade a print of each for a lithograph?

I think Mother plans to leave N.Y. next week and before long she will be visiting with you. I think she has enjoyed this Eastern trip very much. She certainly looks young and youthful. Elizabeth was constantly amazed.

Our best to you and Marie. Please write.

Chas

Notes

[1] See Glossary.

[2] The United Auto Workers union newspaper was the *United Auto Worker*.

[3] In Richmond, California, workers at the Ford Motor Company started organizing into a union. In April 1937, faced with the refusal of the company to recognize the union as a legitimate representative of the workers, the workers organized a sit-down strike at the Richmond plant to gain Ford's formal recognition of the union.

Charles (Michigan) to Frank (California)

Detroit, Michigan
July 24, 1937

Dear Frank,

I am sending the enclosed cashier's check for Mother to you because I don't know where she is. If she isn't with you by now I imagine that she will be before very long. We haven't heard from her directly since she left New York. Sande sent us a letter she had written them while she was in Tingley.

This is very little to send, but it is the best I can do at present. Elizabeth hasn't been able to find anything to do

122

and her family has needed some help, though they are now getting on their feet again. I think probably the situation will be improved by the fall, for it is certain that Elizabeth will have something by then.

I don't know whether there are prospects for a raise in salary here or not. I am getting tops now, but there may be some increase after the convention. Of course I will still do work on my own, and I think that the possibilities for a larger return from this are somewhat improved in my present position. I have some hopes of interesting a publisher in an illustrated book of songs.

Please let me know how you are situated and what plans can be made for Mother.

The perspectives for work with the UAW are certainly exciting – It is exactly the thing I have been working for these last two years. We are bringing out our first poster sometime this month; I am to see the first proofs this afternoon – a four-color lithographic job (commercial). I expect this to be the beginning of a long series. If it is any good I will send you one.

Have you been receiving the paper? It was ordered sent. I think I am improving a little on the cartoons.

Please write and let us know what is doing.

Chas

Did you get a letter I wrote you a month or so ago? I'm not sure about your address.

Frank (California) to Charles (Michigan)

[*July 25, 1937*]

Dear Charles,

I have proved a shamefully poor correspondent. Your Detroit letter announcing your new connection[1] stirred my imagination and deserved an early reply which I fully intended to give it. But the truth is I've been quarreling with myself for weeks and that sort of temper is not conducive to spirited communication. You understand my trouble for it is not a new malady

which puzzles me, but an old one grown chronic, or nearly so, by the frequency of its visit. It's my way of life.

I've been hanging on to this job with the remote chance one day I'd gain a position and reshape the program with particular attention given the client. At present, all along the line, the attitude is to look out for your own hide and to hell with the client. The client enters into the picture only insofar as he makes certain our job. If the caseload drops in any one month there is consternation; if it rises there is glee. That's Commodity Distribution. Meanwhile the job has been tolerably pleasant, though it is utterly without stimulus and takes all of my time. The personnel, comparatively young, is hopelessly lost with a couple of exceptions.

I can't afford to mark time longer, and that is the gist of what's bothering me. How to get away. We've got to eat. That's our habit. Labor's great thrust forward has captured my thought, but it's impossible to know what's going on without being in the thick of the fight, and that's where I belong. I'm not an organizer but I am a worker and I ought to fit in somewhere. The labor press remains. It is yet to be developed. I'd like to get in on the ground floor of an agrarian worker's press. There ought to be a chance, for the CIO has just recently entered the California fields and canneries. They've got a real job on their hands.

Lou Goldblatt, not long out of the University of California and successful organizer of the powerful warehouseman's union, has been appointed State organizer. By progressives he is considered second only to Bridges,[2] but tops him in the aspect of political education. He is definitely left wing and among the warehousemen workers is spoken of as Little Napoleon.

Those unions which have voted CIO affiliation have had their charters yanked by Vandeleur, secretary, State Federation of Labor. New charters have been issued to rival factions. Within the last week, here in San Francisco, Vandeleur has gone so far as to send AFL[3] scabs through a ten weeks old picket line in an attempt to break a strike of cannery workers who had voted affiliation. The AFofL scabs, in a steel screened truck, were convoyed by police cars while police on foot beat out a path of worker's flesh with

their billy clubs. Strong protest was made. Vandeleur denied the charges. The cannery operators (Tea Garden Products) declared a lockout until their worker's (scabs) lives were made safe. The picket line still sticks.

Your paper looks fine and appears to have a real punch. Photographs are very important because they are convincing. Your cartoons hit the mark, I believe. Have you had any worker reactions? Nast's shoes never have been filled. You might learn something from him. As regards my giving you automobile correspondence that's impossible. I'm too far removed from point of operation. Slaby[4] ought to get the right man for you. Do you intend carrying general labor news? Even there the way things stand, the best I could do would be rehash and that would be of little value to me. I've got to make a connection that will put me on the firing line.

Marie is in the Bank, Insurance Clerks and General Office Workers Union. Only a few months old they voted CIO. Having done so the bank group withdrew in a huff.

Mother came in last Sunday from Denver. She looks fine and has been resting up this week. You fellows really treated her royally. She plans to go to L.A. next weekend.

There are some unanswered points in a former letter which I will have to postpone even longer. I'll try to get to them next time. The show of your things out here I gave up for lack of time and means involved.

I know you're going to have the time of your life on that paper. Send along some more issues. Marie sends regards to both of you.

Frank

2955 Clay Street

Notes

[1] Charles had just taken a job with the United Auto Workers newspaper.
[2] Harry Bridges (1901–90) was an Australian-American labor leader and one of the founders of the I.L.W.U. (International Longshore and Warehouse Union).
[3] American Federation of Labor (see Glossary).
[4] Frank Slaby was one of the principal organizers of the United Auto Workers union in Detroit, Michigan.

New York
July 27, 1937

Dear Chas,

Apparently you are up to your ears with work. We got only
the first batch of papers. Have you sent more? However I saw
some of the recent ones which E. sent Steff. You have made
a definite improvement in your cartoons both as to political
clarity and plastic economy. Your drawing is less rigid and
more certain than in the beginning. I can imagine you are full
of ideas about enlarging and improving the paper and I can
sympathize with your concern in regards to the right kind of
talent. I am certain the country is full of excellent material
but how in the hell to find them.

As to the proposition you offer me. I have been studying
it over all day and I'll be damned if I know what to say. But
there are several factors to consider. In the first place, being
a realist about the business and not forgetting that a man
can learn by doing, I feel that a little proven talent would
not be amiss and I question the wiseness of choosing an
unknown quantity when there is so much qualified talent
about. (schools of journalism, Colleges etc.) After all it takes
training to get a story, write it accurately, simply and with
economy. That training I haven't had. Frankly I doubt my
ability to handle such a job efficiently even though I would
make a hell of a stubborn effort.

Another important factor is Jack. I don't know whether
or not you knew it but Jack has been having a very dif-
ficult time with himself. This past year has been a succes-
sion of periods of emotional instability for him, which is
usually expressed by a complete loss of responsibility both
to himself and to us. Accompanied, of course, with drink-
ing. It came to the point where it was obvious that the man
needed help. He was mentally sick. So I took him to a well-
recommended doctor, a psychiatrist who has been trying to
help the man find himself. As you know troubles such as his
are very deep-rooted, in childhood usually, and it takes a
long while to get them ironed out. He has been going some

126

six months now and I feel there is a slight improvement in his point of view.

So without giving the impression that I am trying to be a wet nurse to Jack, honestly I would be fearful of the results if he were left alone with no one to keep him in check.

I have told you this, Chas, because I know it is your concern. There is no cause for alarm, he simply must be watched and guided intelligently. You will understand the necessity of keeping this strictly confidential.

Incidentally, Jack is at the Vineyard for a three-week vacation. I am sure it will do him much good.

Factor three. I am still obsessed with the romantic notion that I should like to be a painter. I have swilled around New York for three years, defeating myself at every turn for one damn reason or another. But I always come up for a return match believing that I will finally get hold of myself and get down to learning something. I have, for a year, had high hopes for a gainful experience while working with Lehman,[1] and as things are going at present I see no reason why I can't get a lot of painting in on the wall. At the present time we are enlarging the design up into full-scale cartoon form and it is really exciting. Disregarding his stinking personality, for the most part his ideas on art are sound, his design is a worthwhile one and I feel I can get some valuable experience in assisting in its execution. Providing of course, that we don't get a fatal dose of WPAitis. No need to tell you of the pink slip onslaught and that the government is making the position of those remaining on the Project as hot and untenable as possible.

So you see Chas the quandary I find myself in. I feel that I have been called upon and found wanting. And yet, truthfully the idea fascinates me a great deal and I am sure that if guts and tenacity count for anything, I could do it should I so decide.

I dislike being equivocal about such an important matter but you have an idea of my position and perhaps your more mature judgment can point out my errors.

It has occurred to me that since you have decided that two members of a family are not undesirable in one organization, that Frank might be a good man for such a job. He has often expressed a wish to be connected with a paper. He has had

some kind of related training and is definitely interested in the labor movement without being a rabid CPer. I am certain that he is dissatisfied with his present work and it might be possible that he would be anxious for such an opportunity. What do you think of the suggestion?

When you spoke of a photographer I immediately thought of a young fellow on the coast named Stark. I don't remember whether you met him. When I knew him he was interested in documentary photography. He might be worth looking into. One could get in connection with him through Frank in Frisco.

As to Barnet[2] I will have to have a little time to get the dope. I will let you know the moment I get it.

The two *UAW*s just came and I have looked them over. Your cartoon "Henry's Idea of Free Speech" is a real gem. I am glad to see you allow yourself imaginary freedom, obtaining as you have in this instance a genuine sense of hugeness if not monumentality in your expression. I am damned excited about it. I am, admittedly, a pretty small fart to be blabbing my mouth about a man like Benton, but I have observed in a recent issue of *Life* his drawings and captions of the Michigan Communists and Fascists. I feel justified in expressing the opinion that if these drawings are to be taken seriously the man is artistically bankrupt and the captions (his) prove him to be politically rotten. For Christ's sake are Michigan workers Tennessee hillbillies a la 1925? I don't give a damn about a man's personal habits but I believe alcohol has softened his last cell. I can't help but draw a comparison between the work of an artist as yourself who has vital interests and the ghoulish capitalization on the struggle and death of workers by an artist who appears to be politically and morally defunct. It is unfortunate and a very upsetting thing to see happen.

I hope this letter will not seem unduly incongruous and you will give me an early answer.

Sande

Notes

[1] Harold Lehman's Riker's Island mural.
[2] Will Barnet, American painter, born in 1911.

128

Charles (Michigan) to Frank (California)

Detroit, Michigan
August 5, 1937

Dear Frank,
We haven't heard a word from Mother – is she still with you or has she returned to L.A? What are her plans, and do you know where she intends to stay?

Please see that she gets this check. I will send more just as soon as possible.

I'm too tired to write much – have been working late trying to finish up a drawing for this week's issue.

Have you made any effort to contact the *Labor Herald*,[1] published in Oakland? I sure hope you find something in line with what you mentioned in your last letter.

Things are as hectic as hell here. Impossible to tell much about the future until after the convention.

Write –
Chas

Note

[1] The *Labor Herald* was a weekly paper that reported on C.I.O. activities in Northern California from 1937 to 1953.

Charles (Michigan) to Frank (California)

Detroit Michigan
September 13, 1937

Dear Frank,
Thanks for your prompt letter. Stark also sent me a letter and some photographs. For my part I am satisfied that he has what I am looking for and I have recommended that he be put on. I am waiting only for a final ok to wire him to that effect.

There is a real opportunity here.

I am sorry to hear that you have lost your job. Who knows,

though, it might be a good thing, as it will give you an opportunity to find something more to your liking. Is Marie still working? Anyway I hope you get what you are looking for. If nothing turns up I suggest it wouldn't be a bad idea to get a job in one of the auto plants and work yourself into a responsible union post. The organization is new and needs capable men.

Along this line Elizabeth has just gone to work for the US Rubber Co. Can you imagine E. working in a factory and a night shift from 1:00 a.m. until 7:00 a.m. at that. She isn't sure she can stand the smell, but she wants to try. If she can stand the gaff I am sure she will go places in the union. She wants to organize.

Had a letter from Mother this morning. It was in answer to a letter of mine asking her to tell me how she was getting on and how much she was receiving from all of us. Her answer upset me a good deal. She didn't complain any, but simply said that she was preparing to give up her place and sell her belongings. She didn't say, but her intention seems to be to take a furnished room. Apparently she has not received enough since she returned to make it possible to keep her house.

I wrote her immediately not to give up the house and not to sell anything and assured her that I would arrange that she could count on enough to stay where she is. The least we can do is to make a concerted effort to do this, I felt.

I know you have continuously borne your share and more in this. Probably the boys in N.Y. have done all they could. I don't know whether they are still working or not, the point is they never tell anyone anything. I don't think they have been as regular and responsible as they might have been. It never occurs to us to do the little things like writing regularly and sending money promptly.

We have all just agreed to send what we could individually without any question as to whether it was enough, or whether it came at the right time. I haven't known what the boys have been sending and you haven't known what I have been sending. We must try and improve on this.

I haven't been sending as much as previously because of the difference in salary, but from now on I am sure I can send

$17.00 on the first and the fifteenth of each month. I have written the boys to find out what they can do. You won't be able to send anything until you are working again, but when you are able please let us all know.

Obviously Mother can't live on $17.00 a month. If the boys are not able to send an almost equal amount, then some other plan will have to be devised. Mother tells me that her rent is $15.00 and I suppose gas and light must be about 5.00.

Do you think it would be wrong to suggest to Mother that she ought to take care of her mother? She could certainly do a lot for her in her old age and certainly she could live more comfortably than at present. I have never understood why she hasn't wanted to take care of her mother in her final days. Perhaps there would be some isolation, which Mother fears, but it wouldn't last forever. With no rent to pay we could certainly provide her with more little luxuries than at present.

Hope you will write soon and tell me what you think of all this.

 Chas

Sanford (New York) to Stella (California)

New York
September 15, 1937

Dear Mother,

We feel very miserable about the way we have neglected you. There is really no excuse for it. True we have been a little hard pressed for money but Jack has sold a few little things and we are slowly getting on our feet again. As long as things go along as they are now we will be able to send you fifteen dollars a month and when possible more. I am enclosing ten now and will send five more in a week.

We had a letter from Chas saying that he had heard from you Mother, and that you planned to sell your things. Now Mother that is the last thing we want you to do. You must

keep your home there and we promise to help you do so, as much as we possibly can.

Mother I know it will make you happy when I tell you the good news that Jack has stopped drinking completely. He went up to Martha's Vineyard and stayed with the Bentons for a month and Rita gave him hell and through her good influence he has pulled himself together, is working hard and is the real swell Jack whom we all love. All of us are very happy about it.

We are busy now painting the apartment and getting ready for winter. We are going to close the big front room off so Jack can have a private studio. I will have the center room for my work and Loie will use our bedroom. I think it will work out better that way.

Mother write us and let us know if you can manage on the money we send. We are all well and ready for some hard work.

Much love
 S.

Sanford (New York) to Stella (California)

New York
November 22, 1937

Dear Mother,
It is a crisp clear morning after yesterday's storm which left us with a few inches of snow. Apparently we will have a real Eastern Thanksgiving – snow and cold. Rita is sending us a Missouri turkey and we will fetch the trimmings so are fixed for a good dinner. Expect to have a few friends in and spend the day at home eating and belaboring the harmonicas.

There is not a great deal new with us. We both are still on the job and feel secure for the winter.

Siqueiros was in town a few days. He told us many things about the situation in Spain. The conditions there are grave but not hopeless providing support can still be found within the so-called Democracies.

132

The thing that seems to be proving ruinous is the unconcern and lax attitude of the PFG[1] of France. Unless there is a radical change in France soon the cause is definitely lost.

Siqueiros is the commanding general of a battalion of ten thousand men on the Northern Front. He was hurriedly pulled out and sent to Mexico on a mission to Cárdenas.[2] We expect to see him again on his way back.

We were glad to hear that Frank is in the Party. I am sure that he will find work there that he will enjoy and be able to expand himself along the lines of his interest.

We are enclosing a little money Mother with the hopes that you will all be together for a good dinner and enjoyable Thanksgiving.

Love,
Sande

Notes

[1] The Popular Front Government (see Glossary) adopted a policy of non-intervention in the Spanish Civil War.
[2] Lázaro Cárdenas (1895–1970), President of Mexico 1934–40.

Sanford (New York) to Stella (California)

New York
November 27, 1937

Dear Mother:

Saturday afternoon with the house quiet and an atmosphere of calm prevailing, conducive to work. I am working on a drawing, Loie is tinkering with a story and Jack has taken a few paintings uptown to a gallery. He is in some kind of a Christmas Show. God knows what the chances are of selling.

We got through Thanksgiving in good shape. Prepared a fine dinner which we shared with Tolegian, Steff and Kadish.

Had a note from Chas. Didn't say much of importance.

There isn't a thing of unusual interest with us here. Of immediate concern is the Artists Congress[1] which is coming up. There is a good deal of agitation for a Federal Art Bill in

Congress – which would set up a bureau or Dept of Art. A mighty fine thing but one that will be difficult to put through. The Artists Congress will concern itself mostly with that problem.

We will be glad to hear from you and learn how you all are. Did Marvin get his job and what is Frank doing?

The three of us are in the best of shape. We send all of you our love.

 Sande

Am enclosing a money order, mother.

Note

[1] American Artists' Congress (see Glossary).

Sanford (New York) to Charles (Michigan)

December 13 [1937]

Dear Chas,

Well I am late again in writing you. There has been so little happen of interest around here that you have missed nothing. Jack and I are still on the Project and feel secure for the winter.

Had a letter from Mother right after Thanksgiving. Apparently there is no change in the Western situation. We were able to send her twenty-five so I guess they were well fed.

Tom and Rita have been with us this past week. He had to be in N.Y. to receive an award from the Limited Editions Club[1] and Rita came along on some other business. They are both well and very happy. Tom seems to have mellowed a good deal. Incidentally Rita tried very hard to sell some of your lithographs to Lewenthal of the Asso. American Artists.[2] I went to Miller and borrowed the "Cotton Pickers" and the family going around the bend, for her to show. He liked them very much and is going to see you in Detroit. He is a good fellow and has a swell thing going. He pays well so it might be a chance for a monthly income.

134

We had a swell party with all the old gang in. Beat hell out of the harmonicas and sang ourselves silly. Steff and I are getting pretty fine in rendering "Jesse James." And Steff is really swell on the dulcimer. Everyone inquired of you.

Before I forget, I have had the utilities put in my name so you will be bothered with it no more.

Don't know exactly what we will do over the holidays. Bentons want us out there for Xmas. We may go if certain arrangements go through.

I am enjoying the *UAW* regularly. I think it is a damn good trade union paper and most of your cartoons I like. The recent one on WPA is one of your best.

The three of us are well and happy. Jack has straightened out, quit drinking and is painting. I am trying like hell to work but haven't done anything worth a damn as yet.

We send both of you our best wishes for a pleasant Christmas, a happy birthday and a successful New Year.

Sande

Notes

1 The Limited Editions Club, founded in 1929, published illustrated books in limited editions destined for subscribers.
2 Reeves Lewenthal (1910–87) was one of the founders of the Associated American Artists (see Glossary).

Sanford (New York) to Stella (California)

New York
December 20, 1937

Dear Mother,
The few weeks since your last letter have gone by and another holiday approaches. It is incredible where the time goes. It seems that one no more than gets settled down to work when a day of exemption comes along to throw things out of gear. Christmas has always been a producer of melancholy with me anyway and for those of us who profess being modern and admit no truck with such a frightful thing as sentiment, it becomes necessary to put on an additional shell of toughness

around this time of the year when one's secret wish is to be home with his Mother and family. Both Arloie and I would love nothing better than having a few weeks with all of you.

The Bentons spent a few days with us not long ago. They invited the three of us and Tolegian to Kansas City for Christmas. We were seriously considering going in Manuel's car when he came down with the mumps. Jack had so set his heart on going that we sent him out on the bus. He will have a full three weeks there and I feel a rest from New York will be good for him.

There is not a great deal new to report here. Of current interest with the artists is the agitation for the establishment in Washington of a Bureau of Fine Arts. In the second Artists Congress which was just held that was the main topic of discussion. The unfortunate thing about such a bill is that outside of N.Y. there is very little or no interest in the bill. The majority of people are naturally more concerned as to what Congress is going to do towards giving them work and means to eat. The Artists Union has voted to affiliate with the CIO. We all feel proud and infinitely stronger being now a genuine part of the labor movement.

A group of us within the Union are establishing a workshop along the lines of the Siqueiros shop which died for the lack of work. Now we are certain of getting all the jobs we can handle from the various CIO unions. Having in mind particularly, May Day.

We are enclosing a little money Mother. It is our sincerest wish that you have a pleasant, cheerful Christmas. We send our fondest regards and to you Mother, our deepest love.

Sande

Jackson (Kansas) to Stella (California)

[December 1937]

Dear Mother,
I suppose you have heard of my coming to Kansas City for the holidays. The whole bunch of us had planned to drive

through in Tolegian's car – and at the last moment he came down with the mumps – so I came alone on the bus. I like Kansas City very much and the country is most beautiful. The air is very clear and clean. Of course I am staying with the Bentons. They have a very beautiful stone house adjoining a large park. I will stay two or three weeks and try to go back through Detroit and see Chas.

Well Mother I hope you all have a happy Xmas – I imagine Frank and Marie will be with you and Mart and Alma – Wish all of us could

All my love –
 Jack

Tuesday
1180 Valentine Rd
 Kansas City, Mo –

Sanford (New York) to Charles (Michigan)

New York
December 21, 1937

Dear Chas,
Your letter came this morning and I was glad to have it. As I told you we were planning on a trip to K.C. for Xmas. At the last moment Tolegian came down with the mumps so the whole thing blew up. However Jack went out on the bus. He has three weeks off the Project so I imagine he will have a good time.

You spoke of coming to N.Y. New Years. We will be glad to have you and can put several people up with no trouble at all. Why can't you make it for Xmas? We would love to have you and can promise you plenty of good chuck. If that is possible, wire me.

You probably have heard that the Artists Union has voted to affiliate with the CIO. Fundamentally it is a move we approve of. It remains to be seen what use is made of our new power. I attended the open session of the second Artists

137

Congress. It turned out to be a pretty dull affair. The main topic of discussion was the Bureau of Fine Arts. You probably have read the Bill. George Biddle and Rockwell Kent[1] were the main speakers and God how they stank.

I hope very much that you and Elizabeth will be able to get down to see us. If not for Christmas then New Years.

We sent Mother fifteen dollars so they will at least have a dinner.

Our best regards to both of you. Hoping to see you soon.

Sande

Note

[1] George Biddle (1885–1973) and Rockwell Kent (1882–1971) were American artists. Biddle was best known for his social realism, combat art, and strong advocacy of government-sponsored art projects. Kent was a painter, illustrator, and author.

Sanford (New York) to Stella (California)

[December 27, 1937]

Dear Mother:

We were happy to have your letter this morning but we are not at all glad to hear of Marvin's illness. Let us hope that the tests will prove the Doctor's assumption incorrect. It seems that Marvin's health hasn't been what it should be for a number of years. The strain of these past few years has probably damaged the health of most of us and we will all need to take extra good care of ourselves. Please keep us informed about him and let us all hope that it is nothing as serious as diabetes.

As Loie has told you we had a quiet, pleasant Christmas. Just good, simple food, shared with friends. One could hope for little more, unless it would be that you were with us.

I know the concern you rightfully share with us about Jack, Mother. And I feel that it is not more than fair that we keep you informed about him during this trying period he is experiencing. First let me tell you that Jack is making a very strong and admirable effort to straighten himself out and find

his own place in this life in relation to the society in which he finds himself. True, he has slipped a little bit as regards drinking. But just a couple of times when the going was extremely tough and nothing, I feel, so very serious. He was beginning to become restless so that was the main reason we wanted him to go out to Kansas City for a few weeks. As you know the Bentons are very fond of Jack and Rita insists and can make him stop drinking. Loie and I both feel that this little rest from NY will do him much good. When spring breaks we hope some arrangement can be made so that we all can get into the country. So Mother don't worry about Jack. He is doing the best he can and you know that Arloie and I will do all possible to help him.

As Loie has told you, Charles may be down for New Years. I hope very much that he will be able to come. There are so many things to talk over.

Hoping that Marvin is much better and that you are well.
Love
 Sande

Charles (Michigan) to Frank (California)

Detroit, Michigan
December 27, 1937

Dear Frank,
It has been such a long time since I have heard from you that I am wondering how you are making out and whether you have found any work. I had a letter from Mother this morning and she said that she had not heard from you which seemed very unusual. I hope you and Marie are both well and that you are looking forward to a happy New Year. Mother seems well but she says Mart is under the weather and the doctor seems to think that he may have diabetes. I hope for Mart that the doc is mistaken.

Had a letter from Sande in which he says that he and Jack both feel certain of their jobs. They are all well. Elizabeth was laid off some weeks ago. She thinks she may be called back

139

after the first, but the hours she has been working are killing and I would just as soon she didn't go back.

Have you been getting our paper? What do you think of it? What has happened to Stark? I wrote him two letters recently and haven't had any reply. I can understand that he was disappointed that the job I had outlined to him did not materialize. However this was no one's fault particularly. What you have here is a new organization struggling desperately to stabilize itself and get on a solid foundation. You can understand that the various departments are not as well coordinated as they might be. All of this coupled with the depression has made it impossible to put through some of the plans I had drawn up.

However there is still some possibility of putting on a staff photographer. At any rate I was asked to bring the matter up again the 1st of the year. I don't know whether to consider that Stark is still interested or look elsewhere. If you have any idea how he feels, please let me know. By the way, how about the trade I suggested some months ago – lithographs for prints of you, Mother and Mart?

If you have the time write and let us know what you are doing.

Best wishes for the New Year!

Chas

1938

[1938]

Dear Chas,
While your letter is still fresh in reminding me of my inexcusable negligence, I will answer immediately lest I slip again.

First, let us congratulate you and Elizabeth on your decision to have a child. To have children is a very healthy desire and a necessary one I think for the full maturity of man and woman. It takes a hell of a lot of courage though in this screwy society to even make an effort toward normalcy. We hope that Elizabeth gets along with the minimum of discomfort.

We too had a letter from Mother since the deluge out there.[1] We were relieved to know she was untouched. She spoke of going to Frisco for a spell and of her discontent in L.A. I have been very concerned about Mother and have thought a lot as to what would be the best thing for her. So far I haven't come across a solution to the problem but of one thing I am certain and that is that we can't send her to Iowa to stay. I know definitely that that would be a most unhappy arrangement for her. She hates Iowa and has a horror of the slow death that hangs over Tingley.[2] I feel it would be positively cruel to even suggest such a thing. As I say I haven't a

141

concrete suggestion to make at this time. Our plans for the summer are very indefinite except for one important thing which is to get Jack out of New York. It has only been with a very commendable and courageous effort on his part that he has held himself in check. I don't remember whether I told you but in the first part of the winter he was in serious mental shape and I was worried as hell about him. He's in pretty good condition now, doing some fine work but needs relief badly from N.Y.

So I suggest Chas, that we leave the problem of Mother until Spring breaks when we will have a better idea as to the summer.

I was sorry to hear that things weren't going so well on the job. You didn't explain the difficulty. Frankly I feel that it might be the best thing for you to get back to painting. I wouldn't let the money angle weigh too heavily for it is possible to live on Project wages. Friends of ours have had a child and seem to be getting by on the paltry bit.

I don't think your venom is being well spent in raving at the mistakes of the CP. It is not they who were bombing Barcelona and raping Austria and directing the idiotic policies of Chamberlain and Blum. The Russian trials have knocked the guts out of my beliefs toward any kind of Communism or proletarian (as well as all kinds of) dictatorship. I know damn well that I am wrong but I am developing a shell of extreme fatalism. The human race seem to me a pack of dogs and were it possible I would have no truck with them.

There is no need saying I am alarmed at the mad mess in Europe and am trying to figure out what the hell I am going to do when an Army Officer comes up the stairs and asks "does Sande McCoy[3] live here?" I think I'll kill the bastard on the spot!

Well anyway good luck with your baby having and let us hear from you.

Sande

Notes

[1] The 1938 flood in Los Angeles began at the end of February after three days of heavy rain. The Los Angeles River overflowed its banks; more than 100 people were killed and over 5,000 homes destroyed.

[2] Stella's mother was ill in Tingley.

[3] In 1935, Sanford changed his name, taking his father LeRoy's birth name of McCoy before he was adopted by a Pollock family. Reuben Kadish said it was for political reasons: two members of the same family, living under the same roof, could not be employed by the F.A.P./W.P.A. The name change was not made official until much later, in the 1940s.

Sanford (New York) to Charles (Michigan)

[1938]

Dear Chas,

I haven't heard from you since my letter before May Day. However your cartoons are still coming through so I assume Marvin didn't dispense with you on his visit.

We had a letter from Mother telling us of her plan to go to Iowa. I suppose she decided that would be the best thing to do, with which I agree if it is her own decision. I don't know what kind of a time she had in San Francisco.

Things here in New York aren't of the happiest kind. On the Project there is considerable unrest and demoralization due to the One Thousand dollar cost ruling which is being considered in Washington.[1] The Union is putting up a good scrap.

Some time ago Benton had asked Jack to go with him on a six weeks trip. Jack had planned hard on it but has been unable to get a leave with an assurance of getting his job back upon his return. Naturally he is upset over it for he needs material badly.

It is pretty hard to predict what kind of a summer we are going to have. We have picked up a Ford and have been trying to establish a place in Bucks County [Pennsylvania]. How it will work out will depend largely upon Project developments.

I have been watching the papers closely on the German Czech situation. Do you suppose that mad-dog is really going to shoot the works? And the position of England and France seems to me to be the ultimate in rottenness. However I haven't been naive enough to expect more.

143

I wish you would give us a letter telling us of recent developments there and how Elizabeth is getting along. We all send our best to both of you.

 s.

Note

[1] This refers to a proposed 50,000 dollar grant that someone suggested would be better used to hire 50 artists at 1,000 dollars each.

Sanford (New York) to Stella (California)

[April? 1938]

Dear Mother:

This must be a rush note as we are busy as hell preparing floats and the like for the May Day demonstration which we expect to be the largest in history.

Siqueiros is in town and a group of us have established a workshop for the purpose of doing experimental research in new medias – that is in painting, but for the time being we are bending every effort toward making May Day a tremendous success.

We were very glad to get your good letter Mother, and Frank's. We are glad that Frank and Marie have gotten themselves established in S.F. – Hope they will be happy there.

It is not clear to us what happened to Betty – and Sarah. Is she not expected to live?

Charles has been in N.Y. for a few days on business. He is in good health and seems contented with his job.

Jack and I are still on the job – for how long God only knows. However we rather feel the project will continue through the summer.

Spring is finally getting around to us, and welcome it is after the many long months of winter.

 With much love to everyone

 Sande

Charles (Michigan) to Frank (California)

[June 5, 1938]
Detroit, Michigan

Dear Frank,

I imagine Mother must be with you, so I am writing you directly instead of sending Mother's check to L.A. Also, I want to tell you what the situation is here. I am afraid it is going to be impossible to send Mother as much as I have (as little as that is) for the next few months. Although Elizabeth is now going into her 7th month we have not bought any of the many things that will be necessary for the baby and Elizabeth is beginning to get uneasy. The doctor's most recent examination reveals that the baby is lying where it is usually found just before birth. This is not especially alarming, but the baby might arrive prematurely and we are afraid we might not be prepared.

Elizabeth is feeling fine and the doctor assures her she is in excellent health. Since we moved out of the center of town she is much happier. I don't know what is the reason, but I assure you we were never so poor in N.Y. Please tell me whether Mother will have enough to cover her fare and other necessities to Iowa?

Although I have been working hard hours, especially at the end of the week, when we make up the paper, I am still painting and doing some pretty good work. Made two new lithographs this spring. I have been thinking of going on the art project [FAP[1]] and doing part time work for the UAW. Am waiting to see what the new WPA setup will be. Don't know whether you remember Sylvester Jerry.[2] He studied with me in 1927–28. He is head of the art project here and is anxious to get me on.

If the Projects aren't curtailed, I think I could get a good mural. In fact I would have the field pretty much to myself as the young painters here are not much developed.

The threat of a reduction in wages is creating demoralization everywhere. Sande and Jack are both worried. What kind of job do you have and who are you working for? Is the situation as desperate in S.F. as it is everywhere else? I

145

suppose you are wondering what is happening in the UAW. It looks like a showdown fight this time, but it is impossible to estimate the strength of the opposition.

Ask Mother if she knows where that large framed engraving of Titian is? When does Mother intend leaving for Iowa? Hope you will write soon and let us know how everything is.

Our best to you, Maria and Mother,

Chas

Notes

1 Federal Art Project (see Glossary).
2 Sylvester Jerry (1904–90) studied with Thomas Hart Benton at the Art Students League in New York City. He spent most of the 1930s in Michigan, first as director of the Kalamazoo Institute of Arts and later as director for the Michigan W.P.A. Federal Arts and Crafts Project, a position he held from 1939 until 1941.

Sanford (New York) to Charles (Michigan)

[1938]

Dear Chas,

Just got home from the country late last night to your letter. We also had word from Mother last week giving us the same impression you speak of. I wrote her enclosing twenty dollars and asked her how much she would need to get out to Iowa. It seems that when it rains it pours for poor folks. You asked about the payments. As yet they haven't come through – however Jack is off the Project for at least the summer months. It began to look as though it might get hot for the both of us being on. So we decided he should take a leave of absence for a few months. He missed out on the Benton trip however. Now I don't want anything said to Mother about it, for she will feel all the worse receiving money from us. As far as I know I am pretty certain I can continue sending Mother, if not twenty, at least fifteen a month. We have been lucky enough to sublet the front half of our apartment for the rent we usually pay – so we only have the utilities to pay here. We are sharing our country place with Kadish so our rent there is only five a month. And we can damn near eat off the garden.

146

Once Mother gets to Iowa I don't believe she will be so pressed for money.

There is nothing to be alarmed at – I am sure we will manage to get through.

Benton is in town. He seems in fine shape. Has all kinds of irons in the fire. Incidentally his K.C. job was renewed – he didn't seem to give a damn. Rita is coming in tonight from Italy. I suppose we'll have a harmonica tooting party.

How are things going with you on the job? I was glad to hear you were back to a little painting.

Is Elizabeth getting along well? Tell her I found the carton of stuff she asked about and will get it off to her as soon as possible.

Love,
S.

Sanford (New York) to Charles (Michigan)

[September 21, 1938]

Dear Chas,

We have been waiting to hear that the baby has arrived.[1] But not a whisper so far. Why not let us know.

I was glad to hear that you have decided to get on the Project and get a wall. It no doubt will be hard going economically but I am certain you will be a good deal happier painting.

It seems to me Chas that it would be wise to get the paintings you have here placed with some dealer ... such as Lewenthal. They might sell. Christ knows they never will stuck in a closet.

There are a few interesting developments on the Project here. A plan has been evolved to send about eighty artists out of town to various other States. I was immediately interested and looked into the thing. There are being established numerous Art Centers throughout the country. The artists who are sent out will be in charge of all the art activity in the community. Apparently it will be similar to the kind of thing the Resettlement attempted. I think it a hell of a fine idea but not the kind of a thing I feel I could handle. And I

too have submitted a design and color sketch for a wall here which I am very anxious to put up. Its present status is that of being mulled over by one of the various committees. The wall I chose is a small one six by sixteen in the living room of the Nurses' residence, Welfare Island. There were immediate problems presented by the room architecturally, its function and by the specific class of workers (young nurses in training) who will be its exclusive audience. Then too there are these damn commissions who have to be hurtled which are no small obstacle for a man doing his first mural. And yet one can't do a thing totally innocuous. I chose a subject which I am certain would be of interest to my audience, is definitely of interest to me and affords me exciting plastic possibilities. Namely, Frontier Nursing, a service that is carried on by a group of social conscience women in the hill country of Kentucky. These women doctors and nurses go out on horseback to deliver babies and give medical aid to the poverty stricken people of the back country. I feel I have done a pretty good job with my design considering all the problems I faced. My only concern now is to get the thing passed so that I can go ahead with it. I will send you a photo of the sketch as soon as I have one.

It is uncertain whether Jack will get back on the Project. As to your suggestion, he will have to answer.

Meert has been in town for a few weeks. He seems a little unhappy with his teaching job. Would like to get back to N.Y.

The Bentons missed N.Y. on their way back to K.C. so we didn't see them.

Haven't heard from any of the family for months. Don't know what Frank or Marvin are doing.

The European mess is so shockingly monstrous as to have me stunned. Any comment I could make would seem trite.

We give our heartiest love to the <u>three</u> of you.
Sande

Note
[1] Charles and Elizabeth's daughter, Jeremy Eleanor Pollock, was born October 2, 1938.

Charles (Michigan) to Frank (California)

Detroit
November 8, 1938

Dear Frank,

Haven't heard from you for such a long time I wonder if you have got some of Mart's screwy notions. Since the Party laid down the line, Mart won't even write, for fear, I suppose, of being contaminated.

Probably you have heard from Mother that we have a little baby girl. Jeremy Eleanor was born October 2. I am sending you some pictures we had taken when she was 28 days old. We think she is pretty wonderful. Of course we wanted a boy, but are quite happy with Jeremy.

I quit the UAW about 8 weeks ago and am now supervising and painting on the art project.[1] I like it better. Do you remember Jerry[2] who studied with me in N.Y? He is State Director and it is a pleasure working with him. I don't regret the year I spent with the UAW. I learned a lot, but the organization is too young to do the things I had hopes of doing.

Mother tells me you have a new job you like better. She didn't say what Marie was doing. Hope you are both well. I guess we are fixed here for a while. I certainly would rather have settled somewhere in the West, if I had had a free choice, but we are sort of settled here and there is plenty of interest, I guess we will just stay for a while.

 Chas

Notes

[1] Charles was W.P.A. Supervisor for Mural Painting and Graphic Arts for the State of Michigan.
[2] Sylvester Jerry.

1939

Alma and Marvin Jay (Ohio) to Marie and Frank (California)

January 1, 1939
Springfield, Ohio

Dear Marie and Frank,

Thanks so much for the Christmas presents – though, of course, you should not have sent them. We did away with presents entirely this year, and didn't even give to each other. The main idea was to keep my folks from spending so much this year, as they are planning to come back east for a visit this summer, and I knew that if they spent the usual amount for Christmas they never would be able to save enough money for their trip. We promised that if they would not give we would not either. They kept their word and so did we. The only gifts we gave were to the little children in the Party here. The tie you sent Jay is a perfect match for his dark suit, and the soap is very elegant – I use lanolin cream on my skin all the time and it is grand to have soap with it in, too. Thanks again.

We were so disappointed that you never answered Jay's last letter. We are particularly eager to hear about your work and experiences. The success of the election campaign in California indicated that all of you must have done some

swell work. Don and his wife are in the Party now, and he wrote us telling how hard they had worked. Well, it is certainly worth it when you achieve such results.

The small group of us in Springfield have no spectacular results to show for our work, but we are accomplishing something, never the less – we hope! The union movement here is very weak, with the A.F.L. dominating, and the only C.I.O. Union, the United Automobile Workers, torn asunder with the ghastly machinations of Martin's group.[1] Jay has his hands full in his union, being the only really progressive person there. But he is making some headway, and the apprentices look to him for leadership. Needless to say the heads of the Union have already spotted him and will do everything possible to thwart his moves. The Union is now negotiating the new contract and, if they are successful, they will receive a substantial increase in wages and better conditions. It is very doubtful, however, as there are so few fighters, and Jay is not on the agreement commitee. We are pretty eager to see how it comes out, not only for the material gain, but also because it will indicate the strength of the Union.

Among our other activities are the following: Jay is now a member of the Central Trades and Labor Body; he has joined the Eagles (for mass organization contact); he is attending a Public speaking class; and most important of all, Jay has been fortunate enough to get in with a group of very progressive professors in Antioch College, in Yellow Springs, a small college town about ten miles from Springfield, and from this group he already has recruited two party members, and hopes to get more in the near future. The students in Antioch have organized a "Bare your ribs for Spain" movement, and every Sat. they spend only a quarter for lunch and dinner and send the rest to Spain. They raise around ten dollars every week in this manner. We hope to get a good Y.C.L.[2] group from among the best of these, and I may have the privilege of directing them. I am a member of an A.F.L. Womens Buying Club here, a member of the Y.M.C.A.[3] and – oh, what with party meetings – and meetings – and meetings (you know) we manage to keep fairly busy. I'm sure I've forgotten at least half of the things, but you get the idea.

Now it is your turn. How about it?

By the way, did you kids ever meet Frank Bonetti, one of our L.A. Comrades who went to Spain? He is back now in New York, after having served eighteen months and having suffered the loss of his left leg. We have been in correspondance with him since he left for Spain, and we hope to have [him] come to stay with us for awhile until he gets more on his feet, or decides to leave for California. He has just recently gotten his artificial leg, and he wants to stay in N.Y. near his doctor until the leg completely heals. We are eager to see him again.

I'm enclosing the last two Bulletins that we put out each month. This is the eighth month, with never a miss, and we are quite proud of ourselves. What do you think of it? None of us had ever put out anything on a mimeograph machine before – and it's an old one at that – and we have had lots of fun getting this one out. It's so damn much more work than you would ever imagine if you had never done it. Jay does the actual running the machine, our Organizer types the stencils, and I do all the art work and lettering on the stencils. Several of us write the articles, and as many as we can get chip in on the work of gathering, stapeling, folding, enveloping and mailing, etc. We mail out five hundred each month and distribute some. Give us your criticisms; we'd appreciate it.

And – please don't be so long in answering this letter. We would love to hear from you.

Sincerely,
Alma

Dear Frank and Marie:
If you have a chance show these bulletins to Betty Gannet. Our party in this little provincial city is small with a membership of thirty five with eight or ten active people. The A.F.L. leadership is reactionary and follows policy of do nothing. I so far play a lone hand among Crowells three thousand workers and it is very slow and cautious work. We are clearing up the mess in the U.A.W. and expect some good developments at Int[ernational] Harvester[4] in the future. We have discovered a gold mine at Antioch. Browder speaks to their assembly this month. By that time we will have a student

branch and a professor branch established. Do you ever hear from the kids in New York? What is their position?

So long,

Jay

Notes

[1] Homer Martin (1901–68) was a controversial leader of the United Auto Workers union.
[2] Young Communist League.
[3] Young Men's Christian Association.
[4] Manufacturer of a wide range of agricultural equipment.

Sanford (New York) to Charles (Michigan)

[1939]

Dear Chas,

Sorry you missed my letter even though it wasn't of much importance. It seems to me I wrote you a short while before Xmas – you make no mention of it so perhaps it was intercepted by an agent of the Dies Comm.[1]

We got through the holidays with no casualties. Had plenty to eat Christmas and Steff and me did some right smart work on our harmonicas. Didn't have presents, though we sent Mother a few things. We too had a letter from her. She seems fine though bored with her isolation.

Hope to hell we can get her out of there this summer.

Of immediate concern around here are the lay-offs. You probably know as much about it as I do. There are one hundred and ten pink slips in the mail right now. The Union is storming and raising hell but frankly I can't see that we can do so very much about it. From all appearances this may be our fatal year. Reaction is preparing to ride high and hard in Congress.

How much danger is there of you getting the axe? Is there any kind of an Artist Union in Detroit?

Jack finally got back on the Project. He is in the Easel Division.

I've been having an awful time with Approvals Comm. So

far they have rejected my things. Now I find myself in a real dilemma as to what to attempt for them. It's slightly discouraging for one who has never done anything. I know of cases where an artist has had six or seven good designs rejected.

You seem to be busy. Of course no harm can come from it but I don't see how you expect to learn printing. It seems to me that is a full time job and one in which one must be prepared to spend a lifetime in really learning. This guy [—] has been working at it for ten or twelve years and can only pull a second rate print. You had a painting in the Western show (not a very happy choice I felt, particularly from the point of view of color). The show in general was nothing to have an orgasm over.

Benton's *Susan and the Elders* failed to interest me much.

Seems to me the man is going off on a peculiar tangent.

Saw some photos of Orozco's Guadalajara frescoes. Christ what a brutal, powerful piece of painting. I think it would be safe to say that he is the only really vital living painter. Incidentally some of his Communist followers around here are shitting in their drawers for the man has painted, as a leader of the masses, a clown juggling on his nose the Swastika, Hammer and sickle and Faces. The Comrades claim that the man is confused!

Now a word or two about that little brat we have been hearing so much about. Hell if those photos are an accurate record she looks like nothing more than an Irish miz Pollock. Didn't Elizabeth have anything to do with it? I can detect no trace of that Semitic beauty that is her mother's. I will admit though definite evidence of Arkansas heritage.[2] Can she play a Bach Cantata on the harmonica? I shouldn't be surprised at the rate she was going in her mother's last letter. By god if we'll admit it but we're so jealous I think I will adopt a child six months old and then just up and have twins to get the best of you. Or at least even things up. Seriously though we're certainly aching to have a child. As things stand at the moment we are too frightened economically to make the move.

I can imagine how joyously happy you both must be with her. I guess a person hasn't really lived until they have had children. Do you find the experience overburdening? I suppose it is simply a matter of adjustment.

We would sure like to take a run up there and see her and you folks.

What do you all plan for the summer? Suppose you'll have to stay on there as long as the Project holds out. We haven't any definite plans. Hope to at least get out into the country.

Speaking of babies we hear the Bentons are expecting.

The three of us send our love to all of you and best wishes for a good year.

S

Notes

1 House Un-American Activities Committee (see Glossary).
2 Elizabeth came from Arkansas.

Sanford (New York) to Charles (Michigan)

[1939]

Dear Chas,

I was glad to have your letter. I was particularly interested in your attitude as regards the UAW. Naturally from where I'm standing the whole damn fracas appears to be a bedlam of confusion. It is even difficult to discern exactly what the issues are.

The whole international progressive movement seems to be without leadership or direction – is paralytic and ineffective. I agree with you that there is no revolutionary movement in the real sense of the word.

It's probably in some kind of self-defense that I find myself thinking in terms of nihilism.

Steff and I get together on the harmonicas right regularly. We played and sang for the kids at the Little Red School House.[1] They loved it. Don't see much of Tolegian. It became impossible to play with him.

Speaking of Steff I just saw some of his latest lithographs and they were swell. He has made considerable growth.

155

Glad to hear you made the World's Fair.[2] We didn't submit, knowing there was no chance. Phil [Guston] is doing a big mural for the WPA building.[3] Had but two months to design and execute it. Incidentally some of the artists around here are making themselves a tidy fortune doing commercial murals at the Fair. Makes me feel like a damn fool for not getting in on it. I guess it's simply against a universal law for a Pollock or McCoy to ever make money.

We have been investigated on the Project. Don't know yet what the result of it all will be. Should they ever catch up with my pack of lies they'll probably put me in jail and throw the key away! They are mighty clever at keeping the employees in a constant state of jitters.

Jack is still struggling with the problems of painting and living.

I am working on a drawing for a small panel. Arloie has been writing some stories for children. So far has had no luck selling them. Bill Hayden is in town. He is still trying to find out which end he is standing on. I haven't kept contact with Granjean.[4] We had them in for dinner one evening. She spent her time in anti-Semitic discourse and clarified the confusion in our minds as regards Hitler.

Understand Benton is having a big retrospective show at the Asso. Amer. Artists next month.

I don't know a thing about it but I shouldn't imagine your idea on folksongs would interest Lewenthal. It seems to me that a music publisher would be the people to approach. However with a little effort I believe you could sell Lewenthal on your lithography.

Haven't heard from Mother for a long while. Suppose she is all right.

Mart wrote me a note asking if I would be interested in a Roto[5] job. I decided against it. Don't know what the hell Frank is up to. Do you ever hear from him?

I can well imagine the joy and fun Jeremy is. Won't be so awful long until she will be jabbering away. We'd love to see her. Think there is any chance of you all getting down this way?

Love, S

156

Notes

[1] Small experimental grade school in Greenwich Village, New York, founded in 1921. (The school still exists today and one of Sanford McCoy's grandchildren is a pupil there.)

[2] The New York World's Fair, 1939–40, was one of the largest World's Fairs of all time.

[3] On the facade of the W.P.A. building, New York World's Fair.

[4] A friend of the Pollock brothers in California.

[5] Rotogravure printing.

Sanford (New York) to Charles (Michigan)

[1939]
New York
May 3

Dear Chas,

I think I'll try to get a letter off to you now before months slip by and in that way perhaps we can get our correspondence going along a little more smoothly.

We were glad to hear that Lewenthal has a little something for you. It would be a real break should they handle your prints. They seem to be swell people and have a good thing going. Their new gallery is elegant beyond description and they seem to have plenty of backing. When Tom was here we got together a good deal and had some fun playing the harmonicas. Benton's show is a pretty impressive business. His last paintings are primarily concerned with surface and tactile values with his emphasis on form organization. Even though it must be admitted to be really fine painting I personally feel he has gone off on a long tangent from his early Indian panels which I consider to be his best work from a purely creative point of view. Tom himself seems fine and happy – still the same powerhouse of energy. Rita expects her child sometime in June. T.P.[1] is growing up and is a swell musician on the flute and oboe.

We here are muddling along. Are rather dazed about the whole damn business, national and international, to say nothing of our inability to solve a few of the problems of paintings. The situation on the Project looks darker than it

157

ever has. You know as well as I that the Tories are out to get us and it appears they may be successful. The May Day demonstration struck me as being really sickening. The crux of the slogans and the spirit of the whole thing seemed to be – Labor Unity for War! It strikes me as being a bastardly bit of war mongering.

I am doing a panel for the Project. I am trying to paint with a casein wax emulsion. I'm not sure whether I like it or not. It has a little more flexibility than straight casein and when rubbed produces a velvet finish. In any event I am having a hell of a wrestling match with the thing.

Are you doing much painting? And what are you using?

A friend of yours, Miss Jones, came up. We were unable to get her in for dinner.

Is there any possibility of the Project sending you here for anything at all? We would like to see you.

S

Note

[1] Their daughter Jessie was born in July 1939. T.P. was their son, Thomas Piacenza Benton.

Sanford (New York?) to Stella (California)

[1939]

Dear Mother:

I'm late again in writing to you. It seems impossible for me to form decent habits about such things.

I guess it's been at least a month since your last letter. Imagine you are damn well fed up in that hole. I get the shudders every time I think of it – but we seem helpless to do anything about it. We don't know what way to jump around here. The reactionaries' threat to our jobs has become very serious. Today papers announce another W.P.A. layoff of two hundred thousand. And in June there are to be still larger dissmissals. God knows what the poor folks are going to do. I suppose they will try to stick us into

this European mess. That's one way of solving the unemployment problem.

Everyone here is gabbing about the Worlds Fair. It seems to me to be a Chamber of Commerce complex gone berserk. We haven't been out and may not go at all, it's so damn expensive. Phil did a large mural[1] for the W.P.A. building.

Benton was in town for a few days. He is having a large show here. We saw a good deal of him and had some fun playing the harmonicas. Rita is expecting a child late in June. They still live in Missouri and seem happy about it. T.P. is a good sized boy now (twelve) and is becoming a fine musician.

I Iad a short letter from Charles today. Nothing much new – says the baby has cut two teeth. I imagine she is a sweetheart and I bet Charles is crazy as a bed-bug over her.

We don't know what we will do this summer. Everything will depend, of course, upon whether the Project folds up or not. We would like to get out of the city and this World Fair mess if possible.

The three of us are in relative good health. There is a prevailing mood of gloom and disillusionment which seems contagious and I must admit we have failed to escape. Every one seems to be eating, sleeping and waiting.

Much love from the three of us.
S.

Note
[1] Philip Guston's mural, *Maintaining America's Skills* (now destroyed), was on the facade of the W.P.A. building at the New York World's Fair.

Alma (Ohio) to Stella (California)

September 16, 1939
Springfield, Ohio

Dear Mother:
Did you think you would never receive that promised second letter? The problem has been one of getting the snapshots. I wanted to get one copy of each made first so that we could

choose the best from those to send to you and to the kids. None of them are particularly good, except, perhaps, the close-up of Sandy, which I think is swell, and the one of Loie, and one or maybe two of the snap shots. However, I know you will be interested in getting pictures of the kids and their summer farm, even if they aren't exactly works of art. The group at the table is gobbling up a most delicious chicken dinner which Arloie made the day after we arrived in Penna. Not only chicken but – a fresh peach pie, created by Arloie's own dainty hands, and the most lucious, cozy-juicy thing ever wolfed by seven greedy mouths!

We started out Friday as soon as Jay got off work, and drove till midnight, then up again the next morning for four-teen hours more driving; reaching Ferndale, Penna. about ten o'clock at night, where Sande and Loie met us and took us to the farm. Phil and Musa share it with them you know, and they were there. It was very swell seeing everyone again, but we were pretty tired, and soon went to bed. The next day was Sun., and we lay around getting acquainted again, until the above-mentioned chicken dinner, after which we started out for New York, by way of New Jersey to the Hoboken docks, where we got our first glance of the New York skyline from the Ferry.

We then went to the kids' apartment[1] to clean up a bit, before starting out again; this time, down to the battery, and then on the new Staten Island ferry, out past the Statue of Liberty, Governer's Island, Ellis Island, etc. From the ferry we got that world famous view of the N.Y. skyline that the European Liners bring to the eager and freedom-seeking folk the world over.

Next we returned to Greenwich village, and the apt. from which we took the subway to Times Square. Imagine to yourself the thrill of that – Times Square the night War was declared![2] With the news headline in electric lights from the Times Build. flashing the latest war news to the milling, thousand-headed crowd below. We walked up the "Great White Way" – Broadway, and 42nd Street, topping off the evening by eating in an automat, back to the subway – and so to bed.

Monday started out by driving over the eastside Parkway,

160

where Mayor LaGuardia has had to build parks for the under-privileged children all along the river, to take the place of the refuse heaps, and to provide playgrounds to keep the kids off the streets – one of the best of LaGuardia's many intelligent social projects. We then crossed the Brooklyn Bridge. Next we drove through the nightmare of the eastside, where even a stone heart would shudder at the squalor of these incredible tenements (unless of course, that stone heart belonged to one of the landlords profiting from this human misery!). Next we drove to the battery and walked about a bit in the vicinity of Wall Street, where we were turned cold by the sinister menace of these narrow streets with their towering, closepacked buildings – and most menacing of all – Trinity Church! Did it affect you the same way? Next we went to the Aquarium where we were greatly amused comparing the specimens we saw there with people of our acquaintance. We then took the westside (sorry) Skyway to midtown, where we went down to the docks, and saw the two largest ships in the world, the Normandie, and the Queen Mary. We lunched at a kind of Sailors Bar, after which we took the new Lincoln Tunnel (which is a wonderful job) to Jersey, where we drove along the Jersey Palisades to the magnificent George Washington Bridge, that marvel of the modern age, a suspension bridge completely supported by cables from side to side. We crossed the bridge, then drove down Riverside drive, through Central Park, and home for another quick clean-up, and then to Chinatown for dinner. And so to bed once more.

Tuesday Loie and I went shopping in the morning, and then all of us went to the Modern Museum in the afternoon, followed by a trip to the observation roof of the Rockerfeller Center Bldg – the high-spot of the vacation, and a breath taking thrill. Until you have seen New York from up there – you simply haven't seen N.Y. Next came more shopping, dinner at home, and about midnight we set out for Harlem, for a peek at some real swing, and some hot music. And home again in the wee small hours.

Wednesday we went to the Frick Museum, and the Metropolitan Museum, drove up Fifth Ave in a double decker bus, had supper, and went to a show in the evening.

And Thursday the Fair![3] I am afraid I had better try to cover the fair in my next letter, as this one is already getting absurdly long. We spent just one day and night there, but I would like to give you an idea what we liked best, when I have more space.

Friday we returned with the kids to the farm, and spent the afternoon lying in the green grass, and looking at the green hills, and dozing, and, incidentally, taking your pictures; and, in general, resting up for the long drive ahead of us. Sat. morning we were up early and away for home. We hated saying good-bye, as you can imagine, but it was certainly grand having the chance to see them again – and, after all, N.Y. isn't so terribly far way! There is still the chance of going back some other day, don't you think?

Jay is slightly laid up at the moment with a cold (too much vacation, I guess!) so I won't ask him to add to this, but perhaps in the next one he will. We both send our dearest love, and our earnest wish for a nice big letter from you <u>soon</u>!

Lovingly,
Alma

P.S. If the slip I got in New York for you doesn't fit properly, please send it to Arloie, and she will take care of getting the proper size. It is hard to be sure of anything these days until you try it on.
Alma

Notes
[1] Jackson and Sande.
[2] Britain and France declared war on Germany on September 3, 1939.
[3] New York World's Fair.

1940

Charles and Elizabeth (Michigan) to Frank (California)

Detroit
January 7, 1940

Dear Frank,

Your lovely gifts came last Wednesday but I have been too tired evenings to write and thank you both for your thoughtfulness. They were much appreciated, especially the bear, who now helps Jeremy to sleep every night. We have had so many addresses since living here that it naturally took a little time for the post office to locate us.

Jeremy is a constant delight to us both. She is growing like a weed, sturdy and strong and as smart as they come. But she has pretty near worn Elizabeth down. I am home so little I can't relieve her much.

I am still on the Project and working hard too, supervising everything except sculpture and at the same time completing my mural. This is the opportunity I have been waiting for and preparing for too many years. Although I am doing only one panel of three, it is a good size (11′ × 24′) and commanding in position. This is one of the few instances anywhere in the country where it has been possible to work with the architect from the beginning of construction. In consequence I have faith the final result will be impressive.

I have completed all my drawings and when I have finished the color sketch, perhaps in another 10 days, I will be ready to begin actual painting.

There seems excellent prospect for the project in respect to work in sight. How long we will be allowed to continue is anyone's guess. Meanwhile we are taking over all the craft projects in the State and the new setup will mean an increase in salary for me (at any rate this is anticipated). If this transpires I will be able once more to send Mother something. I am sorry I have been unable to help any these many months.

I learned from Mother that you and Marie were in Mexico. I can imagine what fun you had from the experience. What are you doing now? Somehow I envy you living in San Francisco. The first opportunity I get I am returning West. Do you ever meet any of the folks we used to know in Chico?

Please write once in awhile –

Best to you both,

 Chas.

Dear Frank and Marie,

If we had some word from you along with the grand gifts it would have been perfect. Jeremy is in love with the "bobby bar," which translates into "baby bear." I'll send you some snaps of the baby real soon. She's 100+% Pollock – blonde, blue eyed and pink-white. But the poor thing is her mother's daughter when it comes to manner – noisy, talks as much as many 2-year olds, full of the very devil of fun and mischief. I'm afraid she'll break the Pollock tradition for gentility and shyness. Can't keep us Jews out!

In fact, your niece is a stack of fun and a joy to us. Actually looks like your mother a lot, Frank.

Charles is very happy in his work – which makes me happy as well. I'm a housebroken hausfrau, nursemaid and laundress – but the baby's worth it all.

Do write us about yourselves very soon and thanks again for the grand box.

 Elizabeth

Jackson (New York) to Charles (Michigan)

[1940]
January

Dear Chas,
Got both your notes – Glad you're beginning to get something done.

We had a big Christmas here – ate to beat hell then just fell asleep. Rita sent the gang another turkey – They made a recording and sent it out – it was pretty damn good. Tell Elizabeth we got the present, thanks a lot. We ran out of turkey so sent Mother 10 instead.

Had your prints mounted – and got another frame for the *Judge.* Yours was impossible, will turn them in this week (the paintings).

There's no news here – not having much luck with painting + got my last painting turned back for more time – they didn't like the form in the water – if it had been a good picture I wouldn't have consented?

When are you coming in town again, we ought to have the band together before Steff pulls out.

Jack

Am sending music and watercolor

Jackson (New York) to Charles (Michigan)

[Summer 1940]

Dear Chas,
Tell Elizabeth the suit is a pretty good fit – and thanks.

I haven't much to say about my work and things – only that I have been going through violent changes the past couple of years. God knows what will come out of it all – it's pretty negative stuff so far. I'm glad you are back in the painting game again and wish you luck on the Social Security job.[1] I haven't been up to any of those competitions. Will try when my work clears up a little more. Phil Guston and his wife

have been winning some of the smaller jobs. I'm still trying to get back on the Project, and it doesn't look any too damned good. At best it will be another four or five weeks, and then it may be the army instead.

Jack

That child of yours is really a beaut.

Notes

1 Social Security murals (see Glossary).

Sanford (New York) to Stella (Iowa)

[1940]

Dear Mother,

Your letter came this morning. We were glad to have it and to know you are well. Also glad to read the notes from Marvin and Charles. We never hear from them – nor they from us for that matter.

We, as everyone else I suppose, are unhappy and really frightened at the turn of events in Europe and especially at the terrific rate of speed this country is traveling down the road to war. The American Chamberlains are rapidly getting in the saddle – hell bent toward repressive legislation, the destruction of Civil liberties and war. You asked me what I thought about Wilke.[1] My feelings about him are that as far as the American People are concerned it makes little difference to them if their rights are being trampled under, whether the criminals are Democrats or Republicans. It's like asking who one favors, Hitler or Mussolini. We on the Project have been forced to sign an affidavit to the effect that we belonged to neither the Communist or Nazi parties. A wholly illegal procedure. And now I understand the Army is snooping around the Project finding out how the Artists could fit into the "Defense Program."

Jack is still off the Project. It would be necessary for him to get on Relief before he could get his job back and the Relief Bureau is making it as miserable as possible for single men.

Trying such tricks as suggesting that the Army has openings for healthy young men.

We sublet the front half of our apartment to a married couple – very good friends of ours. We share the kitchen and groceries so it's not like having strangers around. They are going to share our shack in the country too. So we are getting by and getting the most out of what little money we have. We have put in a good-sized garden and hope to can a lot of tomatoes and things. I would just as soon that Jack didn't get tangled up in the Relief mess and instead have a good healthy summer in the country. It makes anyone nervous to have to go through such an humiliating experience and Jack is especially sensitive to that sort of nasty business.

Arloie hasn't been up to anything much of special interest. Making a few summer dresses and housework is about all. We are all in good health.

Tom Benton was here for a few days. He is doing some drawings for *Life magazine* on the Republican Convention. Rita and the children are at the Vineyard.

You have heard us speak so many times of Helen Marot and Caroline Pratt.[2] Miss Marot passed away a few days ago. She was quite old – in her seventies I believe.

It was a shocking loss to all of us. And especially to Caroline. They had been together thirty years or more. She was one of the most wonderful women I have known.

We see Phil [Guston] and Musa[3] often. They are well and struggling along. They speak of you. Also see Lehman and Steff. Don't know if you remember Steff. He plays the harmonica with me. They are expecting a baby this Fall.

It's strange that you haven't heard from Frank. Wonder what he is doing.

Mother do you remember that Mexican friend of mine in L.A. Luis Arenal?[4] He used to come up to the house often. Well he came to see me here a few weeks ago. Then he went back to Mexico and I read in the paper where he was implicated in that attempt on Trotsky's life.[5] Siqueiros too is involved. Can you beat that? God knows what they will do with them.

Well I had better close and get to work. I am just finishing

up a panel for the Project. They seem to like it well enough.

Hugs and kisses from all of us,
S.

Notes

[1] Wendell Wilke (1892–1944), Republican nominee for president 1940.
[2] Caroline Pratt founded the City and Country (elementary) School in New York and Marot, a Fabian socialist, was Pratt's "lifelong partner." Jackson and Sanford worked at the school briefly as janitors.
[3] Musa McKim (1908–92), American painter, Philip Guston's wife.
[4] Luis Arenal (1909–85). Born in Mexico, Arenal studied art and architecture in Mexico City before moving to Los Angeles in 1932. While there, he assisted David Siqueiros in painting murals.
[5] On May 24, 1940, there was an attempt to assassinate Leon Trotsky at his home in Coyoacan, Mexico. Among the participants in this attempt were Siqueiros and Luis Arenal.

Sanford (New York) to Charles and Elizabeth (Michigan)

[1940]

Dear Charles and Elizabeth,

We have meant to write you folks these many months but somehow the unreality and weight of all this mess has kept us from it. But today's note from Mother of your illness gives me real concern and forces me to do the least in letting you hear from us. What is the trouble and how serious is it? Hope it is nothing chronic and that you have recovered.

We have had a winter of ups and downs with the latter in the majority. I was off the Project from August to January. Just getting things leveled out and now Jack gets kicked off this week without much chance of getting back on. From all reports and rumors the whole damn thing may collapse in June.

Arloie has a dinky job with the League of Women Shoppers.[1] Works like hell for twelve bucks a week when they pay her. Like most liberal outfits they made her join the union to get the job and then pay her sub-union wages.

Haven't done much painting. Get pretty bound up what

168

with relief bureau and Project approval committees. I am working on the third cartoon for a panel – all of which have been rejected to date.

Jack however is doing very good work. After years of trying to work along lines completely unsympathetic to his nature, he has finally dropped the Benton nonsense and is coming out with honest, creative art.

It is hard to report on what is going on here in the way of art. There are, though, definite rumblings, questioning of accepted values and some provocative ideas astir. The Benton show last year seemed to have no positive reaction. Except that his latter work (the nudes) were disappointing. The whole idea of a Missouri Venetian, both in idea and paint, seemed phony. One had a feeling he should rush up and hold the pretty girls on the canvas. The large Picasso show[2] was a fine one. For imagination and creative painting he is hard to equal.

Saw a couple of good plays this winter. Saroyan's *Time of Your Life* is the finest thing I have seen. Odets' *Night Music* on the other hand smelled. Incidentally Tolegian has a good job playing the harmonica in Saroyan's play. He does a swell job. He isn't doing much painting and what he is doing is dull stuff – Highly varnished pictorials.

Steff is doing some fair Graphics. See a good deal of him – we still fart around on the harmonicas together. Poor Mother, what a dreary job she has waiting for that old lady to die. We feel bad about the whole business but are helpless to do a thing about it.

Never hear from Frank – nor Mart. He was here for a few days last summer. We were rather surprised at his lack of dogmatism and his reasonableness toward his faith. We really had an enjoyable few days together. God knows how he could hold to the Stalinist line by now. Have no idea where you stand politically but I should guess the same place we do – confused. Saw Huberman not long ago – he was unable to clarify things for me. He has another book on U.S. history coming out. Said he was going to Mexico to cover the elections.

Elizabeth, about the baby pictures you asked for. We looked all over hell and couldn't find them. As for the books

– I am willing to crate and send them – but lord it would cost a pretty penny and there are so many which I am sure you wouldn't want, could you look them over. Let me know definitely.

Love to all of you and the baby. Hope you are over your sickness.

Sande

Notes

1 The League of Women Shoppers was started in New York City in 1935. The principal aim of the group was to oversee women's working conditions and to help maintain reasonable prices for everyday goods.
2 *Picasso: Forty Years of His Art*, The Museum of Modern Art, New York, January 1940.

Sanford (New York) to Charles (Michigan)

October 22, 1940

Dear Chas,

Your letter today and I have written to Mother. It is beyond me how I can be so damn negligible and still live with myself. I have no idea what Frank's address is – haven't heard from him in ten years.

Was glad to hear you got something in the S.S.[1] competition. Hope you get a break on it. I didn't feel competent to tackle it. I did try for some of the previous ones but nothing came of it. The designs were bad. Friends of ours, Musa McKim and Phil Guston, won several of the ship jobs.[2]

I am still on the Project and Jack got back on two weeks ago. But as you probably know it has never been so shaky as now. They are dropping people like flies on the pretense that they are Reds, for having signed a petition about a year ago to have the CP put on the ballot. We remember signing it so we are nervously awaiting the axe. They got twenty in my department in one day last week. There is no redress. The irony of it is that the real Party People I know didn't sign the damn thing and it is suckers like us who are getting it. I could

170

kick myself in the ass for being a damn fool – but who would of thought they could ever pull one as raw as that.

Furthermore when they get us in the Army with the notion that we are Reds you can bet they will burn our hides. Needless to say we are rigid with fright.

Arloie got a job in an exclusive girls' school. The school produces several plays a year and it is her job to design and make the costumes. The hours are light and the pay though not much ($18 a week) will help out. She commenced work on Monday and seems happy about it. As she is substituting for someone else she doesn't know for how long it will be.

It has occurred to me Chas that since there is so much uncertainty in the way things are stacking up, if it might not be a good idea for you to get your paintings out of here. Maybe I've got the jumps but I have a presentiment of Jack coming up the stairs yelling "run for the hills men, the dam has busted!" It's my guess that the cheapest way would be by truck. If you are interested let me know and I could get an estimate. Please understand that it's no trouble storing the stuff. It's only that under certain circumstances we might have to break up here in a hurry.

It is encouraging to know it is possible to stop smoking. I shouldn't be surprised if I wouldn't be told the same thing if they ever got me in a doctor's office. My clock sounds like a Model-T Ford. Incidentally I saw Eleanor [Hayden] for a few minutes not so long ago. The bell rang like hell two o'clock one morning – scared the jesus out of us – thought it was the Gestapo – went downstairs and there was Bill and his sister, pinkly plastered. I couldn't find out what she was doing but she said she had seen you all and that Jeremy was wonderful.

According to the snapshot your little girl is a real Darling. We would love to see her and the all of you.

We don't see much of anyone any more. Ran in to Huberman on the street recently. He is labor editor on *PM*.[3] From what little talk I had with him I gathered he is no less confused than the rest of us.

Write.

S

How about some photos?

Notes

1 Social Security.
2 Murals made for the dining rooms or grand salons of transatlantic liners.
3 *PM* was a daily newspaper in New York City, published from June 1940 to June 1948.

Marvin Jay (Ohio) to Stella (Iowa)

Springfield, Ohio
Dec. 22, 1940

Dear Mother,

Alma has been so good about keeping up our correspondence but this seems one time in the year when I should contribute a little.

We had hoped that you would have visited us at sometime during the past year, that being impossible, we will surely see you sometime in 1941. We will always have a place for you mother and always be glad to see you. You will no doubt need some funds to travel on so be sure and let us know when you are ready.

In times like these one hardly knows what will happen next as the old order comes tumbling down and the new order is rapidly pushing forward. One thing we are quite sure of, that there is plenty to do to keep up with each new development and to contribute everything possible for progress and the interest of the people. I have recently been elected secretary to my union which means extra work and organizing campaign is under way, a delegate to the Trades and Labor Assembly, active in the Adult Educational Forum and the new developments in labor movement demands a great deal of concentrated effort besides working eight hours a day, keeps me interested and on my toes. Alma has contributed to the League of Women Voters and done a fine piece of work. Her best effort was a fifteen minute broadcast over a local station on our foreign relations to China and it was really a swell job. The W.W.C.A. [?] and many other activities keep her busy.

We got a Christmas card from Denver (we just solved the problem as being a woman we [met?] in Washington), we

were wondering if some relation sent it that I had never heard of.

We hope you and the folks there enjoy a pleasant Christmas, enclosing a small money order for you.

Hope grandmother is in fair condition and able to enjoy some of Christmas with you. How is your health holding up mother, take good care of yourself.

My best regards and Merry Christmas to all.

Love,
 Marvin

Dear Mother – I just want to add my own wishes for a happy Christmas, and to send a hug and kiss.

Love,
 Alma

1941

Sanford (New York) to Stella (Iowa)

New York
January 19, 1941

My dear Mother,
Sunday evening – Loie and I are over in Steff's apartment taking care of their infant while they take in a show. They haven't been out since the new arrival – so we felt we'd give them a break. Their baby is coming along swell – gaining weight to beat the band. Just heard Charley McCarthy[1] on the radio and was wondering if you were listening too. Do you have a radio?

Well Roosevelt is inaugurated tomorrow – one looks anxiously into the future and wonders what the coming four years holds for all of us. Nothing too pleasant I am afraid – guess we'll just have to stick our chin out and bear with it.

I got my classification from the draft board – 3A – which means I am in the deferred list due to having a dependent. Jack got his questionnaire last week and in filling it out he claimed he was helping support you. He told them he sent you ten dollars a month when he was working. He also told them he had worked ten months this past year. In the event they check up with you out there, you can tell them the same

174

thing. We hope very much that he will get a deferred classi-
fication. Naturally he is rather nervous about the nasty busi-
ness. Also in the event you are questioned it would be best for
you to say nothing about me.

Arloie is still working – had a dress rehearsal and produc-
tion Friday – which always means hard work and a few hectic
and anxious hours. But she loves it and would be tickled pink
if she had such a job steadily. There is still a vague chance
that the other girl won't take the job back.

There isn't much new with us on the Project. There is some
rumor that it may be turned into a defense project – making
posters and such. Which would be bad artistically speaking
but good in the sense that the Project would be more likely to
continue. Having a little cold spell – but really nothing com-
pared to Iowa.

The three of us are in excellent health. Haven't had so
much as a single cold.

Much love,
S.

Note

[1] Charlie McCarthy was a puppet invented by Edgar Bergen, an American
actor (1903–78) best known as a ventriloquist. *The Edgar Bergen and
Charlie McCarthy Show* was a very popular radio broadcast from 1937 to
1956.

Sanford (New York) to Stella (California)

[1941]

Dear Mother:
Your letter came this A.M. We were glad to have it and to
know you were alright.

Loie is at work and Jack has gone to the Project with an
assignment. I have just had my lunch (two soft boiled eggs
and toast) so I felt I would write you before the weeks start
slipping by. We are glad you were pleased with what little
we were able to send. Sorry Chas and family weren't able to
go see you. Guess they have their problems too. We had a

most simple Christmas and new years. Bought a small turkey for Xmas. So the three of us had a quiet dinner together by candle light with Loie fixins, and called it a day.

Loie is still working. She seems tickled about it. Probably will work thru most of February. She has bought material for several dresses. Has made one up and cut another out. She is some girl for these times. Do you know she hasn't had a single store dress since we've been together. I guess she would make her shoes were it possible.

It would certainly help put us on our feet if she could work for a while.

You asked about Steff's baby. It's a girl – born about a month ago. She's the tiniest thing you ever saw. Weighed slightly under six pounds when born. They are of course very happy with her. Steff is still on the Project.

I got my Draft questionnaire some weeks ago. This morning my classification card came. I'm in class three which makes it unlikely I will be called. Jack hasn't gotten his questionnaire yet as he had a high number. I don't feel we need to worry about him though, as he can claim dependents.

This national and international situation has become so complex and run through with incongruities that it makes one dizzy in search of solid ground to stand on.

The position of the C.P. seems horribly muddled and untenable. I can't follow their fantastic reasoning. I wonder if Marvin still goes along with them?

I wonder what the hell Frank is up to? Do you have his address?

Rube Kadish's youngest brother dropped in during the Holidays. He is going to college in Wisconsin. Said Ruben had another baby. He had seen Frank and Marie about a year ago – but didn't seem to know what they were doing but said they were well.

Loie had a letter from her folks.

They seem to be well.

We are in first class health here.

Haven't had any winter to speak of.

Much Love from the three of us.

 S.

Sanford (New York) to Charles (Michigan)

August 22, 1941

Dear Charles,

I have failed to answer your letter, not out of neglect but rather out of sheer dilemma as to how to answer it. We are very troubled as to the problem of Mother, and it seems that no amount of thinking or planning brings results. I hate like hell to write a hard luck letter and plead poverty, but the pressure of things leaves no other out. Truthfully the situation here is rather rough. It seems that either one or the other of us is out of work. Then if we both are on it lasts just long enough for us to even our debts up a bit and then the whole thing repeats. Too, there seems a constant stream of investigations, both Home relief[1] and FBI. Fortunately we've had none of the latter so far. There have been so many firings on the Project (400 last month) that a lot of animosity has developed among the workers and tattling of family secrets has resulted. Of course we have ours to fear.

We worked like hell cleaning and painting the apartment in anticipation of Arloie's baby and what did the bastards do but jack the rent up to fifty dollars. We hit the ceiling and raised a stink, but to no avail. We would move but God what rents are being asked! The gouge is on and we're the victims. So all this and more too makes for a helplessness that is almost overwhelming. I don't know the answer.

It is good of you to offer the washing machine. We can use it.

Arloie is fine – has a good doctor and is in splendid health. Expecting confinement around the middle of October.

S.

Note

[1] See Glossary.

Sanford (New York) to Charles (Michigan)

[October 1941]
Sunday

Dear Charles,
Since word from Mother of Grandma's death[1] I have kept my head busy on what we can do for Mother. I don't know the answer. I too am glad that Mother's miserable job is over. It has been a cruel and undeserving assignment. I know it has weighed on your mind as it has on the rest of us. She must be gotten out of there immediately.

Now that this thing has come to a head and decisions have to be made it is with serious thought and some reluctance that out of fairness to Arloie and myself, I feel I must tell you of the serious problem we have now and have had these past five years. The subject is Jack. As you will remember he was having a difficult time adjusting himself when you were here. I think at that time we felt that it was no more than the usual stress and strain of a sensitive person's transition from adolescence to manhood, a thing he would out-grow. But his mal-adjustment has proven to be a far deeper thing. One requiring the help of doctors. In the summer of 39 he was hospitalized for six months in a psychiatric institution. This was done at his own request for help and upon the advice of doctors and with the help and influence of Helen Morat. For a few months after his release he showed improvement. But it didn't last and we had to get help again. He has been seeing a Doctor more or less steadily ever since. He needs help and is getting it. He is afflicted with a definite neurosis. Whether he comes through to normalcy and self-dependency depends on many subtle factors and some obvious ones. Since part of his trouble (perhaps a large part) lies in his childhood relationships with his mother in particular and family in general, it would be extremely trying and might be disastrous for him to see her at this time. No one could predict accurately his reaction but there is reason to feel it might be unfavorable.

I won't go into details or attempt an analysis of his case for the reason that it is infinitely too complex and though I comprehend it in part I am not equipped to write clearly on the

178

subject. To mention some of the symptoms will give you an idea of the nature of the problem, irresponsibility, depressive mania (Dad), over intensity and alcohol are some of the more obvious ones. Self-destruction, too. On the credit side we have his Art which if he allows to grow will, I am convinced, come to great importance. As I have inferred in other letters he has thrown off the yoke of Benton completely and is doing work which is creative in the most genuine sense of the word. Here again, although I "feel" its meaning and implication, I am not qualified to present it in terms of words. His thinking is, I think, related to that of men like Beckman, Orozco and Picasso. We are sure that if he is able to hold himself together his work will become of real significance. His painting is abstract, intense, evocative in quality.

This is a bare outline of the situation, that I have given you. I have tried to present it as no more nor less serious than it is. It is hard work laden with anxiety, discouragement but satisfaction too. It has taken much of our energy. Before going any further let me impress you with the importance of keeping what I have told you in absolute confidence. I don't want Elizabeth or any of the rest of our family to know a thing about it. If the reasons aren't obvious please believe me they are valid. I insist upon this.

My decision to burden you with the foregoing is that there seemed no other way to explain our inability to meet our obligations to Mother and the family. I needn't say that Arloie and I would truly love to have her with us. All other problems except the one I have discussed could be solved some way or another. I guess we are as toughened as we'll ever get as regards being booted in the ass economically year in and out. It does get a little boring. I can imagine the mess you are in. They're crowding us a bit . . . raised our rent to fifty bucks. I've been off the God damned Project five weeks. Got back recently. . . get my first check tomorrow and every dime goes to the landlord. I have been thinking seriously if I shouldn't try to get back into a printing factory. Don't know if I could do it in the first place even if I got a job. It is a hard decision to make.

Well we're down to here and haven't a single suggestion as to what to do for Mother. I don't know where Frank is, what

179

he is doing nor what his circumstances are. Supposing you write to him. I'll get a letter off to Marvin tonight asking for his suggestions. The moment I hear from him I'll write you.

Don't let this letter disturb you too much. It is a situation that takes a lot of sympathetic understanding, careful handling and more than anything time.

Arloie is in her seventh month.[2] She is in good health and spirit and is getting adequate medical attention. It probably seems an insane thing for us to do in our circumstances . . . we didn't think it out, we simply decided to do it and to hell with everything else. How is your baby? I bet you think she is something!

 Write me.

 Sande

Jack didn't see your letter

Tuesday –

I have delayed sending this hoping that a couple of more days of thinking the thing out – I might be able to write another kind of letter. But no solution has come. Got Frank's letter this morning which seemed pretty negative. I wrote Marvin and should have an answer this week.

 S

Notes

[1] Stella's mother died July 17, 1941.

[2] Sanford and Arloie's daughter Karen was born November 9, 1941.

1942

New York
March 28, 1942

Dear Charles,

I got your note and the money. You didn't say – how did the crates hold up?

We had a letter from Mother this A.M. saying she had a chance to come through to New Jersey with someone. I have written her by all means come. I had wanted to get moved first so that she would be spared the strain and the mess of moving.

But it is still not certain whether we can have the place we want so I see no point in waiting further. It will be swell to have her with us.

I have been looking for work at some of the War Industry Plants. Haven't found anything yet but have a fairly good lead through the efforts of Doctor Hayden.[1] Some of Selective Service Director Hershey's remarks about taking married men with dependents unless they are employed in war production,[2] has rather frightened us. In any event I feel being on WPA can be of no good to one when the time comes for them to take married men. I am seriously thinking of borrowing money and taking a course in vocational training if I can't get a job without it.

Things are unchanged here. We are all well and send our best to the three of you.

 S.

Notes

1 Eleanor Hayden.
2 The draft was originally reserved for unmarried men. Later, married men without children were drafted. In the end, married men with children were eligible for the draft unless they were involved in war work.

1943

Sunday, June 27, 1943

Dear Chas,
I'm in a hell of a fix for not answering your letter days ago.
The truth is I've been so damned busy (70 hours a week) as to
not have an ounce of energy nor time for anything but a bite
to eat and some sleep.

You didn't tell me the formula you are using, so how could
I judge the trouble with it? Are you emulsifying your own
glyptol from the synthetic resin or are you getting it from
some source already emulsified? The glyptol[1] we used came
to us in liquid form and we made up our medium in the
following proportions:
For one pint of medium –

```
300 cc water    (6 parts)
 60 cc casein   (1 part)
 60 cc glyptol  (1 part)
```

Emulsify the casein in water (6 parts water to 1 casein) in the
usual way and then simply add 1 measure of glyptol slowly,
stirring constantly.

There are a couple of suggestions I can think of – one is to

keep your emulsion refrigerated, except for the amount you are using on the day of painting. Secondly, if your medium is separating it may indicate that it wasn't completely emulsified in the first place, which would call for a few drops of ammonia or better still, if you can get it, Morpholine. Not knowing how you are making the stuff, it is rather hard to guess what your trouble is.

Mother writes that she is going up to see you folks while Elizabeth goes to the hospital. We have no idea as to the seriousness of Elizabeth's operation. We hope, though, that it is a minor one and that she gets along fine.

Mother was so wonderful with Karen and we enjoyed having her with us so much, we hope she can get back up this way whenever she feels like coming. We know how happy she will be to see Jeremy and you and Elizabeth.

I have damn little time to read the news seriously, but we take the *N.Y. Times* and *PM*. My general feeling is that we are winning the battle on the war front and losing it at a frightful rate at home.

Here in this dump we have no intellectual connections and one misses the stimulus of good friends, but I suppose it will have to be endured.

We would appreciate a letter from your way once in a while and a print off your wall.

Sande

Note

[1] An industrial paint product developed during World War II.

Jackson (New York) to Stella (Iowa)

[1943]

Dear Mother,

I had your shoes all wrapped ready to send and left the house open for the day and damned if they weren't stolen. I hope they fit. Do you remember the make, size and where you got them, so Lee can get you another pair. Let us know immediately.

It was a very pleasant surprise seeing Frank. He was very proud of his young son Jonathan.[1] The following week Rube came in town for two weeks. He is with the army as an artist correspondent and will be working in India and China. He plans coming east when it's over.

I have been showing some of my paintings – and have been offered a one-man show at the Art of this Century[2] in November.

Best to Mart and Alma

Love,

 Jack

Notes

[1] Frank and Marie's son, born in 1942.
[2] Peggy Guggenheim's gallery in New York.

Lee Krasner[1] (New York) to Stella (Iowa)

[1943]

Dear Stella,

I'm really ashamed for not having written sooner but life in N.Y. is complicated and in spite of the fact that I'm not working (except for the posing I do for Sara) I seem to be kept busy every minute –

It was nice seeing Frank and in uniform, much to everyone's surprise[2] and Sande (who's getting fatter every day) – I suppose you heard that Karen had the German measles when they came in to N.Y. and Loie had her hands full. As for Jackson he has all sorts of wonderful things happening at the moment – As he told you Peggy Guggenheim came up to see his work – She bought a drawing and is giving him a one man show in November – She is really very excited about his work, in fact she said one of the large canvases was the most beautiful painting done in America.

She wants to handle his work and can do a lot for him. Also Sweeney[3] offered Jackson a job – teaching in Buffalo N.Y. – I don't think he'll take it but it certainly gave him a

lift to get the offer. Also some woman who came in from the coast to arrange some shows for the San Francisco Museum offered him an exhibition of his drawings and I can't remember what else is happening but it's all very wonderful.

Please be sure and send me the information about your shoes so I can get them quickly – are you thinking about coming east soon?

I'll write soon

Love,

Lee

Notes

[1] Lee Krasner, born Leonore Krassner (1908–84), American painter. She and Jackson Pollock married in the Marble Collegiate Church in New York City on October 25, 1945.

[2] Frank was against war and refused to go into the army. To avoid the draft he joined the American Red Cross, and because of his educational background and administrative skills he became the field director of the naval shipyard at Mare Island, San Francisco. He was later transferred into other administrative positions at naval shipyards in Vallejo and Pittsburg, California.

[3] James Johnson Sweeney (1900–86) was a museum director, art historian, and critic.

Jackson (New York) to Charles (Michigan)

[July 29, 1943]

Dear Chas,

Thanks for the note.

Things really broke with the showing of that painting.[1] I had a pretty good mention in the *Nation*.

I have a year's contract with The Art of this Century and a large painting to do for Peggy Guggenheim's house, 8′11½″ × 19′9″. With no strings as to what or how I paint it.

I am going to paint it in oil on canvas. They are giving me a show Nov 16, and I want to have the painting finished for the show. I've had to tear out the partition between the front and middle room to get the damned thing up. I have it stretched now. It looks pretty big but exciting as all hell.

Sande was down for a day last week – he is looking swell,

and gaining weight on his 78 hours per week schedule. I'm glad Mother can be in Colorado for the summer – it must be grand country.

It was good seeing Frank, I think my painting had him worried for a moment, but then he soon got over it. He was very proud of his little Jonathan.

Hope you can make it East this summer Chas; will look forward to seeing you.

Best to E. and Jeremy.

Jack

Note
[1] *Stenographic Figure*, 1942, the Museum of Modern Art, New York.

1944

Jackson and Lee (New York) to Stella (California)

[February 4, 1944]

Dear Mother –

We were glad to get your letter and hope Alma made connections to Los Angeles ok. Will she be able to stay long? We had a very pleasant week with Sande and Loie over the holidays. Here we have Dorothy [?] came up for a few days – Mac [?] has gone overseas – Nina and Bernie Schardt[1] are both working. I have a number of paintings out in traveling group shows now. One show opens in Cincinnati on the 8th Feb.[2] Lee has a painting in it too. The *California Arts and Architecture* – a magazine published in Los Angeles – will reproduce some of my paintings this month. Will have a color reproduction[3] in *Harper's Bazaar* in a month or so.

 We have had a very mild winter here so far will expect to see you in the not too distant future.

 Love

 Jack + Lee

Notes

[1] Bernard Schardt (1904–79), and his wife Nene, American artists.
[2] Cincinnati Art Museum, February 8–March 12, *Abstract and Surrealist Art in the United States.*
[3] *The She-Wolf.*

Jackson (New York) to Charles (Michigan)

[April 14, 1944]

[written on the announcement of the Peggy Guggenheim *Art of this Century* exhibition][1]
Dear Charles,
I have just got my contract set for next year – so am a little more at ease. I have really had amazing success for this first year of showing – a color reproduction in the April *Harper's Bazaar* – and reproductions in the *Arts & Architecture*. I'll send out a copy if you haven't seen it. Mother looked the best I have ever seen her look in a long time. She gave me the impression that it's pretty damn cold country out there. If it weren't for the god damn war I'd head west for awhile – any chance of your coming east during the summer?
 Best to Elizabeth and Jeremy.
 Jack

Note
[1] A group exhibition. Among the artists shown were Dali, Max Ernst, Léger, Kandinsky, Masson, and Miro. Jackson showed *Pasiphae* (1944).

Jackson (New York) to Stella and family (Connecticut)

[1944]

[written on the announcement of the Peggy Guggenheim *Art of this Century* exhibition]
Dear Mother and all,
I would have written sooner but I had planned on coming up for a few days – while Lee is with her folks in Long Island. But had to stay to get the painting up for this show. We'll make it together at some later date. The two packages came in fine shape, thanks so much. We can use all of the things. *Harper's Bazaar* came out this morning, my reproduction looks good. Let me know if you can get an issue there – if not I will send one. There is nothing new about next year. The

reproduction should help some and we will try to come to some arrangement this month – There is no chance of getting a new power pack Sande, I'll have a look around the used radio shops on Cortlandt Street, my understanding is that the power pack and speaker is one unit.

Is there any chance of you and Loie coming in soon? Wish you'd try and make it. The newspaper reports on 4F[1] had me scared for a while – but don't think it means much. This should make a pretty interesting show. The Miro and Picasso we saw at Peggy's house – upstairs. My new painting is $56'' \times 96''$. Sweeney and Peggy came down to see it and thought it my best canvas to date – Don't think Rube [Kadish] saw much in my mural – he seemed to like my other stuff though. Understand Phil [Guston] is doing quite a lot of stuff for *Fortune* magazine.

Love,
Jack
Friday

Note

[1] This classification in the Selective Service system (the draft) exempted men from the armed services as "physically, mentally or morally unfit."

Jackson (New York) to Charles (Michigan)

[May 1944]

[written on the back of an exhibition announcement: The Pinacotheca New York, May 9–27, 1944][1]
Dear Chas,
About the emulsion – I don't know of anyone here who has used it. I am told Doktor[2] is someplace in the Midwest. If I run across anyone who has used it I will let you know. I am getting $150 a month from the gallery – which just about doesn't meet the bills. I will have to sell a lot of work through the year to get it above $150. The Museum of Modern Art bought the painting reproduced in *Harpers* this week – which I hope will stimulate further sales. I'm sorry to hear

of Jeremy's sinus infection, and hope she and E can get south this winter. I think Mother will be comfortable without the allowance you have been sending while she is with Sande and Loie – And I will certainly contribute when possible. Had three of the damndest letters from Tolegian – he's a real nut.

Best,

Jack

Notes

[1] A group exhibition: Browne, de Kooning, Harari, Harris, Model, Morris, Pollack [*sic*], Schanker, Scharl, Schnitzler.

[2] Raphael Doktor, responsible for artists' materials on the W.P.A.

Sanford (Connecticut) to Charles (Michigan)

[May 4, 1944]

Dear Chas,

Arloie and I were in New York a week or so ago and I tried to contact someone who might know about Glyptol. Doktor I understand is somewhere in the Midwest and Boris the Project paint chemist is unfindable. I have given you everything I know about the stuff in previous letters – Jim Brooks[1] is out of the country – so I don't know what the hell to suggest.

We found Jack in fairly good shape. He is painting steadily and doing exciting work. The slight recognition he has received hasn't bothered him. The Gallery[2] renewed his contract for another year at the same low figure. But since it lets him paint he doesn't complain. He hasn't had any sales.

My job is expected to wind up in two weeks or so. We have made no plans for the reason that there are several factors involved which are unclear at this point. My draft status changes from 2B (essential industry) to 1A May 17.

For some reason it does not bother me. I would damn near as lief be in the thing as to be a cog in a factory turning out millions of dollars for profit takers. It is beyond imagination what some bastards in the name of patriotism do to turn a dollar.

We are sorry and frightened to hear of Jeremy's chronic colds and sinus infections. Karen has had dozens of colds this winter and I had one hell of a siege of sinus. I often feel as if all of us don't get some sunshine and fresh vegetables and fruits soon that we may not pull through.

I have about decided that living in the East is not living at all.

I think your decision to send E. and J. south or west this coming winter is a sound one. But wouldn't it be more practical for you to find work in the West? There must be some nice teaching commission in a Western College. A few letters of inquiry might turn the trick.

About your problem of sending mother money. I am going to explain to mother your need of setting something aside for your winter plans. We will be able to give her a good part of the difference. She as you well know will understand.

Her needs here[3] are not numerous. She seems happy and is in good health. I wish you could have a hunk of the oatmeal bread she pulled out of the oven this evening – man! man!

Our best to the three of you.

McCoy

Notes
[1] James Brooks (1906–92), American painter.
[2] The Art of this Century.
[3] Stella lived with Sanford and his family in Connecticut for several years.

Frank (California) to Jack (New York)

July 31, 1944

Dear Jack

Thought you might like to know what San Francisco's critic has to say about the show you are sharing.[1] Not terribly important, but he does have a sizeable reputation out here, especially in music which is his field. I'm afraid your stuff is

beyond him as it is with many of the rest of us. But for the bush league, shucks, what can you expect?

SHE-WOLF is hung to excellent advantage at the gallery's end and catches the eye immediately upon entering the gallery a quarter block away. Marie and I were thrilled by it, and it seemed more meaningful than when I saw it in the cramped space of your studio last year. Stark says your pictures[2] were the show, but then, he's already a fond admirer. Incidentally he was mighty pleased to receive the catalogue of your November show.

Visited Ruben [Kadish] a couple of months ago. Apparently he had a shocking experience in India. Seemed morose as a result of it. Gathered by his remarks that he considers India's plight hopeless. Not impressed by either his drawings or paintings. Guess *Life* wasn't either. Stark tells me they extended his contract one month then sent him a note saying they were glad to have had him on their staff. Failed to make any mention of the work submitted. He wants desperately to go to New York. Has decided that's the only place for an artist. He probably won't go. Not yet. His draft board has other plans. He's 1-A. Probably take a defense job instead.

From Ruben learned mother has been visiting you. Am wondering if she's still there. As always I was prompted to write, but as always I put it aside. Knowing better, no wonder my conscience hurts me. Last word I've had from any of the family was your February note. Thanks. Meant to acknowledge it. Ruben enjoyed seeing you and was very favorably impressed with your work. In fact says you're the coming American painter. Seemed terribly disappointed in not being able to see Sande and Loie.

For a fellow who had wondered so much about the family, you'd think he'd do the simple and decent thing and get some letters out. Perhaps I shall. This is a start. How are Sande, Loie and Karen? Do you hear from Charles? Are Mart and Alma still in Springfield? Ruben said Mart had gone to Los Angeles, but it wasn't made clear whether on a business trip, or permanently.

Jonathan is a galloping boy. He's 28 months old now. And very active. To us he has become a very real and charming

personality. Most of the time he's a tolerant and under-standing person. Sometimes he's boisterous and possesses a devilish rowdyism, remindful of you some years back. He got started late talking (four months ago) but now he speaks clearly in sentences. He has excellent body control and is good competition for me in a marble game. He's a south-paw.[3] He removes splinters from his fingers with tweezers with the deftness of a surgeon. He makes a fetish of meticu-lousness. A little dirt on his hands or face drives him to the bathroom. Altogether he's an all around good guy. He only wishes Karen were nearby for a playmate.

Maria hasn't been too well. Nothing serious. Mostly enervation. Been taking thyroid without results. Been under doctor's care since December. That is she makes intermittent visits to San Francisco for tests and check-ups.

We've been here since early in the year, having been trans-ferred from Camp Stoneman. Benicia Arsenal is directly across Carquinez Straits from Martinez. It's the chief source of munitions for the Pacific theater. The Port Chicago explo-sion,[4] seven miles away, nearly blasted us away. We thought it was our day of reckoning. No real damage unless you count fright. Arsenal authorities describe it as miraculous that there were no sympathetic explosions here.

We live in a two bedroom defense housing unit which is adequate. Maria has a garden of tomatoes, beets, carrots, lettuce, corn and chard. We live frugally, but get most of the essentials. Our social life is pretty nearly confined to our front room and an occasional trip to San Francisco 40 miles away.

The war in Europe is on the road home. I've been trying to get over there these past several months. May make it yet. I'll know soon. If I do Maria and Jon will return to San Francisco. Should I go, I'll first be in Washington for a short while and should get into New York for a visit. Hope to see mother, especially.

Maria and Jon send their love. Warmest regards to Lee.

Frank

American Red Cross
Benicia Arsenal
Benicia, California

Notes

[1] *Twelve Contemporary Painters*, a circulating exhibition organized by the Museum of Modern Art, New York. San Francisco Museum of Art, July 19–August 13, 1944.
[2] *The Moon-Woman Cuts the Circle*; *The She-Wolf*.
[3] Left-handed.
[4] A deadly munitions explosion on July 17, 1944; it killed 320 sailors and civilians (202 were African-American enlisted men).

Jackson and Lee (Massachusetts) to Stella, Arloie and Sanford (Connecticut)

[August 25, 1944]

Dear Mother Loie Sande –
No news from Deep River?

Lee wrote a couple of weeks ago, did you get it?

Provincetown looks much better to me now – we are at the west end of town and within walking distance to the beach. We get in for a dip at least once a day – I've taken a crew cut and look a little like a peeled turnip – or beet. Haven't gotten into work yet. Howard Putzel[1] came up last night for a two week stay – we had dinner with the Hofmanns – Hans[2] still has to take it pretty easy. Howard has quit the gallery, which I'm very sorry to hear about, Peggy plans to close the gallery after next winter and will possibly will her collection to the San Francisco Museum.

Had a note from Nina [Schardt] she may come up for August. What are the chances of your coming up? Let us know and we'll work out some arrangement. Are you working Loie? Got this note from Rube [Kadish] yesterday. Write.

Love Jack [and] Lee
Wednesday

Notes

[1] Howard Putzel was an independent art dealer who became Peggy Guggenheim's friend and assistant.
[2] Hans Hoffman (1880–1966), German-born American painter.

195

1945

Marvin Jay (California) to Frank, Marie, Jonathan
(California)

Jan. 9, 1945

4222 Lowell Ave
Los Angeles 32, Cal.

Dear Frank, Marie and Jon:
Yesterday a letter from Charles and today you surprise us.
Charles says he intends coming over sometime during his stay
in Tempe [Arizona]. I have just finished a letter to him asking
him to try and make it while you are in town. We have plenty
of room and I will meet your train.

That's more family correspondence than could be expected
and after ten years of dearth I am sure that Charles didn't
write to you and you didn't write to Charles and so I have
enclosed his letter in yours and your letter in his. Does that
make sense?

I draw the conclusion – your trip to Ontario [California]
– from your letter that you are about to take up farming.
Well it will be nice having you kids down in this part of the
country. Alma is playing all the cards in the deck gambling on
our staying here. I have wired N.Y., Springfield [Ohio] and
San Francisco about the possibilities of a good job. Nothing

in S.F., Springfield is stubborn but can be persuaded, N.Y. hasn't answered.

Paper priority has been blamed for a loss of jobs here and as a result four men are threatened with a layoff sometime this month. I being one of them. It looks like a case for the NLRB[1] as we have evidence that it isn't just like it is supposed to appear on the surface. Nothing to be discouraged about as there are plenty of jobs in photo-engraving shops if I am interested.

Alma is feeling better and to keep her that way we will probably manage to stay out here.

I finally found *Harper's Bazaar* and *Arts and Architecture* and appreciate especially Jack's interview.[2] But the reproduction[3] I have examined from every conceivable angle but nothing registers. Maybe Charles can explain them?

Alma sends her love and best wishes.

So long,
 Jay

Notes

[1] National Labor Relations Board (see Glossary).
[2] Interview published in *Arts and Architecture*, February 1944.
[3] *The She-Wolf*, reproduced in *Harper's Bazaar*, April 1944.

Marvin Jay (New York) to Marie, Frank and Jonathan (California)

[March 1945]

Dear Marie, Frank and Jon,

Alma sent me the registration slip for the car to be signed and returned to you. It came the day before she arrived, Sunday, and has been neglected. We are at the studio tonight and I have been trapped into the job.

Jackson's show[1] opened last Saturday. From all accounts it was a great success and while not necessarily understandable to me it was interesting and powerful in feeling. Mother and Sande came in for the show. Sande went back Sunday

night and Mother stayed over. Arloie is coming in next week. Every one is getting along well and are in good health. Mother has to have her teeth pulled and a plate made. Tried to convince her to have them pulled this trip but she wants to postpone it.

Lee is an interesting girl and grows on you as you get better acquainted with her. She has a lot of common sense and patience which is a required characteristic to handle Jack when he gets in one of his moods. She is an artist and one of her pictures has been selected for a traveling show of representative women in the art world.

It was good to have Alma join me again. We are staying in a hotel near here until April 1. Rented an apartment in Flushing last night. It's a nice modern 1½ sublet for six months. We had intended living in Manhattan so Alma could go to school but there is little choice in this over-crowded city.

I was fortunate in getting a job as re-etcher[2] and etcher with Neo Gravure, one of the largest gravure operators in the country. Got a substantial premium above scale which is $76.00. They do a third of a million dollars business here every month and overtime seems no object even at time and a half, double and triple time. This week I have been covering half the time for the second shift re-etcher and my check will be doubled. We will be here until something worthwhile and stable turns up in California.

Alma says that the few weeks in the California sun had changed your complexion considerably and I take it you are all enjoying farming in the open air.

Good luck on your new venture. Everyone here says hello and best wishes.

So long,
Jay

Notes
[1] Art of this Century, New York, *Jackson Pollock* (March 19–April 14).
[2] Etching produces an image on the printing plate through a chemical or electrolytic process. Re-etching is further etching a printing plate in order to enhance contrasts.

July 11, 1945

Dear Maria and Frank,

About once in a blue moon we get word, via the grapevine, that you kids are still healthy and making out all right. Latest report is that you have a house and are enjoying farming. We are all glad to hear of your progress, and especially Mother. She is pretty badly hurt by your long silence, and says you are stinkers for never writing, yet she perks up and gets a warm glow in her eyes whenever she hears any small bit of information about you.

Right now she would be particularly happy to hear from you, as she is ill and confined to bed. Alma and I were up to Deep River [Connecticut] the last of May to celebrate our collective birthdays and Mother returned with us. She hadn't been feeling well all winter and had hardly been out of the house although she never complained about anything specific. Her teeth were very bad, and we finally persuaded her to have them pulled, and plates made. The teeth were pulled in two sessions, all but two in the lower jaw that were especially sound and deep rooted, and which the dentist wanted to leave in for holding the lower plate. This raised the cost of the plates about one hundred dollars, and now the dental bill is $326.00. Is it possible for you to contribute toward this bill? We will have to meet the doctor bill (I'll explain about it in a minute) and you can see that on top of this, the dental bill is a little staggering. Jack can't help out, as he hasn't sold enough pictures this year to cover his contract, though he went over last year. We don't know yet how Charles is situated financially, but as he has been ill himself, probably not too well.

About Mother's sickness: three weeks ago the varicose veins became extremely inflamed, swollen and painful, with indications of complications setting in. Lee called me about it, and I went in, and between us, we convinced Mother that she must see a Doctor. The doctor put her to bed, is giving her medicine, and keeping a close watch on the condition. There is serious danger of a blood clot forming and traveling

upwards. She has to lose weight, and is on a fruit juice and vegetable diet. The inflamed portion of the lower leg is better, but a large swelling has appreared on the upper leg near the groin. Mother says she is feeling better, but this is a serious development. We will keep you informed of any change in her condition.

At present she is with Jack and Lee, which is not so good because of the stairs, but she can't be moved now, and we have only one room and are clear out in Flushing, too far from the Doctor, and also from the dentist. Mother hasn't gotten her teeth yet, and of course, can't get out now. You can imagine how hard it is for her to stay in bed under these circumstances, and I'm sure you can also realize how much a letter or two from you would lift her spirits.

Jack has had several good reviews since his show last winter. The latest one is in the June 25th issue of the *New Republic*. If you can't get it, I can send you one. His show in San Francisco was postponed because of the Conference.[1] Lee is a swell person, and we like her better all the time, as we get more acquainted.

I was fortunate in getting one of the best jobs in New York, re-etching for Neo-Gravure. I'm gaining some valuable experience, but this climate is definitely bad for Alma's health, and we will probably have to return west at the first opportunity for a job there.

Please write to Mother soon, and let us know what you can do to help on the dental bill. Alma sends her love.

So long,
Jay

141–25 Northern Blvd.
Flushing, Long Island, N.Y.
Apt C6 – c/o De Groot

Note
[1] The San Francisco Conference (see Glossary).

Alma (New York) to Marie and Frank (California)

August 13, 1945

Dear Maria and Frank,

It was good to hear from you again, but we were so sorry to hear that Jonathan has been having such a tough time of it this year. He was such a sturdy, healthy looking little fellow when we saw him last that it is hard to imagine him in the hospital.

There must be a definite ear weakness in the Pollock family as Karen, Jeremy and Jonathan have all suffered the same complaint. When we first came to New York, Karen's ears were seriously affected, and she was almost deaf for a short while. That has all cleared up now, and we hope for good. In several different letters from Charles I remember mention of Jeremy having considerable ear trouble, and Jay says he recalls that Charles had the same thing when he was a boy. I do hope Jon is much better by now, and that he never has a recurrence of the trouble. It seems that children sometimes have one bad year when everything happens to them, and then they go for years without any serious trouble.

This has been a bad year all around for the Pollock family when it comes to sickness, hasn't it? I have been under a doctors care ever since I came to New York – for the first time since my marriage. It just drives me wild to be visiting a doctor, and swallowing medicine, and taking my temperature constantly, but Jack and Lee have unlimited confidence in this doctor, and are sure that if anyone can clear up this chronic bronchitis and sinusitis, she can do it, and of course Jay thinks it is worth a try, at least, so I continue, very reluctantly, I assure you! I will say this, the doctor did a wonderful job on Mother Pollock. Her condition was about as grave as it could have been, and in a few weeks, she had the veins reduced to almost normal, and eliminated the danger of the blood clot (phlebitis). At the moment, Mother says her leg is better than it has been at any time for fifteen years, and we are all so relieved. She must be very careful for the rest of her life, of course, and must continue to lose weight, and remain on a starch-free diet. She is down to 167 pounds now, and

hopes to lose at least ten more pounds in the near future. She still hasn't her teeth, and when she finally gets them, and becomes used to them, I know she will feel much better, and be happier.

We were quite as elated as you were over the British election, for never in our most optimistic moments did we visualize quite such a Labor landslide as occurred. It should have a wonderfully levening effect on the peoples' movements of all of Europe, and it certainly presents us over here with a ringing challenge. Contrary to the rest of the world, our battles in America are before us instead of largely behind (there is something altogether wrong with that similie, isn't there? It sounds like a pun, and I certainly never intended it to be! But I mustn't waste paper by starting this page over). What I mean to say is that while the people of Europe have come to grips with their own fascists, and see them in the dust, we haven't begun the job of getting our hands on our own variety of fascists, and pulling them down from the places of power and privilege they occupy. Which makes the coming period one of limitless responsibility for all of us.

This is Monday, the second day of the suspense of waiting for the Japanese answer to our surrender counter-proposal, and it is difficult to be very coherent; I can't bring myself to turn the radio off, and every few minutes the announcer says, "We are interrupting the regular program to bring you the latest bulletin. . ." and my heart leaps into my mouth, and my fingers get all tangled up with the keys, and that is the explanation of the typographical errors in this letter – and please be kind enough to accept such an explanation!

The imminence of peace presents Sande with the necessity of finding some other kind of employment sooner that he was expecting it. On his last visit to the City, he contacted a company doing silk-screen reproduction, which field interested him considerably. He was hoping to hear something from them, but so far nothing has materialized. He could probably get into Gravure, but that doesn't particularly appeal to him, I think. The truth is that neither Sande or Loie is sure just what they want to do, or where they want to live in the future, but they will probably come to the City for the immediate future, at least.

It seems to me that I should have some more news to tell you, but none appears to be lurking in my mind at the moment. All I can think of is the problem of finding a place to live. We are only subletting here, and our lease is almost up. Jay has his heart set on living right in New York at least for this coming winter, but that is not so simple to do. There are no apartments available at all for less than $125 a month, which, needless to say, is way out of our class, and unless we are lucky and fall into something by chance, we will probably have to move to the New Jersey side of the river. We have several friends there, and would rather be in that neighborhood if we cannot locate right in the city, than be on this side, as the trip is too far for visiting back and forth, and it is lonesome enough to be transplanted to a strange place without being denied frequent visits from the friends one does have. At the moment I have visions of not being able to find any place to move to at all, and of being put out on the street, or of knocking on a friend's door and announcing, "well, here we are – for the duration and six months!"

Do write to us, won't you? Now that we have broken the ice and actually exchanged letters, it shouldn't be too hard to keep in touch. Whoops – there goes another of those bulletins! I might as well say "goodbye" for this time. Let's hope the good news comes very, very soon now, and that we can gird up our loins and solve the tasks ahead!

Love,
Alma

1947

Jackson (New York) to Stella and family (Connecticut)

[September 4, 1947]

Wednesday

Dear Mother and all,

I have a painting stretched on the quilting frame – hope to have it finished in another week – and then send the frame on to you. American Express I think will be best. We have had a very busy summer – and have made some very good contacts – especially modern architects, and their response to my painting has been the unexpected. Nothing new on the New London [—]. A card from Rube [Kadish] today saying Frank is back in Ontario [California]. Any news from him? Lee got the apron – many thanks – I think we will have to go in to N.Y. next week.

Love,
Jack

Epilogue

1959

Thomas Hart Benton (Missouri) to Charles (Michigan)

May 7, 1959

Dear Charles,

I was, after so long a time, delighted to hear from you. Poor old Jack used to keep us informed of his whereabouts and state, or lack of a state, of sobriety by telephone – generally in the middle of the night – but there has not been a peep out of you since God knows when.

What the hell are you doing? In terms of straight ability you were the kingpin of the Pollock-McCoy clan and yet I have neither seen or heard of your work since the old New York days.

Occasionally I see our old friend "Huby"[1] in Martha's Vineyard but he is still so stuck in the Marxist slough that conversation with him is useless. I ran into Bill Hayden in New York a year ago last Autumn, had dinner and a long confab with him, but did not get much of a line on what he is doing – some sort of engineering draughtsmanship I believe. I have occasional conversations with Alvin Johnson and Horace Kallen[2] at the New School but most of my old New York friends have either died or like myself, left town. My New York State commitments have made a new set of

acquaintances, mostly engineers and architects who grab all my New York time anyway.

I left the art world, the world of dealers and exhibitions over 10 years ago and will never go back into it. An occasional picture (Benton picture) gets into the market when collections are broken up but I have nothing to do with that beyond noting the price increase.

As you probably know I've become a regular "Historical Painter" – in the old fashioned, middle 19th century sense – with careful research, everything documented, etc. This means not much production as to number but a lot as to volume.

I'm putting this note in J. de Martelly's[3] hands for your address.

Best to you and yours,
Tom

Notes

1 Leo Huberman.
2 Alvin S. Johnson (1874–1971), one of the founders of the New School for Social Research. Horace Kallen (1882–1974) was one of the first teachers at the New School.
3 John Stockton de Martelly (1903–80), American painter and printmaker.

Glossary

American Artists' Congress: an organization founded in 1936 as a group of artists against fascism

American Federation of Labor (A.F.L. or AFofL): founded in 1886 as a federation of craft unions, but in 1935 a splinter group founded the C.I.O., Committee for Industrial Organization (see below); the two unions were bitter enemies until 1955, when they merged into the A.F.L.-C.I.O.

American Labor Party (A.L.P.): founded in 1936 by liberal Democrats and traditional Socialists, it was based primarily in the state of New York and had strong ties with labor unions

American Workers Party (A.W.P.): a socialist organization established in December 1933 by activists in the Conference for Progressive Labor Action (C.P.L.A.)

Artists Union: founded in 1934 to protect the rights of American artists

Associated American Artists: an association created in 1934 to link artists and their public by making art more accessible and attractive

Black Legion:	an organization within the Ku Klux Klan that operated in the midwestern United States in the 1930s; members wore black uniforms with skull and crossbones insignia and were reputedly responsible for numerous murders of alleged Communists and Socialists, notably Earl Little, Malcolm X's father
Blue eagle:	see **National Recovery Administration**
Brookwood Labor College:	based in Katonah, New York, and founded in 1921 in association with the American Federation of Labor (A.F.L.) as an experimental college, Brookwood was an attempt to create an alternative to traditional colleges; it lasted only until 1937, when it fell victim to the Depression
Citizen's Relief Committee (C.R.C.):	government agency providing help for the poor and unemployed
Civil Works Administration (C.W.A.):	government agency that created public works jobs for 4 million workers; it was terminated in 1934 because it cost the government too much money
Civilian Conservation Corps (C.C.C.):	created in 1933 "for the relief of unemployment through the performance of useful public work, and for other purposes"; one of the most successful New Deal programs of the Great Depression, it existed less than 10 years but left a legacy of strong, handsome roads, bridges, and buildings throughout the United States

Committee for Industrial Organization (C.I.O.):	a labor union created in 1935 by John L. Lewis, a member of the American Federation of Labor (A.F.L.)
Communist International:	also known as Comintern (**Com**munist **Intern**ational); an international Communist organization founded in Moscow in March 1919
Communist Party (Opposition): (C.P.(O.))	a group formed by Jay Lovestone and Benjamin Gitlow after they had been ousted from the Communist Party because of their support for "American Exceptionalism"
Farmer-Labor Party (F.L.P.):	founded in the 1920s to represent both farmers and workers
Federal Art Project:	see Works Progress Administration/ Federal Art Project
Federal Emergency Relief Act:	a law, founded in May 1933, that gave grants to states for their programs to help the poor; a precursor of welfare
Federal Theatre Project:	a New Deal project founded in 1935 as part of the W.P.A., to fund theater and other artistic performances
Greenwich House:	founded in 1902 as a social settlement house in the Greenwich Village section of New York City; in addition to its social services programs, it established cultural programs in music, theater, and the fine arts, and provided vital institutional support for government programs
Home Relief:	a government program, a precursor of welfare, that provided a small

211

	amount of funds to families suffering under Depression-era unemployment
House Un-American Activities Committee (H.U.A.C.):	the first chairman, Martin Dies; was also known as the "Dies Committee"; it was notorious for its exposés of alleged Communist infiltration into U.S. business and government
Labor Non-Partisan League (L.N.P.L.):	formed in April 1936; tried to persuade workers who would have voted Socialist or Communist to vote for the Democrat, Roosevelt
League Against War and Fascism:	an organization founded in 1933 by the American Communist Party and by pacifists to fight against the Nazis
League for Independent Political Action (L.I.P.A.):	this group, that included Lewis Mumford and John Dewey, aimed at promoting an alternative to capitalism, a system they considered obsolete and cruel
Medical Bureau to Aid Spanish Democracy:	organized by a few politically concerned doctors in New York City to raise funds to send medical supplies and personnel to Spain during the Spanish Civil War
National Labor Relations Board:	an independent government agency created in 1935 to administer the law governing relations between unions and employers in the private sector
National Recovery Administration (N.R.A.):	an executive agency developed by President Franklin D. Roosevelt and his administration, it encouraged industries to create codes of fair

competition and to protect workers by setting up minimum wages and maximum working hours; the symbol of the N.R.A. was a blue eagle

National Unemployed League: an association founded by American Socialists to assist victims of housing eviction and hunger

Pocket veto: a particular kind of veto that exists only in the United States – if a projected law is presented to the Congress less than 10 days before the end of the session, the President can decide not to respond to it; the law will thus be promulgated if the President signs it, but if he doesn't, it will not be

Popular Front Government: in France, under the leadership of Léon Blum (June 1936–June 1937); although they wanted to intervene in the Spanish Civil War, the Radicals were opposed and so a policy of non-intervention was adopted

Public Works Administration (P.W.A.): a New Deal program established in 1933 to hire qualified workers for public projects

Public Works of Art Project (P.W.A.P.): a government program designed to employ artists to create works of art to embellish public buildings

Reconstruction Finance Corporation (R.F.C.): an agency established in 1932 by the United States Congress to help state and local governments; it made loans to banks, railroads, farm mortgage associations, and other businesses

213

Resettlement Administration:	one of the New Deal programs in the United States, it created "model" communities to resettle jobless families
San Francisco Conference:	(April 25–June 26, 1945), an international meeting that established the United Nations
Social Security murals:	commissioned by the Section of Fine Arts of the Public Buildings Administration of the Federal Works Agency, which operated from 1934 to 1943 to create art for newly built federal buildings
Treasury Relief Art Project (T.R.A.P.):	used funds from the Works Progress Administration/Emergency Relief that were then granted to the Treasury Department (July 1935–June 1939), the goal being to commission art from unemployed artists to decorate existing federal buildings and new federal buildings without money in their construction budget for art; this was a relief program and 90 percent (later 75 percent) of the artists on T.R.A.P. had to come from the relief rolls
United Auto Workers (U.A.W.):	a union founded in May 1935 in Detroit, Michigan, it had begun as part of the A.F.L. but was suspended and became part of the C.I.O.; it was one of the first major unions willing to organize African-American workers
Workers Alliance:	a national organization of the unemployed founded in 1935
Workers School:	(1923–43), a Marxist institution of continuing education

Works Progress Administration/ Federal Art Project (W.P.A./F.A.P.): government projects designed to provide work for unemployed artists; W.P.A. artists' work was intended for institutions supported by income taxes, and each State had its own W.P.A. director and its own team